# A *Beautiful* Game

FOOTBALL THROUGH THE EYES OF THE WORLD'S GREATEST PLAYERS

## Tom Watt

*foreword* **Arsène Wenger**  *introduction* **David Beckham**

Abrams, London
in association with PQ Blackwell

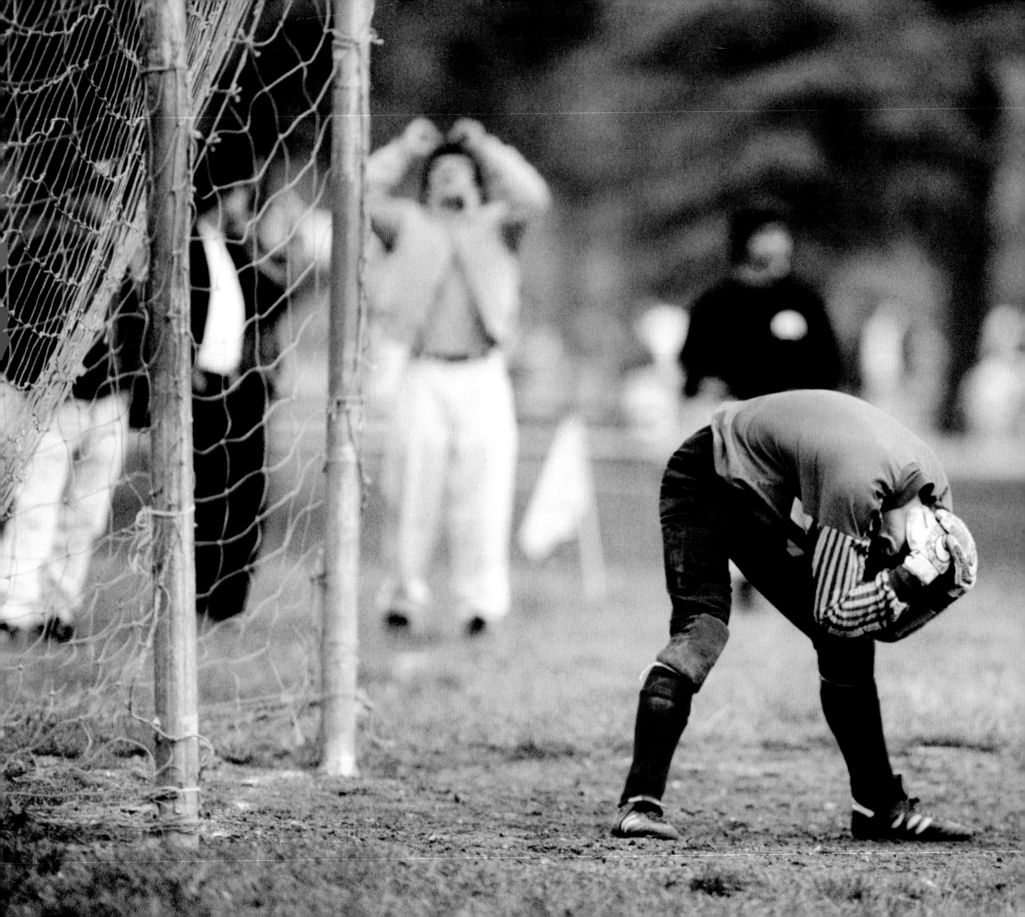

# Contents

**Foreword**
Arsène Wenger 04

**Introduction**
David Beckham 06

Hope
Pogatetz – Austria 12
Suárez – Mexico 16
McCarthy – South Africa 20
Kallio – Finland 24

Family
Laursen – Denmark 28
Healy – Northern Ireland 32
Muntari – Ghana 36
Samaras – Greece 38

Dedication
Donovan – USA 42
Nakamura – Japan 46
Guerrero – Honduras 50
El Karkouri – Morocco 54

Passion
Gordon – Scotland 58
Eboué – Côte d'Ivoire 62
Vogel – Switzerland 66
Kompany – Belgium 68

Pride
Cannavaro – Italy 74
Jazic – Canada 78
Gudjohnsen – Iceland 82
Galindo – Cuba 86

Loyalty
Benjani – Zimbabwe 90
Smertin – Russia 94
Ribéry – France 98
Rosický – Czech Republic 100

Friendship
Boruc – Poland 106
Van Persie – Netherlands 110
Diarra – Mali 114
Nelsen – New Zealand 118
Metzelder – Germany 120

Humanity
De la Cruz – Ecuador 124
Kanu – Nigeria 128
Schwarzer – Australia 132
James – England 136

Flair
Messi – Argentina 140
Casillas – Spain 146
Figo – Portugal 152
Gamst – Norway 156

Courage
Jaïdi – Tunisia 160
Ruíz – Guatemala 164
Silva – Brazil 166
Mido – Egypt 172

**Acknowledgements** 175
**Index** 176

## FOREWORD

Football is a beautiful game because it belongs
to us all.

~ ARSÈNE WENGER ~

Football is a beautiful game because it belongs to us all. The whole world plays. Some of us play better than others, of course, but we all know how it feels to run and kick a ball. Wherever you are, from morning until night, you will see children playing football. Whatever sets those children – or their parents – apart, the game can bring them together. Across every continent, now more than ever, football is a common language and a culture shared: joy, passion, knowing what it is to be in a team; an escape, an inspiration, an affirmation of identity.

A ball, a tin can, a stone or a bundle of plastic bags held together with a rubber band; anything as long as it rolls. A crowded backstreet, a dusty yard, a windswept hillside or a few square metres of beach: where you first kick a ball is part of the landscape of childhood, as much as the schoolroom or the family home. The game is at the heart of growing up, at the heart of life itself, for millions of children all over the world.

What makes a player? Skill, of course. And athleticism. Intelligence, commitment, humility, courage and desire as well. What makes a top player? All those things and one thing more: the greatest players – whatever their backgrounds, whatever the journey they have made – all love football with the same intensity as they did when they were little boys. They love the game and maybe that, more than anything, is what makes us happy when we watch them play.

The best football players are recognized, respected and admired without regard to national borders. Their words and deeds can inspire boys and girls in their own countries and in countries on the other side of the world. Those players' lives have been transformed by football and, of course, the game can transform the lives of children everywhere who look up to them as well.

A great player can say he belongs to the country of his birth; or to the country where he has reached the top of his profession. He can say he belongs to both. The truth is: the great player belongs to football. And his spirit – maybe his story too – belongs to every child who plays.

I hope you enjoy *A Beautiful Game.*

Arsène Wenger,
London, November 2008

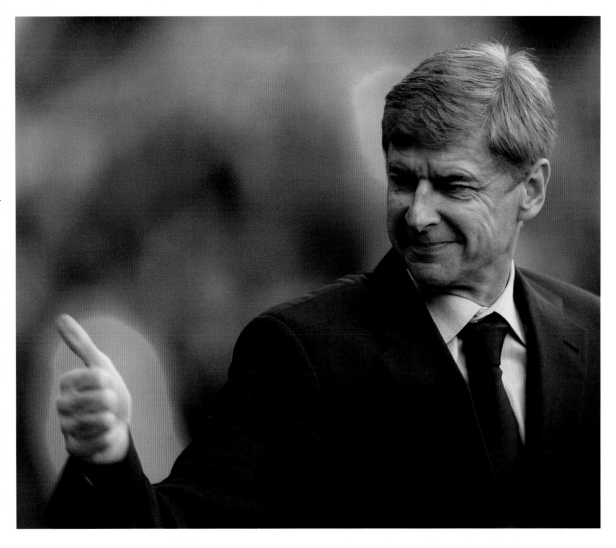

## INTRODUCTION

I can't know what was happening in the rest of their lives. I don't even know if they were all friends: they might have been fighting each other an hour later! But, while we were playing, they were all together, sorting themselves out as teams; and all of them up for a game. Wherever you are in the world, it seems to me, that's what football can do.

~ DAVID BECKHAM ~

I'd never been anywhere like Sierra Leone. While I was at Manchester United, we went to Thailand on a tour and, while we were there, we visited a facility called the Kredtrakarn Centre in Bangkok which was supported by UNICEF. All of the girls there had been involved in sex work or child labour at some point in their lives and exploited by adults. Some of them were still very young. The centre was a refuge for all of them. That must have been at least ten years ago now but the memory has stayed with me ever since: that visit opened my eyes to things I'd never thought about, things I couldn't even imagine.

That visit with United was my first introduction to UNICEF and I was honoured, afterwards, to be asked to get involved personally. I had an obvious connection with the Sport for Development programme and wanted to do something to help. Ever since agreeing to become a UNICEF Goodwill Ambassador, I'd always had this idea to do a trip to Africa as part of what I was doing with the charity. I wanted to go somewhere I felt I could actually do some good by visiting; I wanted to see what help people were getting from the fundraising I was involved in back at home. If I was going to properly understand what UNICEF was trying to do, I needed to see it in action for myself.

When the opportunity to do a visit like that was first mentioned, I talked to the people from UNICEF and we agreed that I should do the thing properly. I didn't want to go somewhere that had been tidied up for my visit so that we could take some nice photos. I wanted to go somewhere UNICEF's work was most needed, somewhere in real trouble. That's when the possibility of going to Sierra Leone came up. UNICEF's focus there is on child survival: 27 per cent of children in the country die before reaching their fifth birthday, the highest percentage anywhere in the world. Once I found out about the situation and the fact that so many of those children die from preventable causes, despite some people telling me how dangerous it was and telling me I didn't need to go somewhere like that to make an impression, I was determined that Sierra Leone it would be.

It was all organized and I know a lot of work went into making that trip happen, early in 2008. It felt to me it was worth it. Don't get me wrong: I wasn't worried about my safety or anything like that before I went. To be honest, what I was worried about was what effect the things I was going to see might have on me. I suppose I didn't really have any idea how I was going to come away feeling. I've got to say that going to Sierra Leone turned out to be one of the most rewarding, most satisfying experiences of my life. It was a trip I won't ever forget.

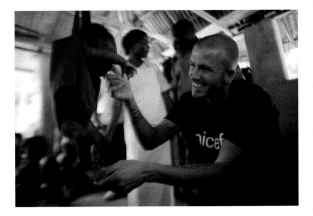

It may seem hard to believe but, in the end, I left Sierra Leone feeling so positive. Of course I saw hunger, illness, devastation, and it was terrible; but, at the same time, the work I saw going on genuinely inspired me. What UNICEF is trying to do in Sierra Leone really is changing kids' lives there and the lives of their families too. I'd never have imagined that: that I would come away from a country that's suffered so much but still feel positive about Sierra Leone's future. UNICEF's work was going on and that meant there was hope. And, you know, football can be a little part of that.

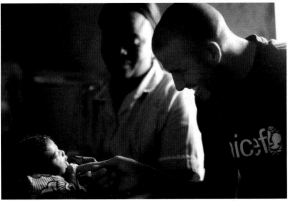

Look at that picture. That was taken in a town called Mangorea, where we went to visit a newborn little girl named Mariatsu, just a day or two old. I went to Mariatsu's house with the community health nurse, Angele. That's her in the background. Mariatsu's mum, Alice, was 16 and was hoping to be able to go back to school soon. Angele was there to give Mariatsu her polio vaccination and I actually got to give her the drops that morning. I can't describe the feeling to you. I just kept thinking: "Am I doing this right?" It was pretty incredible.

We stopped off at Mariatsu's house on our way to a community health outreach post near the town of Makeni in the Northern Province. Children from all the villages nearby can go there to see the nurses who check their growth, weigh them, give them vaccinations and talk to their parents about hygiene and nutrition. After we'd met the staff there and seen what was going on, we came outside and there were all these children waiting around. I looked at the crowd of kids and thought: "We should

give them a football." I grabbed one and hid it behind my back. I think the kids had already seen it, though, and you can tell from the picture how excited they were.

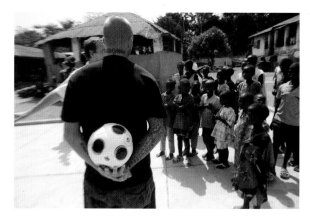

I found myself thinking how lucky our kids are at home; how much our kids have to enjoy. There, in Sierra Leone, you could see how much a football could mean to those children. A proper ball. The excitement on their faces is the same excitement, though, that I see on my own kids' faces when they're having fun. Playing football makes those children happy in Sierra Leone just like it makes our kids happy back at home. I think they were excited to see me. But I think they were even more excited about getting a real ball. They were amazed by it but, as soon as I handed it over, they were straight into playing a game: they ran off and forgot all about me.

I went through so many different emotions during my time with those children in Sierra Leone. We went to another UNICEF-supported clinic, Binkolo, in the town of Makeni. They look after mums and their children there, especially trying to prevent the transmission to newborns of HIV. I met so many children. Like those twins in the photo.

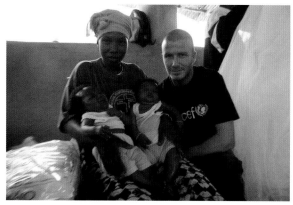

Can you imagine the love you feel? Of course I love my own children. But you're there in West Africa, away from everything you know, and holding those twins in your arms. They were just a few months old. They've no idea who you are or what's going on. But you can feel a parent's love welling up inside you. I'd been worried – I'm a bit on the emotional side, you know! – that I'd get upset; that I'd get a bit overwhelmed by it all. But you can see what's being done; their lives are so hard but those children look bright and happy. One boy came up to me when I arrived and handed me a little flower,

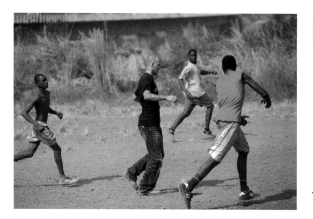

a daisy or something. In return, he expected me to carry him around in my arms for the next hour! What could I do?

Well, I could play football. And I'd had in my mind all along that, as well as the visits, it would be great to do something to do with football, even though I wasn't sure what. Later in the day, we were driving along, just crossing over a bridge in a place called Aberdeen, which is a neighbourhood of the capital of Sierra Leone, Freetown. I saw this cloud of dust coming up off a field by the side of the road. There must have been about 40 kids on there, running around in the middle of a game of football: eight- and nine-year-olds through to guys my age.

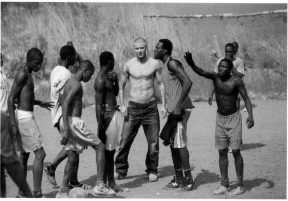

I called out to our driver: "Stop!" A couple of the guys looking after us said it would be better not to stop right there but I just said, "No, I'm going for a game of football." There were some old metal goalposts; nets, even. I wandered over and they came running up to me. First, they were just amazed to see a white guy coming to join in. Then I think some of them recognized me. But we just started playing: it was a game of Shirts versus Skins. I played Shirts first half and then Skins after.

We must have played for about half an hour. I've got to tell you: it was hot; ridiculously hot! I don't know if I've ever sweated like that during a game of football. And I've definitely played on better pitches! It was really bumpy but some of the kids had great touch which was probably down to them playing on that sort of surface. So lean, too, look at them; fit – really good athletes. You can see, in the picture, the guy in the orange shorts and the red shirt. He took it on himself to become my "minder" during the game. He made sure nobody tried to kick me too hard or foul me. And, at the end, it was him that managed to get me back to our vehicle: it got a bit mad once we finished playing. I gave him my shirt to say thank you.

I can't know for sure but I got the feeling those lads are probably out on that pitch pretty well every hour of every day. You could see how much they love football; how much they love playing the game. People in Sierra Leone love watching too. Anywhere there's a TV, if there's a game on, you'll see 40 or 50 kids crowded round it, trying to have a look. The African Cup of Nations was on while I was out there and everybody wanted to be in front of a screen whenever there was a game. You'll be driving along the road and see a bar with a telly on and it's just a crowd of people – kids, adults, everybody – out in the street, watching. It's fantastic.

Manchester, Madrid, Los Angeles or Freetown: football's a game people love everywhere you go. Since I made my debut for Manchester United – that's a long time ago now! – one of the things that's changed in professional football is that there are players from all over the world playing in the different leagues now. From the supporter's point of view, I think foreign players have brought so much to the Premier League in England, for example. People like Eric Cantona and Dennis Bergkamp and Gianfranco Zola made a huge difference to English football while I was at United. At Real Madrid, it felt like a privilege for me to be playing alongside truly great players like Zinedine Zidane and Ronaldo. And, here in Los Angeles, it's the same: every dressing room, it seems, is full of players from different countries, different continents. But, even though you may not speak the same language as your teammate – and you may have been brought up in completely different backgrounds – when you're playing football together you understand each other perfectly. Just like with those lads by the side of the road in Sierra Leone: as soon as we had a ball in front of us, we all wanted the same thing. Didn't matter where we were or what the prize was: it was all of us together, just wanting to play and wanting to win. I can't know what was happening in the rest of their lives. I don't even know if they were all friends: they might have been fighting each other an hour later! But, while we were playing, they were all together, sorting themselves out as teams; and all of them up for a game. Wherever you are in the world, it seems to me, that's what football can do.

David Beckham
Los Angeles, October 2008

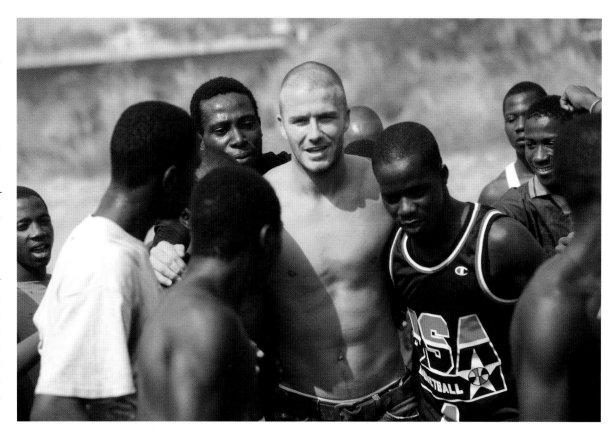

## HOPE

I don't ever want to lose that love I had for
football when I first started to play, when
I was a boy.

~ EMANUEL POGATETZ ~

# Pogatetz (AUSTRIA)

*Emanuel Pogatetz*

You know, it's funny with football in Austria. It's a healthy country. There are so many things for people to do. There are lots of sports, and maybe, when it's cold and wet, people would rather go to the cinema or something! But everyone cares about their football club. If you go to any town in Austria, everybody knows how the club is doing, how the last derby match went. They seem passionate about it but they don't always come out to the stadium to watch.

Graz is in Styria; quite a small town with about 200,000 people living there. There are two football clubs: Grazer AK and the team my dad, Alois, always supported, Sturm Graz. I grew up just 200 yards from their stadium. The place was part of my life: Dad started taking me to

## All my memories about childhood are to do with playing football.

games when I was very young. We went to every home game. When it came to playing, at first I played ice hockey which is a very popular game in Austria. There was a hockey arena alongside the stadium in the same complex and for a year, when I was five until I was six, I was going along to do hockey training. But I loved football. Before hockey and after it, every minute I had, I was playing football.

Dad used to take me along to a park nearby and watch while I played. Not organized games: just whoever was there, we'd play. The park, Grungar, was a patch of grass surrounded by tall apartment buildings. In the winter, we would put water on it which would freeze overnight and we'd play ice hockey on it the next day, but as soon as the weather got warmer we got our boots out. All my memories about childhood are to do with playing football.

Most of the other kids lived in those tall blocks but, even though I was from outside, living in a house a few streets away, they accepted me after a while. The buildings on one side of Grungar were painted yellow and the ones on the other were painted black, so those were the teams: Yellows against Blacks. Because I didn't live in one of the blocks, I could choose which team I played for. Even though we were young, the games were competitive: the Yellows wanted to beat the Blacks and the other way round, of course.

Dad always wanted me to do sport but there was never pressure on me: whatever I did, my family would have supported me. But I wanted to play football all the time and I think my dad saw that: here's something he really likes. You know, I can still remember now – I was six years old – I don't remember much from back then but I can still remember one night, lying in bed: Dad came in before I went to sleep and said, "Think about it, make a decision. If you want to be good at something you need to decide: ice hockey or football." I lay in my bed, looking at the wall, thinking. That picture's still in my head even though it's a long time ago. But it was no big decision. When Dad came back in, I said, "Dad, I already know. I want to play football." And that's been my life, from six years old.

I loved to play football but I think the reason I got so passionate about the game was from going to watch Sturm Graz with my dad. It was just a little ground that could hold about 12,000 people. Almost everybody stood on the terraces. Back when I was watching, they had a good young team and it was a club with a big sense of tradition. They were in the second division then, but for the big games the stadium, the Gruabn, would be full. When you're just a kid, that sort of atmosphere really affects you, doesn't it? I became a real supporter. I used to play in the park until it was dark and, at night, I can remember having dreams about playing for Sturm Graz.

I watched those players, got to know the way they played. They were my heroes. They seemed so fast and strong. It was a young team then, but when I came up through the youth system and started training with the Graz first team, some of those players were still there with the club. They even qualified for the Champions League. I had so much respect for those players, when I was a kid watching them from the terraces, and then later when I was a young player myself, training alongside them.

I don't know what's happened to all the boys I used to play with in the park in Graz. I went on to school with some of them and I think one or two made careers in football in the lower leagues in Austria. But, even now, I remember those games, when we were just playing for fun. Playing for a club professionally, there are pressures that come with a career in the game: the money, the bills, winning and losing, being in and out of the team. But I don't ever want to lose that love I had for football when I first started to play, when I was a boy.

Sometimes, in the summer when we might have six weeks off, I go home to Austria. I have a rest but then, after a while, I can't help myself. I'll go out in Graz and start kicking a ball around with my friends. They're not professionals, just friends. And it feels like it did in the park all those years ago: we're just playing to enjoy ourselves. Whoever's there gets a game. Down at the Grungar, Yellows versus Blacks.

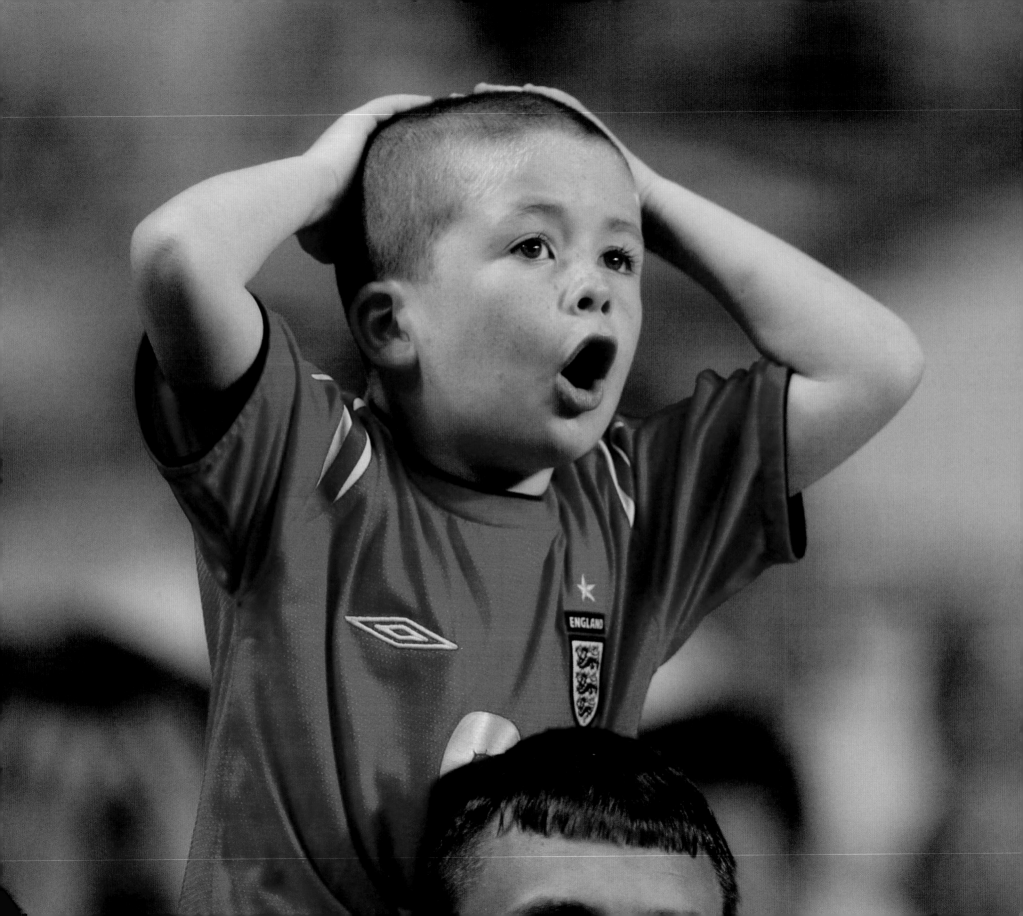

I got the chance to go and watch a game at the stadium just once: we didn't have any money to go more often. But that one time was magical. These players were like beings from another planet almost! You'd seen them on TV and now, to see them play live – when I was young they seemed so strong, so tall. ~ CLAUDIO SUÁREZ ~

# Suárez (MEXICO)

*Claudio Suárez*

When I was a little boy, Texcoco was a relatively small town, about an hour away from Mexico City. My dad worked in the local hospital and so he got housing that was provided by the government. It was a very small house and there were a lot of us: my mum, my dad, me and eight brothers all lived in two rooms which eventually got increased to three rooms. We all slept one on top of the other. I'm the middle son. I have four older brothers: Xavier, Rene, Sergio and Jose Luis; then Claudio. And four younger than me: Vicente, Jesus, Noe and Juan Carlos. Nine of us. And all boys. My parents used to say we could almost make up a team ourselves. Back then, I don't think I realized what we didn't have. Instead, I started playing soccer because my older brothers liked it and watched matches on TV. No question but it's the number one sport in Mexico, so kids always dream about making it as professional players, although I started playing just because I enjoyed it. I didn't have shoes – well, apart from the broken-down ones I'd inherit from my brothers – and sometimes we didn't have food at home, but we had soccer.

We played in the street, our little pick-up games: *cascaritas* we call them in Mexico. Not just soccer: sometimes we'd play American football or baseball, but usually football and always in the street. There's not the support – there aren't the facilities – that you have in Europe or the States, for example, for young players. In Mexico, whoever does sport has to make a success of it by doing it on his own. You find a place to practise, a place to play, and ours was the street. There had been a little dirt soccer field nearby but they got rid of that and so we'd play, using a few rocks to make goals. We'd have to stop when the cars went by – they weren't always coming but, when they did, they might come from either direction! – and then we'd start playing again. We'd play from one end of the street to the other; ten, 15 or more of us. I'd go out with my older

brothers, Rene, Sergio and Jose Luis – Xavier was ten years older than me and he didn't use to play with us so much – and we'd start a game and other boys would see us and come out to join in.

I started playing before I can remember. I was maybe five or six years old. My brothers just took me along. We would sometimes play in the entranceway to the house, use that as a goal. Mum would want us to help with jobs around the house, sweeping and washing. Whoever lost the game would have to do the housework for her! In the mid-70s there wasn't much football on TV but I would watch whenever there was a game on. Then, later, when I was about 12, there was a team in Texcoco in the first division. They were called the Coyotes of Nexa. I got the chance to go and watch a game at the stadium just once: we didn't have any money to go more often. But that one time was magical. These players were like beings from another planet almost! You'd seen them on TV and now, to see them play live – when I was young they seemed so strong, so tall. Everything about it all seemed huge.

When we were young, we would go out and do little jobs for neighbours: take out trash, cut the grass, do painting, anything that meant we could bring a little money into the house. Mum and Dad always wanted us to study. Their dream was that one of us would actually go on to have a career in one of the professions. Dad would always say, "Forget about soccer. Forget about sport. Just dedicate yourself to school." Xavier was a good player but wasn't convinced to take it further. But when I was 12 or 13 I started to think about being a player.

I was still in school, still just playing our little games in the street, when a friend from the same neighbourhood was kicking around with Sergio and myself one day. He was older and was studying at the University of Mexico. I

remember him saying to us, "You should go and give things a try in Mexico City, maybe get a trial for Pumas – the University team – because they give younger players a chance. You guys are good enough to be playing for them." We weren't so sure. It was a long way away. The Pumas campus was a three-hour trip from Texcoco. But the Coyotes had moved to another city in the state and didn't really have a youth programme anyway. So our friend eventually talked us round and we went down to try out. This guy was a huge Pumas fan and would go and watch Pumas training sessions after his university classes. He encouraged us, even travelled down to Mexico City with us. It was only then that we started to realize that we might really be able to become professionals.

By the time I was 14, Sergio was 16 and he joined Pumas and did well. They sent him off to play professionally in the second division. We couldn't really afford for me to continue going to train down in Mexico City as well, though. I started playing for amateur teams in Texcoco. I was still just a youngster but I was playing in the adult leagues – I was the youngest player by far – and the owners would sometimes give me a little money to play for their team. I would sometimes play two games in a day and get 15 pesos: five dollars. With that money I was able to start going down to try out for Pumas again. There was one coach there, Juan Armenta, who liked the way I played. The others wanted to let me go because I hadn't had proper technical coaching all the way through since being a young boy. They wanted to give my place to someone who'd been training with Pumas since 12 years old, which is when they start working with their young players. But Juan Armenta insisted I stay and because of him I got my chance in the team.

I'd always thought that a career in soccer would be simple: you play and they pay you, maybe. I'd had a lot of times

when I went without something to eat so that I could afford to go and train with Pumas. I realized, though, that football might be a way to earn enough money for the family to afford what we hadn't had when I was young. And I got my chance. Nowadays, some boys in Mexico perhaps have more opportunities to train and play. There are more soccer schools. But they are businesses; you have to have money to go to them. The government isn't thinking about the kids who can't afford that, who just need a space to play on their own. And in that way it's maybe even more difficult for kids in Mexico now. The places to play just

don't exist; even the streets are busier now as the towns get more and more crowded. There's a lot of crime, there is a big drugs problem and young boys are getting involved with all that. Those things weren't so much of an issue when I was young but, during the course of my career, I've watched it grow: I have friends, guys I played soccer with when we were kids, who went off into alcohol and drugs.

I was lucky my parents and my oldest brother, Xavier, were strong examples. And I played soccer because it represented so much fun while I was growing up. The game gave us the opportunity to forget about our problems, to

I think back to our games in the street, our *cascaritas*, when we just played for fun. When you become a professional player, you become aware of the responsibility that comes with soccer. I've played for the national team and, although you want it to be fun, you're aware of how important a game can be; you know that a mistake can cost your team everything. One mistake can mark your career forever. I can't remember who it was but that coach was right, the one who told us that the secret was to go out and play a *cascaritas*, but do it seriously! That would be the ideal: to have fun playing at the same time as being able to shoulder the responsibilities.

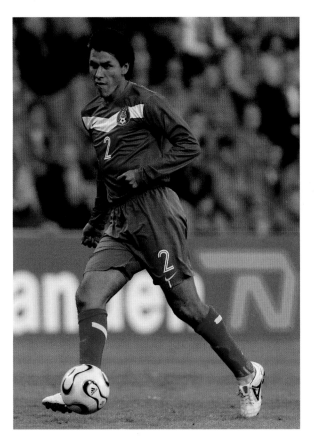

> It represented so much fun while I was growing up. The game gave us the opportunity to forget about our problems, to stay away from bad influences.

stay away from bad influences. My dad passed away in 2008 but I go to visit my brothers who still live in Texcoco. It's very sad to see what's happening to young people there now, where we grew up. What can we do? A couple of times, I've been to see the government in my state – that's the state of Mexico City – and talked to them. It would help if we could just open up some spaces for kids to go and play. If I was six years old now, I'd still have to play soccer in the street but that would be even more difficult, you know. It's so overcrowded, houses built one on top of the other. There's even less space. Just like when I was young, sport isn't really part of the culture in our schools either. We'd go to do our arithmetic and study and, perhaps just two hours a week, we'd have what they called physical education. Sport was never encouraged as something that should be part of a student's life. And I'm not sure if that's changed much now.

Soccer has given me a lot; things have gone well for me financially. My wife, Irma, comes from a very humble background too, and we have three children: two girls and one son, Claudio. We try to make sure they understand where we came from and how we've been able to get where we are now. We try to pass on values to them but it's difficult: they will have to live their own lives for themselves, after all. I say to Claudio, "You don't have to go through what I went through. You have space to play, boots to wear." And I tell him to make the most of that opportunity. He could turn out to be a better player than me. Who knows? Would I have been a better player if I'd had proper coaching when I was young? Or would I have lacked that hunger for playing the game? All I know for sure is that I value what soccer has brought me: that's why I'm still playing at 39 years old!

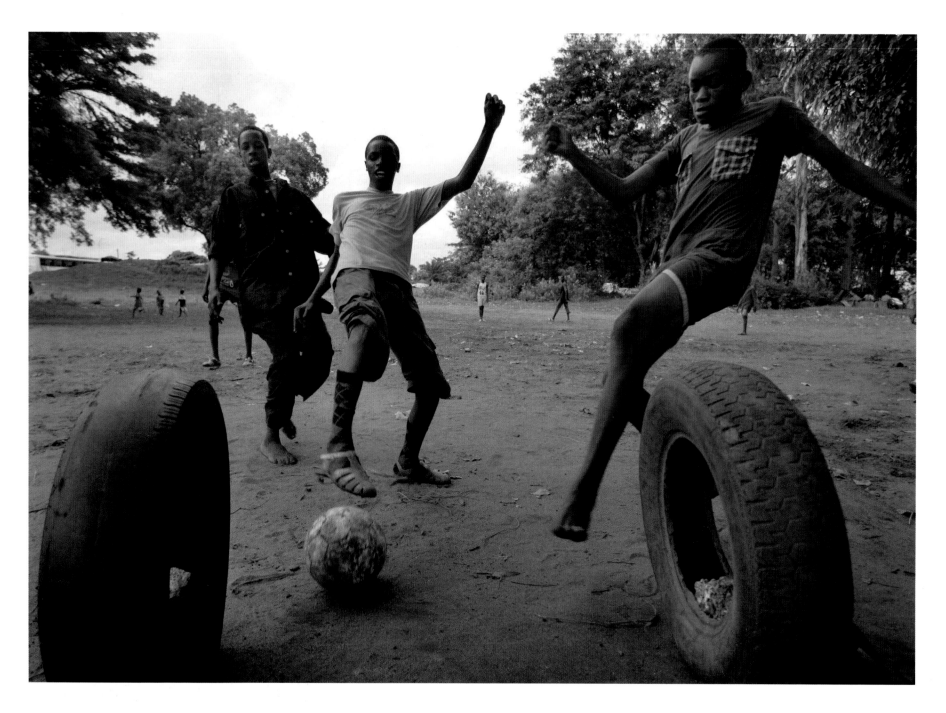

Boys in South Africa think, "If he can do that, why can't I?" They don't just dream about playing for Kaizer Chiefs or the Orlando Pirates. Now, they can dream about playing for Real Madrid or Barcelona or Manchester United. ~ BENNI McCARTHY ~

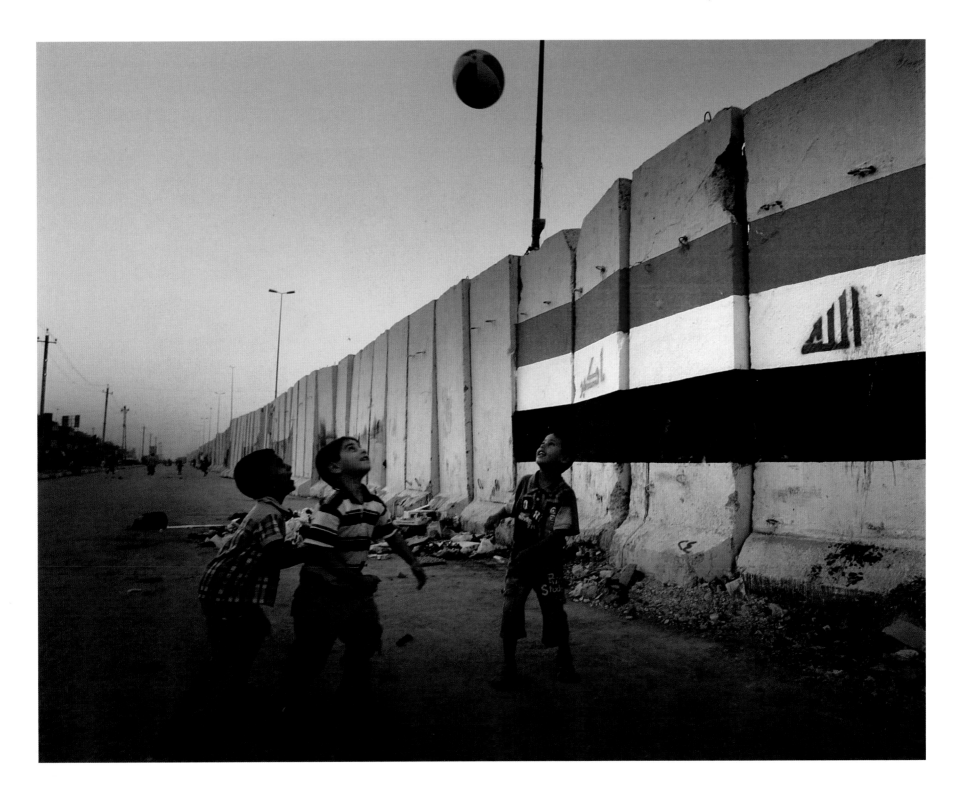

# McCarthy (SOUTH AFRICA)

*Benni McCarthy*

Without a shadow of a doubt, football is South Africa's national sport. I know we do well in rugby and cricket but that's because there are only a few countries that play those sports. We can get into the top two or three. But football? That's harder, isn't it? You're playing against the rest of the world: England, Brazil, Argentina, Germany, Italy; it's a long list. But everybody in South Africa loves football. Definitely, it's the national sport as far as the black population are concerned.

I was a massive Kaizer Chiefs fan when I was a little boy and I'd go with my mates and my brother to watch them play whenever they came to Cape Town. I can still remember when I was seven or eight, Arsenal came out to South Africa on tour and I watched them play Kaizer Chiefs on TV. David Rocastle was one of my favourite-ever players. My heroes back then, though, were guys like Doctor Khumalo and John "Shoes" Moshoeu, who I still think were maybe the most skilful players I've ever seen. They were big, big players in South Africa, two of the best of all time. Watching them was an inspiration. I'd say to myself, "One day, that's going to be me."

My father, Abraham, was a very good player. Everybody in Cape Town knew about him and maybe, if South Africa hadn't been outside international football when he was playing, he could have done what I've been able to do: break out into the world game. He could have been one of the first. As it is, he was a massive influence on me becoming a player. Without him, I would have ended up being another promising young player who got side-tracked and went the wrong way and ended up selling drugs or being a gangster.

We lived in a very modest house, in a very modest neighbourhood: I grew up in Hanover Park in Cape Flats. Everyday life in Hanover Park was all about gangs, drugs and crime. You know, you grow up there and either you stay out of trouble or you join in with all that. And I've got to say, it was fun joining in. When you're a boy, fighting boys from other neighbourhoods down on the street corner and proving your manhood, running around with a gang – it was all like being in a movie.

But the one thing I knew was that the moment my dad found out I was involved with a gang and getting into trouble, I was going to come home and I'd get my ass beat up. And I was so scared about that, I think, eventually it made me stay out of trouble. My father knows now how grateful I am for what he did. There's a deep mutual respect between us because we both know what would have happened to me if he hadn't been there.

When I was growing up, I would say football was the one thing that was a get-out from gang life – the fighting, the drugs and crime – for all of us. Street football: people from different neighbourhoods, different gangs, would put down their weapons and play. For me, playing in those street games from when I was six or seven years old was a part of that fun of "joining in". Football could bring people together. It was such a big thing in Hanover Park and all my friends played.

We'd find a patch of land by the road or sometimes a park to play on. And we'd have little tournaments between teams from different neighbourhoods. You know, each team would put up 50 pounds or 100 pounds and the winner took all. I was the best player and if I played we won! Those games toughened you up, playing against older boys. You had to stand up for yourself physically; you had to know how to fight back. And me being the best player, that earned me respect from when I was young.

I think that because people knew I was a good player there was less pressure put on me to get involved with the gangs and that life around the neighbourhood. People knew my dad too. He grew up in Hanover Park himself and had his own reputation as a footballer. If you were in the wrong neighbourhood or walking on the wrong street, you never knew what could happen, but I'd be left alone and stayed safe because they knew about me and knew about Dad.

## Watching them was an inspiration. I'd say to myself, "One day, that's going to be me."

I still go back to Hanover Park all the time, to the streets I grew up in playing football. I still catch up with my old friends. You know, some of those guys are big-time gangsters and drug lords now. But I think people respect that I still go home and I haven't forgotten my roots, or forgotten the people I grew up with. I do what I can: my main personal sponsor, Nike, gives me kit and football shirts and shoes for the boys in my neighbourhood and I get them involved in work in schools and charity.

But the most important thing: I take it seriously that I'm a role model for kids back in South Africa now who are growing up in the Projects. Kids playing football in the street like I did say, "I'm going to be the next Benni McCarthy." Their parents say to them, "Look at what

Benni did. He listened to his parents. He went to school."
You can have players like David Beckham that boys look
up to but I'm their best example because I come from their
neighbourhood and I haven't forgotten it.

When I was young, I wanted to be a professional player
but I could never, ever have imagined my career would
have worked out like it did. If someone had told me then
that I'd play in Europe, win the Champions League, and
play in the Premier League, I'd not have believed them.
It's not just what happened to me: boys in South Africa
think, "If he can do that, why can't I?" They don't just
dream about playing for Kaizer Chiefs or the Orlando
Pirates. Now, they can dream about playing for Real
Madrid or Barcelona or Manchester United.

The World Cup in 2010 is going to be the most inspira-
tional thing ever to hit the streets in South Africa. For
the first time, the World Cup won't just be something
that is happening on the other side of the world on TV.
OK, not many of the boys in Hanover Park will be able
to go to watch the games. But think about the excite-
ment – the biggest players, from all over the world, will
be playing football in a stadium just round the corner
from home.

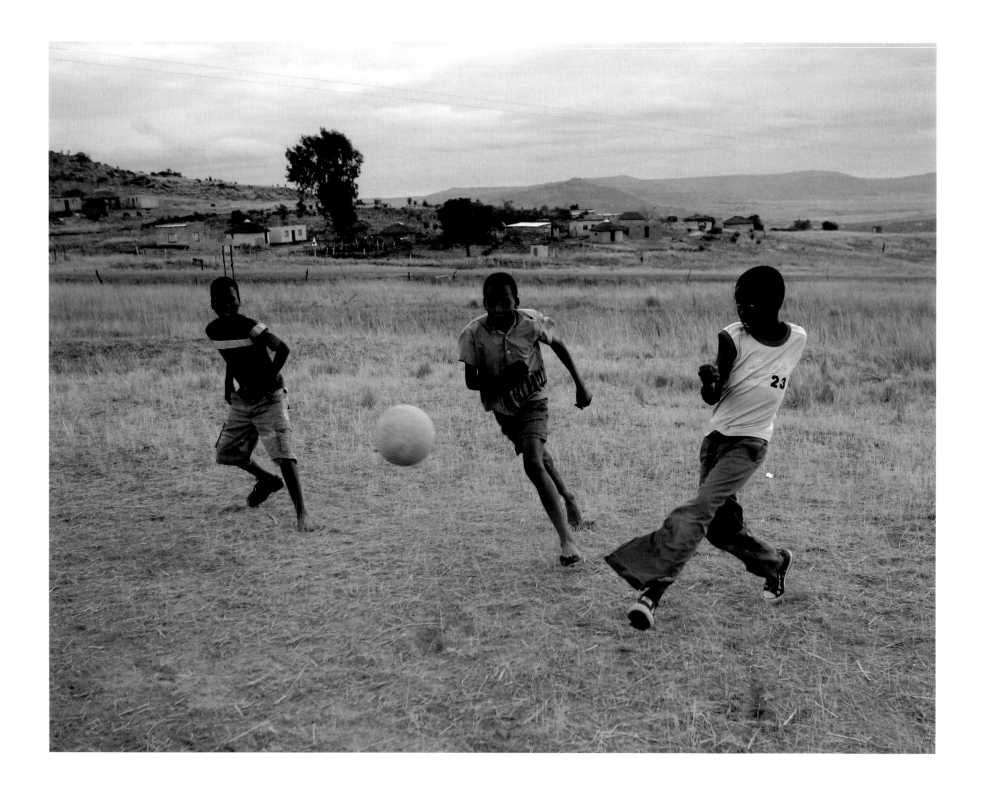

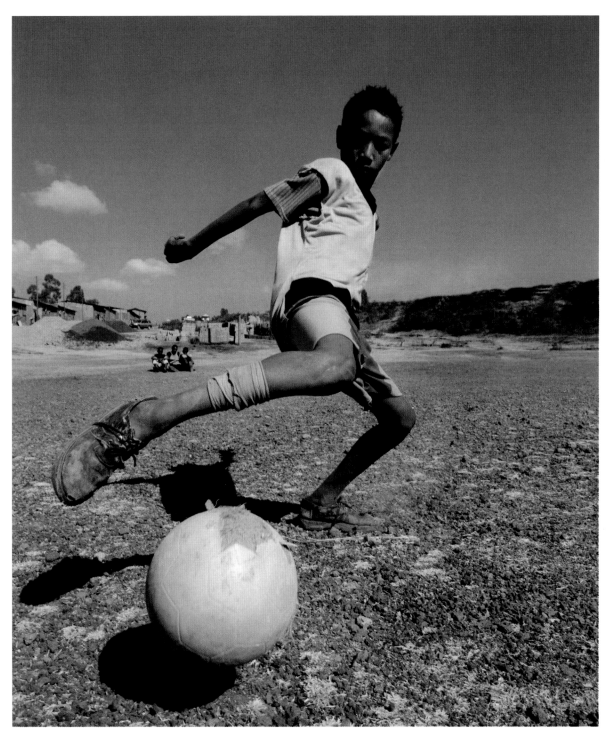

I didn't have shoes – well, apart from the broken-down ones I'd inherit from my brothers – and sometimes we didn't have food at home, but we had soccer. ~ CLAUDIO SUÁREZ ~

# Kallio (FINLAND)

*Toni Kallio*

Wintertime in Finland is a dark time. We get maybe six hours of daylight, something like that. That's part of life there. I grew up in a city called Tampere, which is in the south of Finland, a couple of hours from Helsinki. It's got a population of around 200,000 and is a really nice city; back in the 1950s it was very industrial, a city full of factories, but now it's modern and more a place where families live.

My home was actually in a small village called Kangasala which is right on the edge of Tampere, about 20 kilometres from the middle of the city. Kangasala is a beautiful place, surrounded by lakes. There is a real sense of a community there. When I was a boy, everybody knew everybody, although now it's grown and so that feeling isn't exactly the same. You could say it's like a suburb these days: lots of people who live in Kangasala go into Tampere to work. We were in a street with about ten other houses and we were the end house. It was pretty quiet. Past our house were just fields and lakes.

Mum and Dad bought a piece of land and built their own house; a lot of people do that all over Finland. My dad had his own company which put in electrical systems for big buildings like factories and hospitals. He started the company with one of his friends and they've done well, but when I was growing up he was busy with work all the time. Mum was always at home, though: she was a child-minder. People who were out at work could bring their children round to our house and Mum would look after them all day.

The football club in Tampere has done well recently so there's more interest in football but still ice hockey is the big sport in Finland. It's a winter country, after all! Even so, there are a lot of registered football players: around 100,000, I think. When I was growing up, though, ice

hockey was the first sport any of us would play. I played. I played volleyball, too, because that was my dad's sport. But I always played football at the same time. My uncle, Kimmo, was a footballer and I kind of followed in his footsteps. I used to go and watch him play. I'm not sure how professional the game was in Finland back then but he played at the top level. His team was called Ilves – the ice hockey team in Tampere is still called that – and Dad took me along to the stadium when I was very young, maybe three or four years old.

## Maradona was always the player I dreamt about being when we were playing our little games.

What was it about football? I don't know! Or I can't remember. I was only a little boy but something about the game grabbed me and made me feel as if I wanted to follow my uncle. As soon as I discovered football, I decided I didn't want to do any other sport. It was all I wanted to play. I stopped playing ice hockey and then, later, when I was about 12, I stopped playing volleyball too.

I'm not sure if it was the football itself or watching my uncle but I do remember how much I loved going to see him play. One year, they qualified for the old European Cup Winners' Cup and were drawn against AS Roma from Italy. That was a huge game for his club. It was a huge game for the city. Crowds aren't usually that big in Finland but the stadium was full for that game. My uncle played. I think they lost two-zero but it was a great night. And, after it, I started to follow Roma and Serie A, the Italian league. Juventus were always my favourite team.

I must have started playing when I was five or six years old. At school. Sometimes in PE classes we would play

football but usually it was just us, a group of friends playing together in the schoolyard or wherever we could find a flat piece of ground. English football was on TV and is still very big in Finland. We could watch the World Cup as well, and so Maradona was always the player I dreamt about being when we were playing our little games. That's why I started out as a striker, wanting to be like him. During my career, though, I've slowly moved backwards until now I'm a defender!

When I was about six or seven, I joined a local club in Tampere: TPV. They are a professional club but with a big juniors system. They were the nearest good club to where we lived, and I still have really good friends who started out with TPV at the same time as me. We played football together for many years. It wasn't anything to do with a scouting system. That's not how it works in Finland. Basically, if you want to play you can just go along and join the club. It doesn't matter how good a player you are, you can still go along to train. At those young ages, they're not throwing anybody out. It doesn't become competitive until much later on.

At TPV, we would train maybe three times a week after school, 15 or 16 of us. I'd go home and have something to eat and then the parents would work it out between them: sometimes Dad would drive us to training; sometimes it would be someone else's dad. Right from the start, they did basic technical work with us: passing, control, running with the ball. Then we'd have little games amongst ourselves. It wasn't just hanging around. It was proper

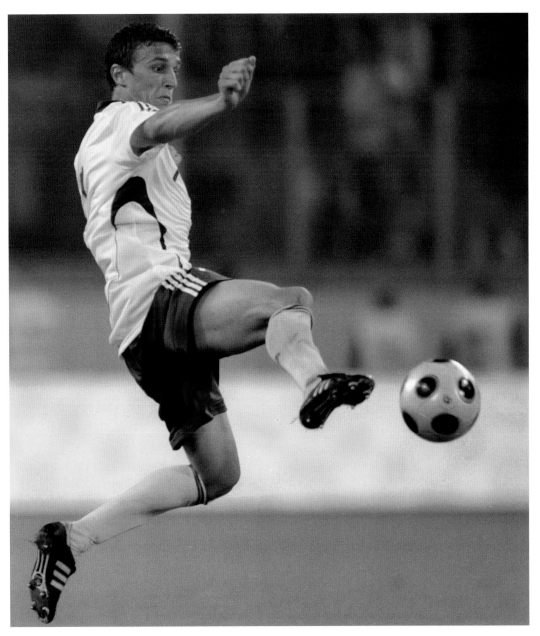

training. We would train in different places: sand or gravel pitches or indoor halls, with really hard, worn artificial surfaces, in the winter. You need those indoor halls when it's 20 degrees below outside! Once a week we might get to train on a proper grass pitch. That was what everybody really looked forward to.

TPV had training centres all around Tampere so boys could just join the one that was local to them. When we were nine or ten, the best players from all the different groups were brought together. That was like a first team and I still remember how good it felt when I got called up. We didn't play games against other teams every week. Once a month there might be a little tournament that ran over a couple of days when we'd play against other clubs: three games on the Saturday and then, if you got through, more games on the Sunday. When we got a bit older, we travelled abroad to play in tournaments too: Denmark, Holland, England. I have great memories from those times.

So, there was a group of us – good friends – who played together all the way through until the A team: from seven until we were about 18 years old, until I moved up to join the first team at TPV on my first professional contract. The other boys played another year in the juniors. Very soon after that, I was transferred to Helsinki. That was when that group broke up, I suppose. They are still friends, though. We'll be friends for life. But football, I guess, is different for me now. I'm not excited about it, maybe, like I was when I was a little boy going to watch my uncle play. I don't go along to training with a big smile on my face every day: you have good days and bad days. Back when we were kids, there was no stress, no responsibility. We were just having fun. Now, football's my job. But I'm lucky, aren't I? It's a great job to have.

## FAMILY

I know I talk about my mum all the time, but you have to understand: she made sacrifices for us. A lot of my friends, when I was a boy, had to go out to work. If they didn't, there would be no food to eat. So those boys didn't have time to play football. Mum worked so we had the time.

~ SULLEY MUNTARI ~

# Laursen (DENMARK)

*Martin Laursen*

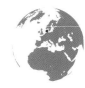

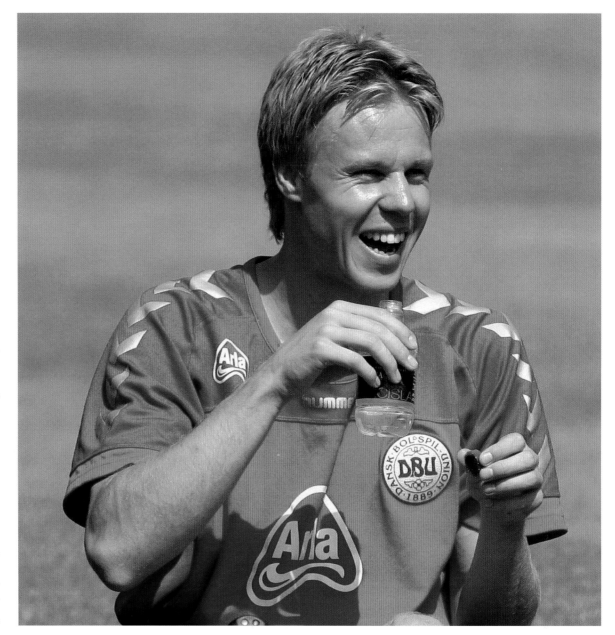

I'm from a very small town called Fårvang in Jutland, in the west of Denmark. It's a village, really; not even 2000 people live there. Very much in the countryside. I lived in Fårvang with my parents until I went off to school in a bigger town about 20 kilometres away called Silkeborg, which was where I went on and became a professional footballer. It wasn't until then, at 15 or 16, that I realized maybe I had the ability to go on in the game. When I was younger, football was just something I enjoyed, along with other sports like badminton and table tennis. I was never the boy who had the kind of outstanding talent that meant you could see I would go on to play for a big club and play for my country.

My dad helped as a coach for the Fårvang team, HFIF. Even though we were a small village, we had a nice sports complex just on the edge of the village: three full-sized pitches to train and play on and an indoor sports hall too. Football is the national sport in Denmark. And in Fårvang too: we were never short of players. I suppose I started playing when I was about six, along with my brother Anders, who's a year younger than me. We would move up together through the age groups every two years, so, right through until I was about 14, I would be one of the oldest and Anders would be one of the youngest and we'd have Dad as our trainer.

We used to play all the time: at school, when we came home. We'd go round to our friends' houses in our street to ask them if they wanted to come out to play football. And we'd play at the club as well. My dad had never been much of a player but he saw how much his boys loved playing and wanted to be involved. That's why he started coaching, and we were lucky: not every boy's dad can be a coach but our dad was really good at it. He never treated me and my little brother differently to the other boys. He was good with all of them. I think he's good

with people. It was never a problem that our coach was our dad.

HFIF aside, our house was in a cul-de-sac. Dad was a building engineer, so we were comfortable, but it was just an ordinary house. My parents still live there now. And at the bottom of the street, we had a children's playground, with a pitch to one side where we could play football.

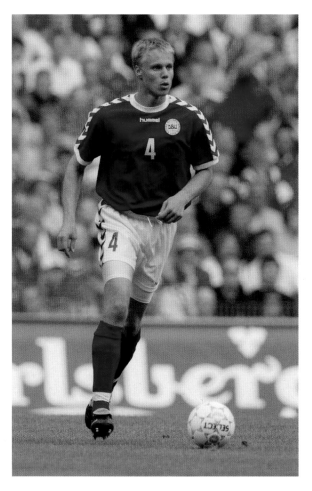

It even had two goals. It was absolutely perfect for us. Our parents didn't need to worry about us being safe. We were lucky too: there were always enough boys of around our age living in our street that we could get a three-a-side game going with. And it was the same at school: we were out playing every break time. There were other things to do but most of the boys always chose football.

I was never so interested in watching. At least, I wasn't one to try and collect autographs or anything. I didn't really have a hero. There wasn't a history of playing in my family; nobody had ever played professionally. And it wasn't as if I was much, much better than the other boys in the village when I was young. So that wasn't something

I wasn't like the older brother; I wasn't the leader. But, whether it was football or table tennis or anything else, I was always just a *little* bit better at it than him! Obviously, you are affected by what your parents do and what they enjoy. But also there are things you're born with, things you love to do. That's what football was for me and Anders. And it was always the two of us. So, even if no one else was around, we could take a ball up to the playground together and play.

You know, the best thing about football when you're young, perhaps playing for a small team in your village, is that it's not made to feel too important. You don't *have* to be there. You're there because you like it. No one's saying

> Me and my younger brother were like twins ... it was always the two of us. So, even if no one else was around we could take a ball up to the playground together and play.

we used to talk about at home, really. Nobody was saying, "Martin, you must become a professional player!" But, of course, Denmark won the European championship in 1992 while I was growing up and that was a big, big event in the country. If I had dreams about football at all, I suppose it was about playing for my country.

When I talk about growing up, I say "we" all the time instead of "I". Me and my younger brother were like twins; he's always been with me. We had the same friends, enjoyed the same things; we did everything together. Anders played a lot of football too. He came to Silkeborg as well but had a bad knee injury and had to stop playing.

to you that you *have* to go; that you *have* to run that much; that you *have* to win next week. The longer it's like that the better. There's plenty of time later for football to get serious. You can learn the basic things: how to control the ball, how to pass the ball. But you mustn't get burnt out; it mustn't stop you doing other things: you have to grow up as a person too. It's only football and who knows whether you're going to be one of the few that makes it? What's going to happen to you if you don't? It's a great thing to chase a dream – and football is a dream job – but I hope you don't have to miss out on your childhood.

My dad had never been much of a player but he saw how much his boys loved playing and wanted to be involved. That's why he started coaching, and we were lucky: not every boy's dad can be a coach but our dad was really good at it. He never treated me and my little brother differently to the other boys. He was good with all of them.  ~ MARTIN LAURSEN ~

# Healy (NORTHERN IRELAND)

*David Healy*

Killyleagh is about 20 miles south from Belfast, on the coast there, in County Down. I've heard people describe it as a little fishing village. There's not that many people live there but I've always thought of it as a town. Maybe that's how it seemed when I was young, anyway. Like everywhere in Northern Ireland, it's improved since then: lots of new houses, lots of building going on, new restaurants and bars. It's very close by the sea; there's always a sea air blowing in off the Strangford Lough.

The street I grew up in was 50 yards from a football pitch, which was handy. We called it the "Council Pitch" because it was the Council that owned it. There were five of us lived in a little terraced house and lots of friends close by and, with the pitch right on our doorstep, football was all we wanted to play. There were goalposts, and if there was a game at the weekend, the man from the Council would come and put nets up. If there was another game in midweek, they'd leave the nets up until the Tuesday. That was great stuff for us.

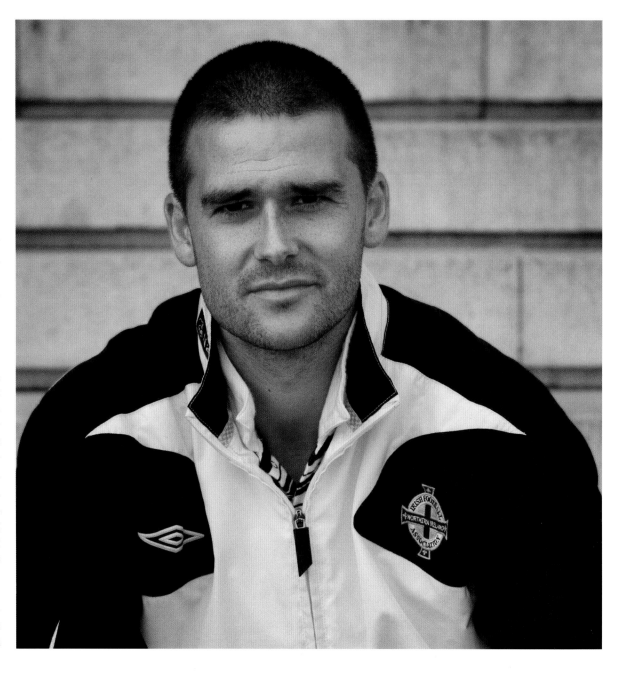

My dad, Cliff, played for the local team, Killyleagh YC, for years and then later he used to help out with the first and second teams. They played on another pitch – where the proper team played – down at the bottom of our estate. It was a little more out of the way and they didn't really like other people playing on it. Every Saturday morning, Dad would put the nets and corner flags up and sometimes mark out the lines and the penalty spot with that white lime stuff. So, from when I was four or five, I'd go down with him and that was where I started: kicking the ball into the goal from three or four yards out, ripping the pegs out that held the nets down at the same time as he was trying to hang them up.

There were no worries for parents back then: we could just go off and play. In the holidays, we'd go down to the pitch at eight o'clock in the morning and not come back

till seven or eight o'clock at night. We used to play a game we called Knockout World Cup. Back then – 1982, 1986 – Northern Ireland qualified and there was a bit of a buzz. We'd take players' names: someone would be Zico; someone else would be Norman Whiteside. There'd be maybe ten or 20 kids and one unfortunate goalkeeper. It was every man for himself and if you scored you went through to the next round, one person getting knocked out at a time. We'd play on half a pitch and whoever got the last touch would be the one who got the goal, so goal scorers like me would hang around in the penalty box, let other people do all the hard work, and then try and shoot it in at the last minute!

Sometimes there'd be little five-a-side goals set up down there during the summer and we'd all put in ten or 20 pence each and have little penalty competitions. I used to come home with my pockets full of ten-pence pieces. Other times, we'd have games – no-holds-barred games – against boys from other estates. In Killyleagh, lots of people were related to each other. My mum and dad, for example, had ten brothers and sisters each. But when we played against other estates there'd be fighting and arguments, 20-a-side on a patch of ground 30 by 20 yards. And we'd tear into each other, cousins or no, every time we played. Even from five or six years old, there was competition in everything, not just football. At Halloween, we'd compete to see which estate could build the biggest bonfire.

Growing up, you wanted to be part of everything that was going on. And when a football came out, everybody turned up. There was the buzz of playing and there was not liking to lose and I think it taught us all to grow up quickly: how to look after yourself, how to make sure you didn't go to school the next day having lost a game. Or having lost the fight that went with it! I was always quite a small boy, and from very young I wanted to play football. My mum's got pictures of me playing with older boys where the shirt I'm

wearing is hanging down by my knees. I was always the youngest in my school teams but I'd be there for every game and they'd put me on, even for just five minutes, because I'd turned up. They'd let me play because I was good but also because I wouldn't leave them alone about it.

The first game I really remember watching was the 1985 FA Cup final. I saw it on TV: Norman Whiteside scored the winning goal for Manchester United. It made us proud, a boy from Northern Ireland scoring in the biggest cup final there is. I can remember thinking then, for the first time, "Wouldn't that be nice? Playing for Northern Ireland; playing for Manchester United?" Everybody wanted to be the next Norman Whiteside. Not just in

too: we even did it watching football on telly. And from around the same time, when I was seven or eight, he used to take me on the boat over to watch Rangers play as well. We'd leave town at four or five on a Saturday morning to get the old Stena ferry, which was a three-hour trip from Belfast to Stranraer. We'd get the bus from Stranraer up to Glasgow and then we'd come straight home again after the game: we'd get back at two or three on Sunday morning. What an adventure: I can still remember the excitement, getting up in the morning. Sometimes we'd travel in the middle of winter: Dad would try and feed me a seasickness tablet but, being small, I could never seem to swallow the thing. He'd say, "It's a bad day for sailing. You won't be able to go unless you get that tablet down!"

> There'd be fighting and arguments, 20-a-side on a patch of ground 30 by 20 yards. And we'd tear into each other, cousins or no, every time we played.

Killyreagh. I'm sure that was going on all over Northern Ireland. Now, kids have got computer games and laptops and DVDs. But back then every Christmas was a football or a little kit or a pair of goalkeeper's gloves: torturing your parents for a pair of Puma Kings! And Mum and Dad could see how keen I was. They'd get me to go outside the house and practise keepy-ups or two-touch against the wall or work on my weaker foot. Used to drive the neighbours mad: "Don't go kicking that ball against my wall!" I was always outside.

My dad used to take me to games around the country with the local team from Killyreagh. They used to call us "Big Cliff and Wee Dave". We'd be stood together watching amateur league football. Dad used to whistle while he was watching and, pretty soon, I started whistling

So I had to swallow it. I had to go. I'd been looking forward to going all week: the games, Ally McCoist scoring goals, 45,000 people inside Ibrox all singing the songs.

Growing up, my head was just full of football and I still love playing, still love training; I still hate to lose. I know for some players football's a job and they switch off when they go home but I think I'm a football fan as well as a football player. I used to collect *Shoot* magazines and Panini stickers when I was young. My mum's still got all my old sticker books: I started with the 1988 European championships. I still collect things now, like opposition shirts from international games. I still love watching football too. All that's changed, really, is that I don't whistle like "Big Cliff and Wee Dave" any more.

My mum got me a pair of Adidas boots. I was so happy. I slept with those boots. I used to go to sleep with them in my arms. I just wanted the next day to come so I could go and play in the boots.  ~ SULLEY MUNTARI ~

# Muntari (GHANA)

*Sulley Muntari*

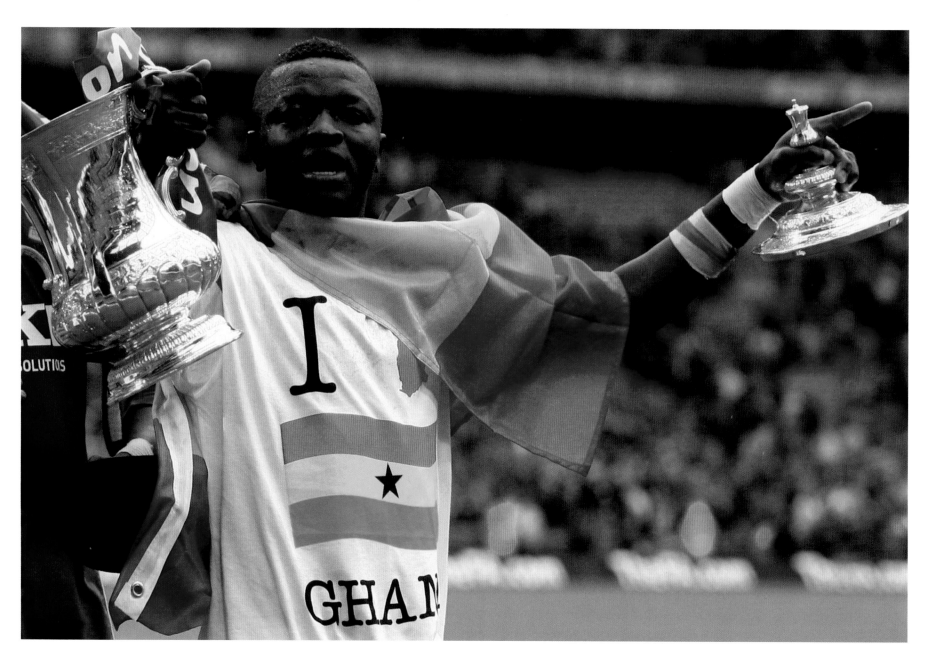

First of all, I had football in my family. My dad was a coach. I was born in Konongo, in the Ashanti region of Ghana, but he went to work as a coach in Nigeria. So we moved there and whenever he went along to take training somewhere, I'd go along to the training grounds with him. He was coaching a local team – I can't remember the name – in Kaduna. It's funny: we lived in Kaduna and that's what my grandma started calling me because we'd moved there. When I came back to Ghana, she kept calling me that name. Anyway, Dad would come home and then go out training and I went along with him. I'd be there, running around and kicking a ball on my own. That was when I was about five years old. I just loved football and that's how it all started for me.

We came back to Ghana when I was about nine. I used to play football in the street with the kids who lived near us. The streets were dusty all the time; even the fields were hard, hard with no grass on them. I wasn't out on the street all that much. We were poor, but not that poor. My mum tried her best to do everything for us and we weren't poor like some of the street kids. She worked hard so that we didn't have to go and find a job to get food. She made sure there was always food in the house. I think Mum saw me play football and she believed in me and helped me through any hard times I had.

When we came back to Ghana, my grandma was still living in Konongo so we went there and stayed for the next ten years. Konongo is just a small local town. I'm not Ashanti; I'm a Muslim. But I was there so long, I love the people. They are lovely people; Ghanaians are lovely people! There was a local team in Konongo and I trained with them, even though I was very young. Sometimes I'd play, but not often. They were big guys and I was just a boy. I couldn't play in matches but they let me train with them. I would get up very early in the morning, when it

was still dark. By the time I had walked to the training ground, it would just be getting light, maybe around six o'clock. We'd train and then I would go home to have a shower and get ready for school.

And school? Well, I had a bit of a problem with my education. I didn't want to go to school. I skipped classes.

I think Mum saw me play football and she believed in me and helped me through any hard times I had.

The only class I wanted to go to was English, so I could improve my English, you know. I wanted to be able to express myself. But that was the only class I'd go to. The others, I'd go off and play football instead. That was all I wanted to do. From very young, I had a belief I would make it as a footballer. I didn't know when or how it would happen, but I had that belief. And I thought learning English would need to be part of a career.

I don't remember when it was exactly – it was a long time ago! – but I can remember the first pair of boots I had. My mum got me a pair of Adidas boots. I was so happy. I slept with those boots. I used to go to sleep with them in my arms. I just wanted the next day to come so I could go and play in the boots. I thanked God and I thanked my mum. I know I talk about my mum all the time, but you have to understand: she made sacrifices for us. A lot of my friends, when I was a boy, had to go out to work. If they didn't, there would be no food to eat. So those boys didn't have time to play football. Mum worked so we had the time. Dad was still in Nigeria, coaching. So she had to do it all, look after the four of us, on her own. That's why I could play. She was a very good mum.

We didn't always have lights. We didn't always have electricity. Back then, there might only be one TV in the local community. When we had a TV, neighbours would come round to the house to watch. If you walked through Konongo, you could see people looking in the windows of houses, to see the TV. But I watched football on TV whenever I could, especially European football. There was a show on Monday nights, *Sports Highlights*, when they would show goals from around the world and I would try and watch that. There were one or two Ghanaian players playing abroad then – Tony Yeboah, Abédi Pelé – and they would show their games. Those guys were my heroes and they still are. I wanted to do what they had done. They did a lot for Ghana too – they lifted our flag around the world.

I'm the oldest in the family. I have two younger brothers and a sister. My brothers play too. You know, when I was starting to play and had to go to training, it might be five o'clock in the morning and I'd wake the younger one up. He'd come along with me to the training ground. We'd be there, alone on the field, kicking the ball. I'd throw the ball for him to do headers. And if he didn't do it well, I'd get angry with him. Not angry like I didn't love him. I do. But that was the way my dad taught me and I was passing that on to my brother. He's still in school now but both my brothers know how to play football. They're very good.

# Samaras (GREECE)

*Georgios Samaras*

Heraklion is on the island of Crete. It's the fourth biggest city in Greece: maybe 200,000 people. Like any city, it has good areas and areas that aren't so good. We lived in a pretty good neighbourhood, a neighbourhood that was great for me. There were three big apartment buildings together, a big school just along the road from us: there were lots of other children to play football with and there was an open area for us to use as a pitch just in front of our building. We could play in the street too. I have very, very good memories of growing up. Not only football: we just played all the time. I was lucky; I had so many friends.

My dad, Ioannis, was a very good footballer. He played for 12 years for a professional club in Heraklion, OFI Crete. In between, he was with Panathinaikos in Athens for four years. He won 16 caps for the national team too. And then, later, I played for OFI's youth team, of course. Dad and I would go to training together. When I was a boy, my mum knew all about football too: married to my dad, she knew all about the life of a professional player!

Dad played football with me, like all dads do with their sons. And I have memories of playing out in the street on my own from four or five years old. I was the only child in my family but there were always other children around. I could go outside and my mum and dad didn't need to worry about me: I was right out there in front of our building. We used to play in the car park: it was a surface like a road but there was lots of space and we could use the concrete posts for goals. However many there were of us – sometimes it would be one against one; sometimes it would be ten against ten. Other times, we would arrange at school to go and play a game against boys from another neighbourhood nearby.

We could play late into the evening because it stays light in Greece until nine or ten o'clock at night. I didn't play football on grass until I was ten or 11, but that was fine: the only problem was that, when you fell over, you would cut yourself and rip your clothes. My mum would say to me, "Oh, no! What have you been doing?" She'd put disinfectant on the grazes on my leg and then I'd have to go to sleep lying on one side, trying not to turn over, so that the bad leg wasn't touching the bed!

> [Dad] just wanted to make sure that I enjoyed the game. That was the important thing when I was a boy: not to think about football but to enjoy it.

It didn't matter what the ground was like. Even if we didn't have a ball, we'd get an empty Coke tin, squash it flat like a hockey puck and kick that around. In primary school, that's what we had to do most times, because they wouldn't let us play with a football. We had very short breaks between lessons and I suppose they didn't want us to get a match started. But we'd be whispering amongst ourselves in class to say: "Let's have a game!" And then we'd meet in the playground, even if we could only play for a few minutes. Someone would have the Coke tin or maybe even a tennis ball hidden in their pocket.

When I was eight or nine, Dad tried to steer me away from football. I don't know why. He tried to push me towards tennis or basketball. But, by then, football was all I wanted to play. I wasn't thinking about a career: I just wanted to play for my team, for OFI Crete. It's natural that you want to play for your local club, whether you are from Manchester or Barcelona or Heraklion. I grew up at OFI: watching Dad play, hanging around at the training ground, being in and out of the dressing rooms. The club was so much a part of my life then. And it still is. I have such good memories of that time but I never got the chance to play for the club because I left Crete when I was 16 and went to Holland.

In Greece, we go to primary school for six years from six years old. Then, we do three years at a middle school before we go on to high school or whatever. By the time I was ready to go to the middle school, I was already a youth player at OFI Crete. When I was 12, I went to a special athletics school. Most of the children were from Heraklion but there were a few, too, from small villages around the city. It was a school for kids who played football or any other sport: basketball or volleyball or athletics, whatever. You went along for trials over a weekend in the summer and you were selected depending on how well you did at your sport. It was almost like a club: they would choose the boys they needed to make up a first team squad of 23 or 24.

It was a lovely school. About 200 children, split into maybe 30 each year, and each year divided into different groups depending on which sport you played. That was a busy time for me. From eight o'clock until ten o'clock each morning, we would have training at school. Then, from 10.30 until 2.30, we would do our schoolwork. And then I'd go straight off to train at the football club. There were lots of us who were at the school and with OFI too. We'd all get the bus together. At the same time, we would have games for the school sometimes and

games in tournaments for regional teams that were organized by the Greek FA as well. Ten training sessions and maybe three games every week: we were playing football all the time. There were ten or 12 of us, always together. Even away from football: when it came to going out for a pizza, it was that same group of friends.

Dad was my role model and he still is today. Any problem I have, I know I can turn to him for advice; about football or about life. I can still remember when I was five or six years old, little children would come to our front door and ask to have a photograph taken with him. That told me that my father was something special. And, of course, everybody knew me as my dad's son. Nobody used to call me by my first name: I was always known just as "Samaras" because of him.

I learnt a lot from my father but I learnt the game for myself. Taking me to one side, telling me how to do this or that, like a coach would, one on one? He never did that. One or two little details, perhaps, but he never told me, "Shoot the ball like this. Head the ball like that." He just wanted to make sure that I enjoyed the game. That was the important thing when I was a boy: not to think about football but to enjoy it. And when I play now, I still feel like I did when I used to play in the street outside our apartment building in Heraklion. When I lose the ball, I go running around like a little boy would: "I need the ball back! Hey! I want to play!"

## DEDICATION

I was always wanting to win: some kids
would be out there just messing around, but
I was so focused and into it. I wanted to find
people who cared as much as I did.

~ LANDON DONOVAN ~

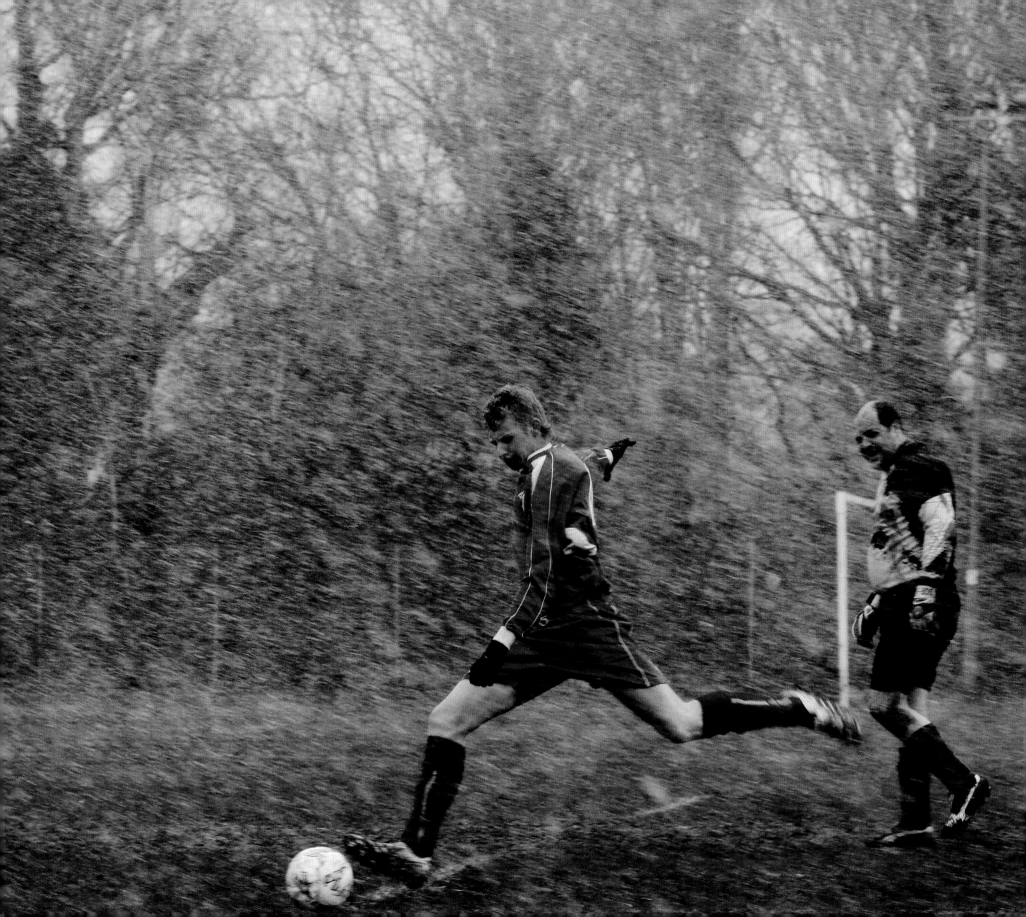

# Donovan (USA)

*Landon Donovan*

As far as soccer goes, I started playing when we were living in a place called Ontario, which is east of Los Angeles, maybe an hour away from the city if there's no traffic. I'd describe our neighbourhood as "American poor". Not poor by the standards of the rest of the world, maybe, but – for America – we were pretty poor. The one good thing was that there were lots of other kids around, so there was always someone to play with. We played all sorts of sports. My first memory of soccer isn't really mine. I have a brother, Joshua, who's five years older than me: I don't remember but my mom says that, as soon as I could walk, Joshua would be running around with a ball and trying to get me to play. He just wanted someone to play soccer with. Someone to hang out with; someone to go in goal, probably!

My parents divorced when I was two but there might have been something handed down: Mom ran track at high school and Dad was a very good ice-hockey player in Canada, where he grew up. Some of the things I have as a player, to do with reading the game, maybe I got from him. I used to watch him play hockey and he had a lot of those qualities: he always seemed to be the one player on the ice who could see what was going on everywhere. He played when he was older too. He didn't have the speed but he understood the game, knew where the puck should go next. I think I watched and learned. Mom says that, even when I was young, she could see that while most of the kids would be running around the pitch in a big group, I seemed to know where the ball was going to squirt out and could get it and do something with it. I always had that instinct.

Back then, you had to wait until you were about five before you could join a team. It's different now – they have little preschool teams. My mom says I would bug her all the time: "When can I play on a team? When can I

play on a team?" But, until I was five, it was just me and Joshua playing in the back yard. You know, when we were young, there wasn't that single-minded passion to play soccer. We played anything. And it wasn't as if we knew what we were doing. We didn't have football on TV. We didn't have cable. So I didn't see a soccer game until I was

It wasn't always the coolest thing, being the boy who walked around school with a soccer ball, but it gave me a sense of who I was.

12 years old. I played it but I didn't know anything about it. But I loved playing it; and I did get that passion for the game. Joshua had it too. And perhaps that's where I got it from: as the younger one, you want to do what your older brother does. I wanted to hang out with him and playing soccer was what he was doing, so it was what I did too.

The first game I ever went to see was during the 1994 World Cup: Argentina versus Romania. I only knew about two players: Hagi, because he was such a star then, and maybe Batistuta. Maradona had already been thrown out of the tournament. I didn't really have a clue what was going on. I just knew it was a great game. Before then, though, I was playing video games. I loved them then and I still do. The first game I had – I must have been about six – was called "Goal". It was so bad! But I have a theory – which most people probably think is stupid – that, because I wasn't able to watch games on TV, playing those video games gave me an idea of how to play soccer. I know it doesn't directly translate but, watching those moves – how a player crossed a ball on the game, for example – fed into me playing, even if it was just in a minor way.

When I grew up, Major League Soccer wasn't around. Very few Americans – 30, maybe – had any chance at all then of playing professionally, say, in Europe. And even they wouldn't have been playing at a high level. You'd say we must have been even more passionate about soccer itself because we didn't have role models to look up to. I couldn't have named a soccer player when I first started playing the game. All I knew was that there was this game that I loved playing. My mom is a teacher; my grandma was a teacher; my sister's a teacher now, so, obviously, school was the most important thing. But my mom never wanted us to be just sitting inside, watching TV. We were outside all the time: I guess it was cheaper that way; she didn't have to buy us toys!

I think with any sport, that's how you learn: by being outside and playing it. If you look at American players, we're less tactically aware and not as good technically, and I think that comes from not playing enough at an early age. Here, there's more emphasis on running and fitness, whereas if you look at Dutch kids, for example, the technical side of the game just seems to come naturally to them because they've been playing right from the start. Just being outside and playing your own games, all your emphasis is on your touch and how you are with the ball. Doing so much of that as a kid gave me an advantage later on. It was more fun that way too.

It was a big thing, finally being able to play on a team when I was around five. I'd never played six v six or eight

v eight before. I had no idea of what soccer was or what it should be at that stage. I just knew that, if the ball was out there, then I could play and I was happy. It was that simple. I was competitive too. Maybe that came from me having a twin sister, Tristan. I was always wanting to win: some kids would be out there just messing around, but I was so focused and into it. I wanted to find people who cared as much as I did, like Joshua and my best friend, Eric, did. Traditionally, Latin kids are better with the ball and seem to have a better idea of the way soccer's meant to be played. The American kids were always athletic – fast and strong – but, for a pure understanding, it was from the Latin kids that I think I learnt how to play. We didn't have Hispanic coaches but just watching how those boys moved and communicated, I picked up a certain style of play.

When I was ten, we moved to a place a bit further east called Redlands. And that's where I really got into playing competitive soccer. In California, we have AYSO – the American Youth Soccer Organization – whose motto is "Everybody Plays". But then you have club soccer too, which is more competitive, and when I could start doing that it became all I wanted to do in my life. It was so much fun to finally play with kids who were good and as competitive as I was, who really wanted to be there. I kept playing AYSO as well so I ended up playing five or six games a weekend, every weekend, driving all over Southern California to play. I loved it: "Where's the next game? Let's go!" Moving from Ontario was difficult for me, leaving friends behind, and so having games and training to go to was important for me. I didn't know anybody at my new school. All I knew was the kids who were on my team. It gave me an identity: "Yeah, that's the soccer guy." It wasn't always the coolest thing, being the boy who walked around school with a soccer ball, but it gave me a sense of who I was.

You have to remember that, in this country, there's money to be made out of youth soccer. That was true when I was growing up too. So, you could never be sure what people's motivation was for being involved. But I had one coach, Clint Greenwood – when I was probably 13 through 16 – who was different. Most of the coaches I grew up with didn't know a lot about soccer. Clint was from Wales and really knew the game. Every time we trained with him, almost everything we did would be technical work. We'd always have the ball at our feet. We didn't do much fitness stuff. We didn't play games on full-sized pitches. Everything was small-scale, in tight spaces, learning how to play under pressure and how to make a yard to get

a pass off. We learnt how to solve problems in a game for ourselves.

I never felt poor. I never felt like there were bad times for us as a family, although there probably were. But as long as I could play soccer, I was happy. The game was the one constant through growing up. I could escape into soccer. I'm a very private person, quite subdued most of the time. If I meet new friends who've never been to a game and they come to watch, they say: "Who's that?" Being creative, being emotional: all that happens when I'm out on the field. Soccer's my way of expressing myself, and it always was.

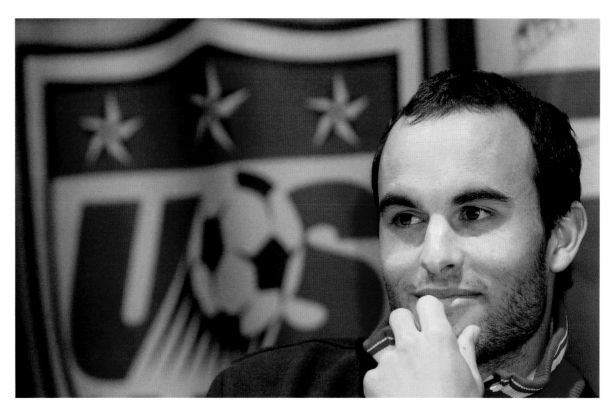

When I talk to children back in Japan now, I say things to them that Mr Bayashi said to me: "Don't just do your best and stop; keep doing your best, keep pushing yourself. That's what makes it possible to realize a dream." ~ SHUNSUKE NAKAMURA ~

# Nakamura (JAPAN)

*Shunsuke Nakamura*

Yokohama has changed a lot since I was a little boy. It used to be a port city. I can still remember my grandmother taking me for walks down to the harbour, but now it's become more of a tourist spot than anything. We lived in a house in a nice area, with a good neighbourhood feeling, away from the city centre: Totsuka.

We were quite a sporting family. I have three older brothers. The next one up to me, Takayuki, played football; the next, Yoshimasa, baseball; and the oldest, Kazuhiro, played tennis. I was about three when I started playing football and joined a football club for the first time: Misono FC. I don't remember first kicking a ball but I have pictures of Takayuki and I together at that club.

In Japan, we start everything younger than in the West. It's early learning; school, English, dancing, music and sports – even boxing and judo as well. We think about doing exercise and a healthy life from a young age. I don't know how my brothers decided on the sports they did but my parents got me to do calligraphy, piano, and football. Football was what I always enjoyed doing the most.

My first real memory of playing football is that the ball used to come up to my knee! It was that big and I was that small. When I was still very young, I could already kick the ball properly and knew how to pass people, how to score goals. Even at three and four years old, though, we played on full-sized pitches with full-sized goals. Maybe that's why it was easy to score goals!

We had a coach and proper coaching right from the start. We used to train in the playground at the nursery school. In amongst the other play equipment, there were tractor tyres, half buried in the ground. We had to dribble around the tyres and play the ball through underneath. Today, we use poles in training but, back then, the tyres seemed so

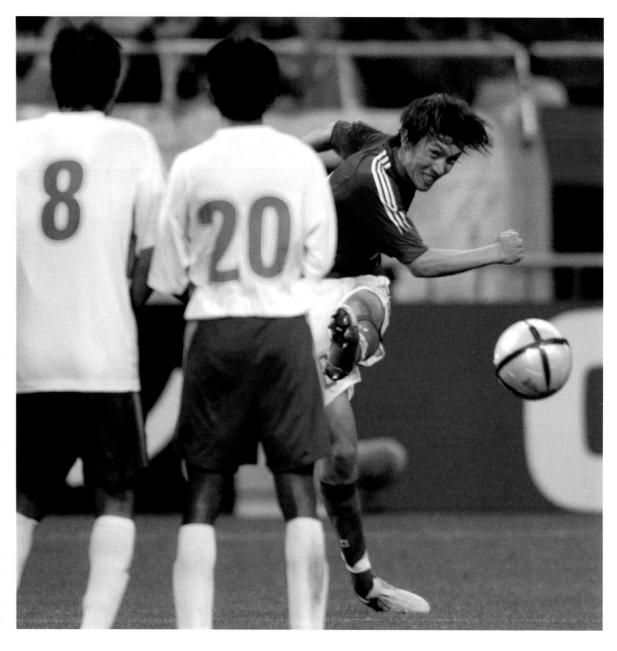

big they were like opponents and, looking back, I think that was very good for developing my dribbling skills.

Our coach's name was Waka Bayashi. He was a very tough man. In the old days in Japan, the tradition was to be very strict with children. Very strict! He was a very good coach, of course; very good at teaching us football. But I think he was very good at teaching us about growing up as well. In Japan, your parents didn't take you to training and bring you home; you went on your own. I was the captain of the team. That meant I collected the money for train tickets, got everybody onto the train and made sure we were well behaved: if someone got on the train we'd give up our seat for them. We learnt independence and social skills in that way. I suppose I was a leader but I didn't think of it in that way then. It was just what we did.

Waka Bayashi was a teacher at our nursery school as well. That's why we used the nursery school playground for training. Usually, after finishing in kindergarten, children would go off to schools in their own local areas. But, once we started playing together and realized we had a good team, all of us stayed to be with our coach. We stayed together because of him. We trained four days during the week and then, on Sunday, we always had a match. On the day off from training, I had to go to extra classes to catch up with my schoolwork. But being together with the team meant I had friends from football as well as friends from school and my neighbourhood; good friends who stayed together all the way through. You know, training was quite hard but nobody left the club. We loved football and we were the second-best junior team in the whole of Yokohama. We loved the competition too, the wanting to win.

While I was at elementary school, there was no professional league, no J-League, in Japan. So I was never really thinking about playing football professionally. But, even when I was very young, I hated to lose and so even though I wasn't thinking about professional football, I was just always thinking about becoming a better player. That was the basic motivation. I don't talk a lot but I think my character comes through on the pitch when I'm playing. That was the same when I was young. People could see my performance and trust me in the team; and that made me feel good about myself.

I was always watching Maradona videos whenever I could. We didn't have sports channels on TV so we couldn't watch any football from abroad. I would have to go to a sports shop and buy a video of him in action. First of all, I was really pleased that Maradona was left-footed like me. And then I watched the 1986 World Cup in Mexico and saw how he just went past everybody. That was it: I wanted to be able to play like that. I used to have to watch myself too. My parents came to every game and videoed them; when we got home, they would put the tape on. I'm not sure but, maybe, that was good to watch the games again and see what we'd done.

Football is very popular in Japan. More now than ever before, I think. There are futsal courts – like five-a-side pitches – everywhere. I own one back at home and it's always full. There are leagues for students and businessmen as well as for children. My brother plays in one. When I go home, I sometimes coach children at my court. I listen to them talking about football. They don't talk about being professional players. Maybe it's more ambitious than that – they talk about being Ronaldinho or Lionel Messi! They're like I was about Maradona.

I joined the junior team at Yokohama Marinos, one of the top clubs in Japan, when I was about 12. With the Marinos, football became more about high-quality, technical coaching. Before that, though, Waka Bayashi was my coach and I think that time was about us all developing as young people as well. When I talk to children back in Japan now, I say things to them that Mr Bayashi said to me: "Don't just do your best and stop; keep doing your best, keep pushing yourself. That's what makes it possible to realize a dream."

I was never really thinking about playing football professionally. But, even when I was young, I hated to lose and so even though I wasn't thinking about professional football, I was just thinking about becoming a better player.

Our teacher tried to console us – we were little kids – but I remember this really intense feeling. I wanted to play them again. I wanted to win. It was a really important moment for me. I had that horrible feeling of losing and thought, "If I feel this bad when I lose, I want to find out how it will feel when I win." ~ IVÁN GUERRERO ~

# Guerrero (HONDURAS)

*Iván Guerrero*

Honduras is divided into eighteen departments, like states. I was born in Comayagua and lived there until I was eight years old. Then we moved to Olancho, where I stayed until I was 17, before I left home and moved to the capital to start my career as a professional player. Once he had children, my dad's ambition was always to move to a city where there would be more work, a better lifestyle, and the chance for us to have a better education. He was a construction worker and had four of us: myself and three younger sisters. Where we lived in Comayagua was just a little town, deprived in many ways; they only got electricity into all the homes a couple of years ago. Most of the people in the town were farmers or farm workers: it's an area where they grow a lot of coffee. A little, rural place. You wouldn't see anywhere like it in the USA but places like my pueblo are everywhere in Central America. It's a way of life for maybe 75 per cent of the people living in countries like mine.

Soccer is a way of life, too, for everybody in Honduras. It's everything. No baseball, no American football, no basketball. Every boy wants to play soccer. There's a professional league and to be a player in Honduras can give you a better life; you can afford a house, a car. It's not like the States or Europe but, even so, it can be a good career in Honduras. I can remember playing ever since I can remember anything! Back to four or five years old. I always loved soccer and always thought that would be my destiny: to be a professional player. I think I was a good boy; I respected my mother and father. If I'd had the chance I might have stayed at school and been a student, but I always knew that my parents wouldn't be able to afford my education. So I wanted to play because I loved the game, of course, but also because I knew it could be a way to help my family financially.

My first experience of playing in proper, competitive games was when I was in second grade; six or seven years

old. My school was called Pablo Zelaya Sierra. One day, our teacher invited some boys over from another school and we had a game against them. I remember those boys being much, much bigger than us – they scored so many

## In Honduras, you aren't taught how to play soccer. You learn for yourself, playing in the streets.

goals against us. And the field we played on wasn't flat: it was like playing on the side of a mountain, a steep slope from one goal down to the other. Not only was their team bigger than us but they got to play downhill. They would just roll down and score. I lost count of the number of goals they got against us. But that day made me realize that soccer was going to take me through all the emotions, happy and sad. I found out how much I hated to lose. Our teacher tried to console us – we were little kids – but I remember this really intense feeling. I wanted to play them again. I wanted to win. It was a really important moment for me. I had that horrible feeling of losing and thought, "If I feel this bad when I lose, I want to find out how it will feel when I win."

In Honduras, you aren't taught how to play soccer. You learn for yourself, playing in the streets. You won't meet a coach until you're maybe 17, someone who'll tell you: hit the ball like this, do this or that to fix your mistakes. But the best of what we learnt was there in the street, playing without shoes on our feet. We all played together; it didn't matter, younger boys and older boys together. Sometimes we'd wait until the evening to play because then there wouldn't be so many cars going by to interrupt our game. There wasn't a professional team in our town or, at least, there wasn't until after I'd left. It wasn't until much later, after I'd moved to the capital, Tegucigalpa, that I went and

watched a professional game. I sometimes saw games on TV, though. I can still remember the 1986 World Cup and having the chance to watch Diego Maradona play. He gave me an understanding of what you could do in soccer: Maradona was able to join a minor club like Napoli in Italy and they became champions because of him.

School would finish at one o'clock, but I wouldn't get home until five or six o'clock; my parents used to get upset that I was always off playing soccer. Dad didn't like that I'd spend all afternoon playing the game. When I was old enough, though, I told them it was going to be my career. They knew they wouldn't be able to afford to keep sending me to school or to college, so they understood what I was trying to say. As I got older, they got behind me 100 per cent. That was after we'd left Comayagua. The town we moved to, Catacamas in Olancho, was more of a city. We had electricity; there was more work for my dad and things were better for us, although we never got to where we could own our own house. And I was happy: there were more people; there was a league and it was all better organized. Dad moved us so we could do better at school. He didn't realize it was better for soccer as well!

I'll never forget my first team in Catacamas: Athletic Oriental. I played for them for four years in the local league. They were only in the third division but they were popular in the city. And I was the first professional player Oriental ever produced. I made all my best friends there: school friends, and friends I made from us playing soccer

together as well. I still miss it; whenever I go on vacation, I like to go back to that neighbourhood we lived in then. I love to watch the local kids growing up. They look up to me now as an example. It's one of the most satisfying things in my life, being able to go back to Catacamas and spend time with the kids there. Every year, on December 24th – Christmas Eve – and on December 31st, everybody in the neighbourhood gets together at about two o'clock in the afternoon and we have a game. Us – a group of old friends – against the younger boys. They're the newcomers. My old club is seeing a lot of players go on to become professionals now.

Maybe me making it is an example for young players: "If Iván can do it, so can I." But I think I have to set an example as a person too. I still go back to the old neighbourhood, to talk to people and enjoy being with them. I go back to my roots; I like to talk to the kids about soccer, and about growing up as good people as well. Those times when I was a boy myself still make me smile, remembering. Now, soccer is a job for me. As a professional, you get stressed out, you miss your family: when I join up with the national team, I might be away for a month at a time, travelling. But when you're a boy you don't have any of those worries. You're just happy playing, without any pressure. Those games every December remind me of what it used to feel like. But I go back home to remember where I've come from too. Here in the US, where I have everything I need, life is so comfortable. It's important that I don't forget where I've come from, that I don't forget playing soccer on the worst pitches in Honduras without any shoes on my feet.

One of my children, Diego – the six-year-old – loves soccer. He's not named after Maradona; my wife just liked the name! I'm not sure how I feel about him playing soccer. I don't really want him to become a professional

player. It's a tough career and you have to give up a lot of things to be successful. My wife and I have always felt that the priority for our children should be their education. I know that may sound contradictory; I remember how I was when my parents wanted me to go to school instead of playing soccer. If Diego has his heart set on it, then I'll support him. But it's different for him. He'll have other

options in his life now. When I was growing up, there was no other option for me but the game. I was a boy who obeyed his parents and, if they'd had the money, I would have done what they wanted and continued with school. But, for me, soccer was the one way I had to make things better for us all.

If I didn't have blood on my clothes at the end of the day, it felt as if I hadn't had a game of football.  ~ TALAL EL KARKOURI ~

# El Karkouri (MOROCCO)

*Talal El Karkouri*

In my district in Casablanca, while I was growing up, we'd play every weekend. Sometimes I'd play four games of football in a day. I'd play games in my own neighbourhood but then I'd go off to other neighbourhoods to see if I could get a game there too. Play one game, then go off and find another. I'd sit and wait for someone to get injured or just ask, "Can I play with you?" We were young and we preferred playing football to studying and things like that. I still remember the boys I used to play with. All ages: it didn't matter whether they were younger or older, we all played together.

We played in the street, in yards, on the sand down on the beach. When we were very young, it wouldn't even be a proper ball. We'd buy a plastic one: it cost maybe three dirhams. And we'd just play, there in the narrow street. You know how we'd score? Each building in the street had its main door. I'd have a door, the other players had a door each. You'd have to protect your own door; that was your goal. And score against someone else's. Or we'd play four against four with just two goalkeepers. I remember, sometimes, seeing a star like Maradona on TV, I'd go out in the street and find someone to go in goal so I could try and copy one of his free kicks. They were hard to do, though.

If we wanted a proper game, it took a little planning. Teams would have a captain and you would have to decide: "We're going to play on Saturday"; because everybody would have to get a little money to pay for the pitch. Even if it wasn't a stadium with beautiful grass, you still had to pay. Every player would put a little money in, maybe five dirhams. On Sundays, we'd be playing games non-stop: seven in the morning till six at night. So, we'd need to make sure we had somewhere to play.

You know, back then, I wasn't a good player. I wasn't good technically. But Saturday was a holiday and Dad would let me go out to play. It was a chance to be with my friends and I only had to see a football and I'd want to be in the game. Even if I was watching a game, if someone got injured, I would run on to take his place. No shorts or T-shirt: just whatever I was wearing. It was a big problem for my mum: sometimes I'd have to change my clothes four times in a day. Jeans were ruined, T-shirts were ruined. I always had blood on my clothes too, from a cut or an injury. If I didn't have blood on my clothes at the end of the day, it felt as if I hadn't had a game of football.

And, because we didn't play on grass, boots might only last for a month. Dad was really good to me, buying me

> Sometimes I'd play four games of football in a day. I'd play games in my own neighbourhood but then I'd go off to other neighbourhoods to see if I could get a game there too.

boots when I wore the old ones out. When you're young, you just want to play. You don't think that your dad is having to work hard to earn money to buy you boots. Every time a new style comes out, you want them. It's just like kids now: "I want this brand. I want that brand." Dad wanted me to be happy and I was the only son. So he kept buying me boots.

We used to watch football too – on TV or sometimes at the stadium – like all kids do. I remember particularly when Morocco got to the World Cup finals in Mexico in 1986. We got through the first round of the competition and that was a big achievement for the national team. Everybody was out in the streets, celebrating; there were

parties going on everywhere. I was only ten but I'll never forget that day. I used to go to the stadium to watch my team, Raja Casablanca. They played in the Moroccan first division. We would just go off to the stadium on our bikes. I hated being indoors when I was young. We wouldn't pay to get in. You'd find someone who would take you in, pretending you were his son, or ask a policeman to let you in. I always found a way, without having to pay.

I can't tell you when I first kicked a ball but I'm sure it was when I was a baby. My parents will have given me one to play with. My dad was a former player but, really, I wasn't planning to be a footballer. I was studying. But it came to

a time when I couldn't get the balance between school and playing football. And I chose football. I loved the game and couldn't put the ball away to study instead. My parents were very angry because it meant I left school, but now they're happy. I'm happy too! I was lucky.

I was at university when I finally made that decision. I was sitting in an exam. I wrote the first sentence and then left. I'd been going in to classes at seven o'clock in the morning. At midday, I would go and train and then, at two, I'd go back to classes. So, seven till six every day, I wouldn't have time to eat and you can't do that and play. Your muscles need water and food. In the afternoons, I wouldn't be able to concentrate on what the teachers

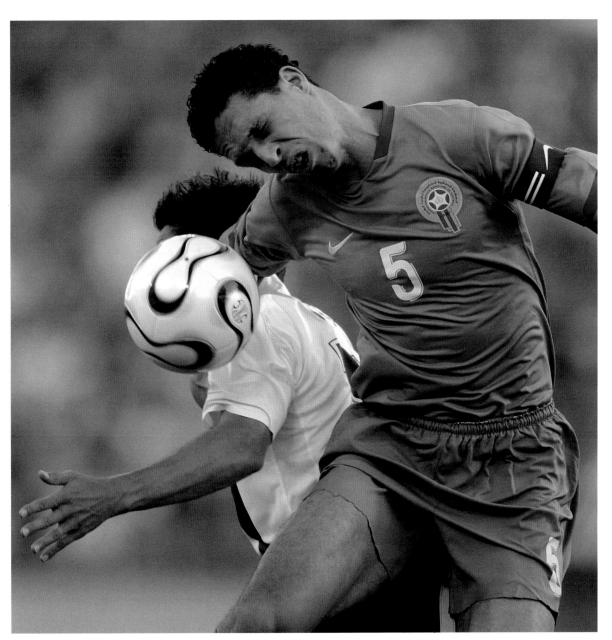

were saying. My parents were worried. That's how parents are: if my little girl falls over now, I'm worried that she might get hurt. It's natural. And, you know, if you're playing football in Africa and you get a bad injury, what are you going to do? It is difficult to come back and play again and difficult, then, to be able to get another kind of job.

When I was very young, I played all kinds of sports. I even did karate. But when I was 12, I went to a special school. Six hundred students and they chose 90 of us: three classes. One class did volleyball, one for athletics and one for football. I was there for six years and took my baccalaureate. When I went on to university, I had already signed for Raja Casablanca. That was the start of my professional career.

When I go back to Morocco now, I can't play football in the street like I used to. As a professional, there are things in our contracts that say what we can and can't do: like skiing or horse-riding. They wouldn't want me to risk getting injured. But I love to watch the kids in Casablanca playing in the street; it reminds me of when I was a boy. Things are different in Africa now, though. We wanted to study. We tried to study as well as play. Now, boys don't want to go to school. They just dream about being football stars. They're forgetting that you need to study as well because you never know what is going to happen in your life. Everybody needs work. Everybody needs money. Life in Africa is hard. You have to study and then football can come later.

## PASSION

Do you know, I can't ever remember a time when I didn't want to grow up to be a footballer.

~ CRAIG GORDON ~

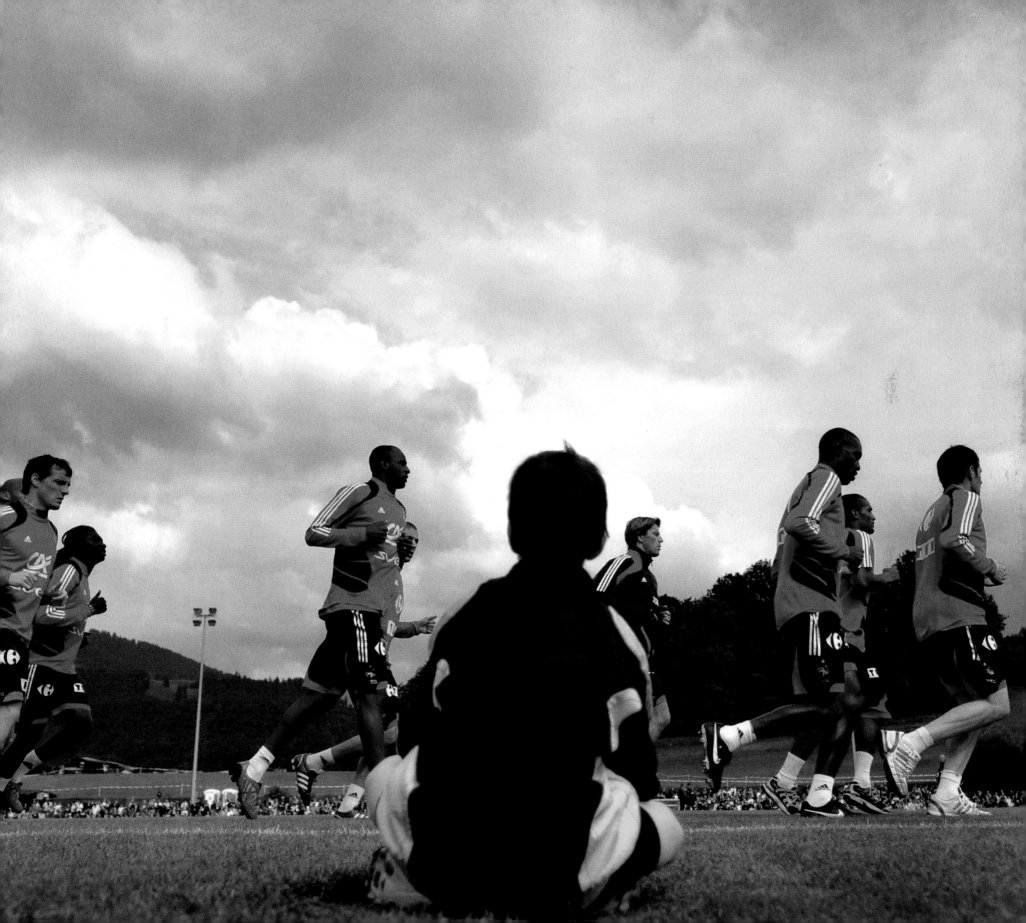

# Gordon (SCOTLAND)

*Craig Gordon*

The village I grew up in is called Balerno. It's just outside Edinburgh, to the west by the Water of Leith, and it's now become a part of the city. You'd say it's a very ordinary suburb and we lived in a very ordinary suburban street in a three-bedroom semidetached house: me, my mum and dad, and my two younger sisters. One of my first memories of playing football is playing inside that house. I got given a little set of goalposts with a net for Christmas. I must have been about seven years old. I set that goal up in the living room the same day and it stayed there for weeks and weeks until the weather got warm enough to start playing outside every day.

just wander down and see who was around to have a game. If there were enough of us, we'd use trees or jumpers for goals and have a match. If there weren't many of us, we played games like World Cup or Ten Bys: one player had to cross the ball in and the others had to try and score with a header or a volley. If they missed, it was a "goal" to the goalkeeper. Whoever was the first to get ten goals won.

Over the years, there were just two or three of us who always played football. A lot of the others drifted off when rollerblades and skateboards came in. But it was great to

Edinburgh now – and he's still someone I turn to, to talk about the game and bounce ideas off.

My mum and my sisters used to come along to watch me play – and they still do – but it wasn't just me that was involved in sport. My sisters, Hana and Hazel, were Highland dance champions when they were girls, competing at a really good level. So, they'd come along to watch me play football and then, if I didn't have a match, I'd go along to Highland Games and championships to watch them.

## If I was playing football at the park I'd play out on the pitch, but in matches I always went in goal. Most boys love scoring goals but I just loved stopping other people scoring them, I suppose.

I knew from quite early on that I wanted to be a goalkeeper. Diving and catching the ball was natural but, even when I was very young, the running around wasn't so easy for me. I could see there were other boys who were quicker than me and other boys who had better stamina. If I was playing football at the park I'd play out on the pitch, but in matches I always went in goal. Most boys love scoring goals but I just loved stopping other people scoring them, I suppose.

As well as football, I played rugby at school too. To be honest, I played any sport I could. And those other games all helped develop my eye for the ball and my coordination, I think. We had two parks nearby, one at each end of the street, and after school or in the holidays you could

be able to go out and play all the time: your parents didn't have to worry about what you were doing or where you were. We could learn and practise the game for ourselves. It's not like that now and that's a massive problem, I think. You wonder where the stars of the future will be able to start playing their football. Things have changed even just since I was a young boy.

My dad, David, never pushed me into anything even though he'd been a goalkeeper himself and played in lower league football when he was younger. He always let me do what I wanted to so I could find my own way with football, but he was the person I could talk to and he still is now. He's become a qualified coach since I was a boy – he works with the younger age groups at Hearts in

Do you know, I can't ever remember a time when I didn't want to grow up to be a footballer. I was that sure. Hearts was my team, although I didn't go to watch all that often, but I didn't really have heroes. I'd just look at those players and think, "That's what I want to be." I remember going into school and the teachers or the careers officer would say, "What are you going to do?" And I'd say, "I'm going to play football." But they'd say, "Oh, but you don't know that for sure. You'll need something to fall back on if things don't work out." I'd say, "No, no. It'll work out. I'm going to do it. Don't be so negative!" To be fair, I did OK at school, got my work done. I came out with a few Highers to my name, anyway.

I played football at school as well; especially at primary school, where we'd play every break time. By the time I was at secondary school, I was involved in Boys Club football and I suppose I saved myself a bit for the training. Everybody knew I wanted to be a footballer, to be a goalkeeper, and that meant they knew who I was. But that could sometimes get me into trouble as well. You know, it's something about us in Britain: there's always someone who wants to knock you down, isn't there? If anything, though, that attitude was one of the things that helped spur me on.

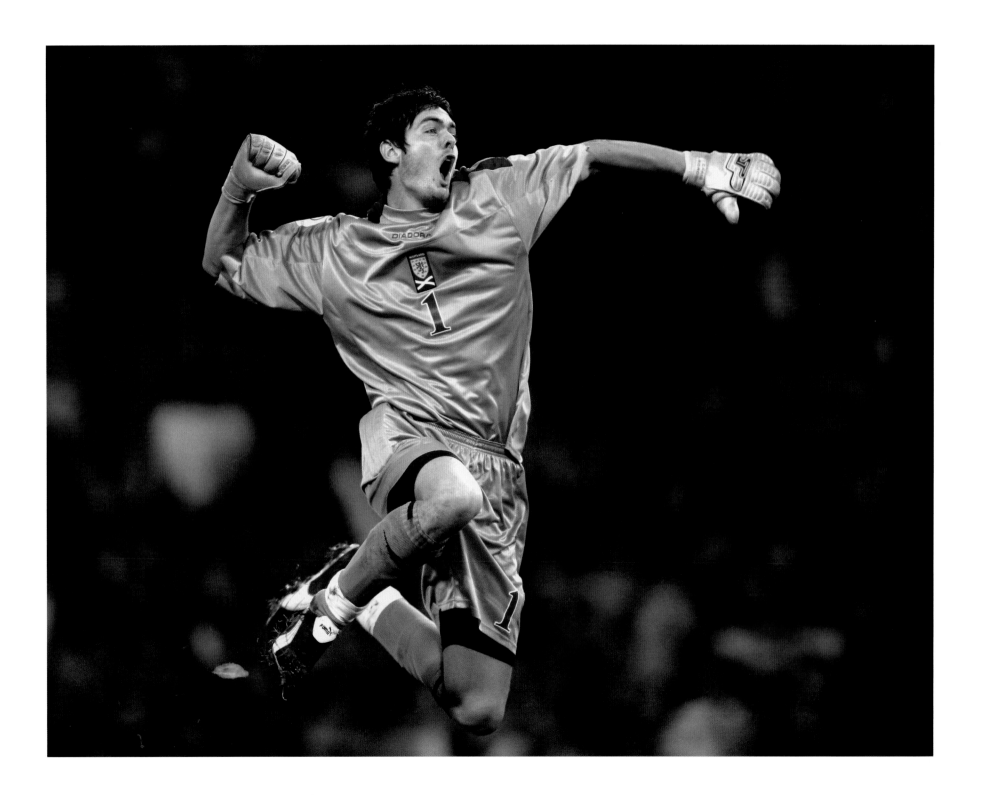

Sometimes I get angry: you know, if you kick me, I'll kick you back! But then, after the game, I just want to say thanks for the game, I want to have a laugh with my opponent. ~ EMMANUEL EBOUÉ ~

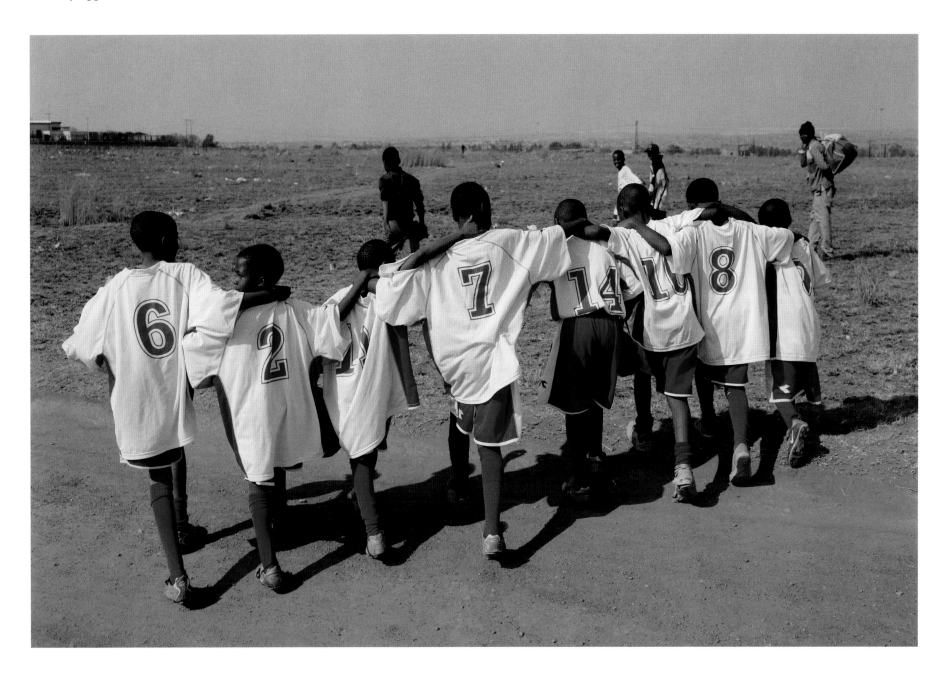

# Eboué (CÔTE D'IVOIRE)

*Emmanuel Eboué*

When I was young, just a kid, there were two things I wanted to do: go to school and then, after school, to play football with my friends. Then, one day, I came home and said to my mum, "Mum, I want to choose. One or the other. I go to school and then I play football. Doing both, I'm tired! I want to play football." She said, "OK. That's up to you." My mum was happy. But my grandmother wasn't! I lived with her when I was very young. She said, "No, no. You must go to school." She wanted me to study and to be a doctor. But I insisted: "I want to play football." And you see what's happened: it was OK.

I was with the ASEC academy in my country for two years and we went to France to play in a tournament. That's where I was spotted and my professional career began. But, before then, I played for a little team in Abidjan for nine years; all of us, friends playing together. We had a guy, a coach, who came to help us. We listened to him; he taught us that playing well was about passing the ball and we listened because we all wanted the chance to be at the Ivorian academy. They had money to spend on young players there and playing well for them meant you'd have a chance to go to Europe.

My dad played football and, before he died, I'd play with him or go along to watch him play. That was when I was very, very young. I always loved football. Before my dad died, he gave me his football boots. I tried to wear them to play in but then I just put them in my room, to look after them. I still have them. I still keep them safe, in a box under my bed. Those boots are very important to me, you know. Dad never played professionally – this was a long time ago – but I'd watch him play in games in Abidjan or when he went to play games in villages outside the city. Everybody knew my dad. Now, when I'm home, they say, "Oh, you play like him!" He was a right back too.

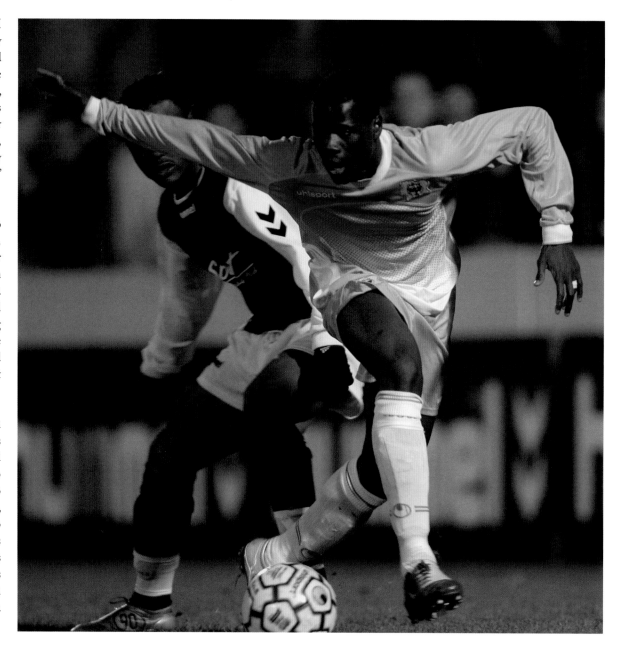

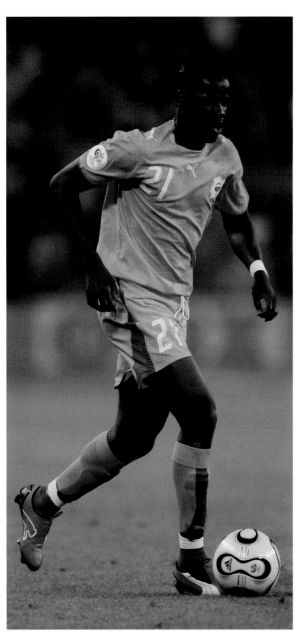

Apart from watching my dad play, I was never a football fan. I mean, I didn't go to games in Côte d'Ivoire and follow a team. While I was growing up, though, we would watch football on TV whenever we could. AC Milan were my team. I'd tell my coaches, "I want to play for Milan!" Cafu, the right back for Brazil, played for them and he was my hero. I'm really happy how things have turned out and that I ended up at Arsenal but, back then, the idea of playing for Milan was a big motivation; something to make me work hard. I admired Lilian Thuram too. I think he has always set a good example for kids and young players: it's like watching an older brother playing football, you know. I met him when we played against Juventus: spoke to him, asked him for advice. And, of course, I asked for his shirt too. I keep that under my bed as well!

I have six sisters and five brothers. A big family. But that's normal in Africa. I'm the youngest brother and I'm the only one who played football. They went to school, went to work. It's just how things happened. I know, though,

that He'll keep me well; that He'll save me. And I've done that since I was a little boy: we were a Catholic family and I prayed that I might be a footballer!

It was my dad who first took me to the little club – Académie Mimoscifcom – I played for in my city for all those years. He would drop me off there every day. He wanted to help me, wanted me to play football. He said to me, before he died, "I want to see you play. I want to watch you on TV." He prayed for me. He believed in me. He told me I had to help our friends after he'd gone. He actually said that to me. That's what I've tried to do. That's why I focus so hard when I play. I've taken a lot from my dad. I'm very nervous when I play. Sometimes I get angry: you know, if you kick me, I'll kick you back! But then, after the game, I just want to say thanks for the game, I want to have a laugh with my opponent. Dad was just like I am now: wanting to win, not wanting to lose. I love to play and I want to play well: for myself, first, and for my family. And because I believe in God.

I always loved football. Before my dad died, he gave me his football boots. I tried to wear them to play in but then I just put them in my room, to look after them. I still have them. I still keep them safe, in a box under my bed.

that they pray for me. And, if you believe in God, that's a very important thing. Whatever skill you have, whatever energy, it goes back to Him. That's why, every morning when I wake up, I pray and say, "Thank you, God." I pray

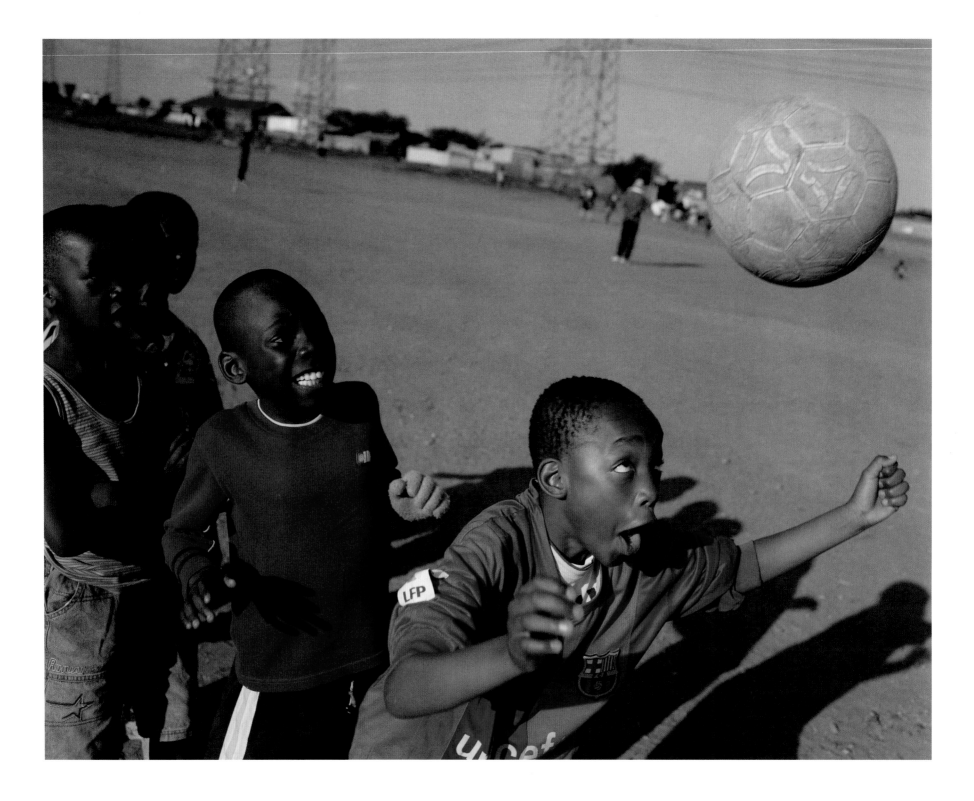

Even though I played for my dad at Meyrin, he never pushed me in football. Right from the start, I think I pushed myself. ~ JOHANN VOGEL ~

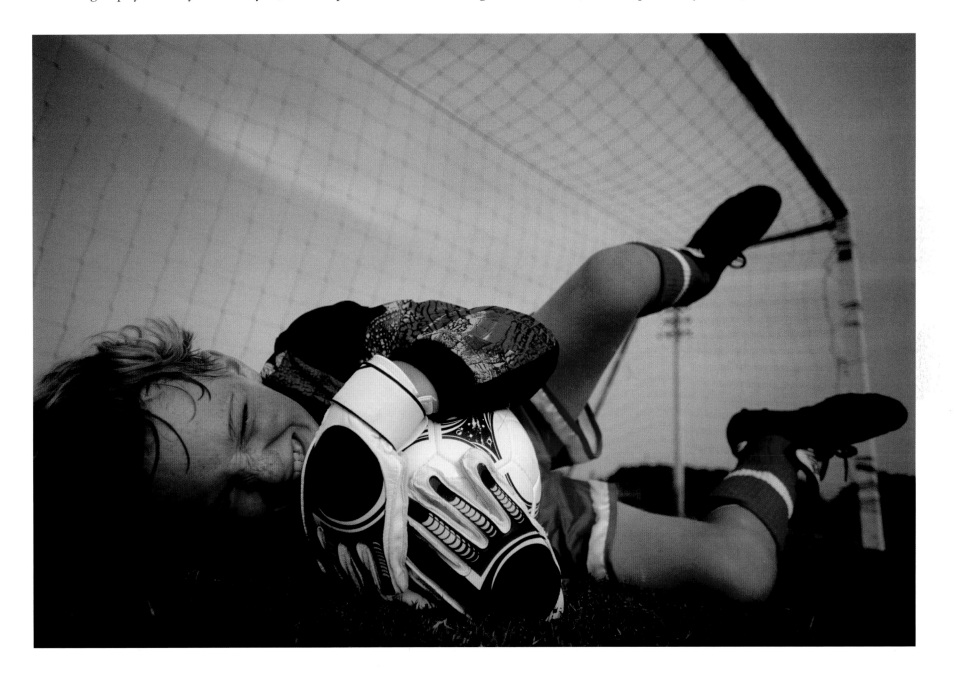

# Vogel (SWITZERLAND)

*Johann Vogel*

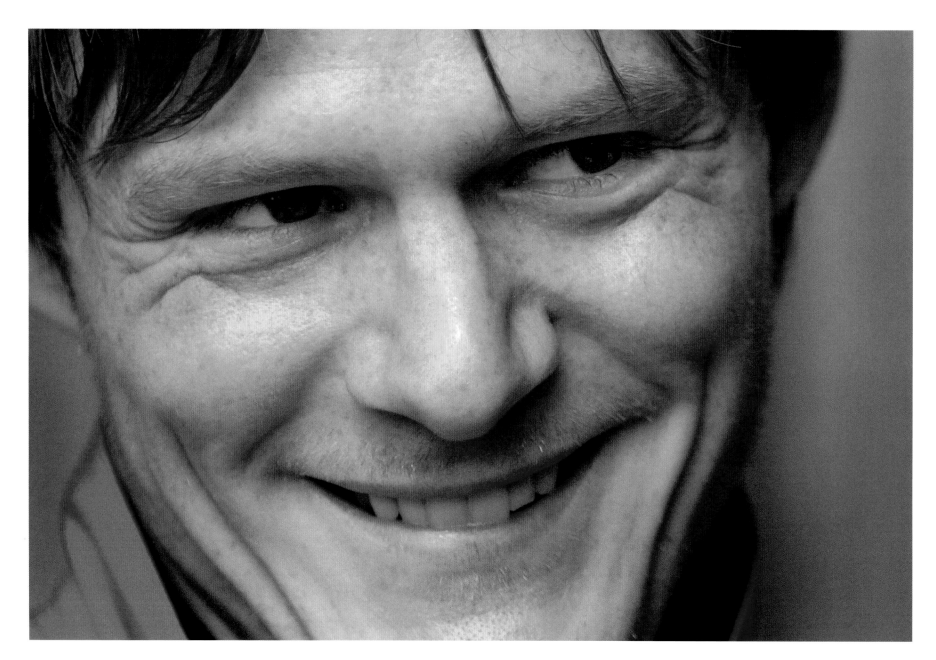

My parents weren't rich or anything. I guess we were a pretty normal family, living in an apartment block on a street in the middle of Geneva. My father, François, was the concierge of the building and we lived a few floors up. I could walk to school from my house in about five minutes. I was a city boy.

Dad was the manager of a boys' team, FC Meyrin, who were based in the suburbs out by Geneva airport. He was a coach and, while I was growing up, he was doing his diplomas to be a coach specializing in working with youngsters. By the time I was five, Dad was already my coach. Of course, I was already playing football, at school and in the street. I used to play inside the apartment too. I'd kick a ball – a plastic ball, a tennis ball, a ping-pong ball – against the radiator on the wall. You could hear the knocking all the time. It used to drive my dad crazy. He said, "Come on, let's go out to play." Maybe that's where it all started. That's probably why he got me out to Meyrin.

School days: at every break time, before school, after school – football. For me and my friends, it was always football. There was no PlayStation in those days. The school was great: a public school in the middle of the city but it was surrounded by a big, big park. Trees everywhere, it was very green and there was plenty of room to run around, plenty of room to play football. It was as if the park was a part of the school.

Even though I played for my dad at Meyrin, he never pushed me in football. Right from the start, I think I pushed myself. When we started, Dad just let us play. There wasn't a lot of tactics. We had a really good team and he made sure we just had fun and enjoyed the game. And playing at the club didn't stop me playing at school or anywhere else that I could. I wasn't a great student at school but Dad always told me I had to do my schoolwork

first and so I did enough to make sure I got through OK. Then there was time to train with Meyrin two times a week and we would have a game at the weekend.

On TV, I remember watching that great Milan side with Gullit and Rijkaard and van Basten. But, in Switzerland, it was Grasshoppers for me. It wasn't the only reason I joined them when I got older but, when I was growing up, Grasshoppers was always the team I supported. They were a team who were always ready to put young players into the first team. They were the only club like that in Switzerland, and that's why they were always my dream team and Grasshoppers players were my heroes.

At five years old, I wasn't thinking about football as a career or anything: I was a bit young then to be worrying about that! But perhaps by the time I was ten or 11, I was starting to imagine it. I think that was maybe because I grew up a little bit faster than other boys of my age. I was a little bit bigger, a little bit stronger. I was playing as a striker and scoring lots of goals and I remember people saying that I had a talent. From then on, I grew up with the intention of becoming a professional footballer.

I left home very young. I left Geneva, left my parents' house, to join Grasshoppers in Zurich when I was only 15. But before then, my parents made sure that I was just having a normal childhood. People might have been saying that I was going to do this or that, that I was a "talent", but they made sure I grew up without feeling any of that as pressure. And when it came to me leaving, they were ready to let me go and find my own way.

## School days: at every break time, before school, after school – football. For me and my friends, it was always football.

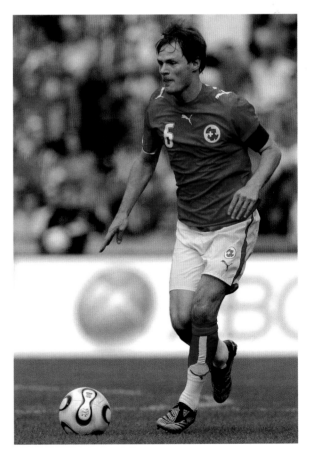

# Kompany (BELGIUM)

*Vincent Kompany*

I was born in a suburb of Brussels called Uccle but I actually grew up in the city itself, in the "Quartier Nord". It was a working-class neighbourhood with a very mixed culture. There are lots of immigrant families there, especially people who've come to Belgium from Morocco. It's a better district now – and very different – but because it's next to the red-light district there was a lot of prostitution and drugs in the area when I was young. We lived on the sixth floor of a high-rise apartment building. It was the kind of neighbourhood, with lots of kids around on the street, where every boy would come into contact with football.

Us living in the "Quartier Nord" was why I got introduced to football too: my parents did everything to keep me off the streets and out of trouble. One way to do that was to send me to join the local football club when I was just six. They sent me to Boy Scouts and to an athletics club as well; all of it to get me to spend as much time out of the neighbourhood as possible. With football, the first club was Anderlecht. They were the only club in Brussels who accepted kids my age; I went along to see five or six other, smaller, teams but I was still too young for everybody else. I was just at Anderlecht to spend time, really; it wasn't until much later on that I realized I'd joined such a big, important club.

I kept going with athletics, too, until I was 13 or 14. The training for that was much more flexible: you could do it any time, really. My sister and little brother were involved as well, so I could play football for my club on Saturday and we'd go to track and field competitions together on Sunday. My first real memories of playing football are with Anderlecht. I guess I must have kicked a ball around with my dad but the neighbourhood wasn't one where a six-year-old would go out and play in the street. That didn't come until later: by the time I was ten I had a real passion for football and I'd play out in the street as well as

at the club. All summer long; and the city put some flood-lights up around the pitch we played on: we could play on until late, late in the night.

I found out about the life of my neighbourhood in those street games and made some friends too. But, by then, football was already a major priority for me so there was no way I was going to get distracted from that. I'd play football but then, when the other boys were smoking and doing stuff, I'd go home. I had my homework to do and my parents didn't let me forget about that! Both my mum, Jocelyne, and my dad, Pierre, were huge influences for me as a boy. Dad played top-flight football in Congo before he came to Belgium. He played in front of crowds of 80,000 people. You know, he wasn't paid, but he played in a big stadium in front of huge crowds and could be a local hero. Of course, though, he chose his studies ahead of football because the game couldn't be a career back in Congo.

Dad came to Europe as a refugee and became an engineer in the aeroplane industry and played a little with friends, just for fun. He never pushed me, but he could give me advice that was as good as the advice I might get from a professional coach. Mum kept me going with my studies and with track and field as well. She knew that you could be injured playing football and knew how difficult it could be to make it as a professional player. She said to look at the neighbourhood we were in: growing up, I didn't see a lot of people around me who were blessed by success. Mum reminded me that if I took a chance with football and it didn't work out, I'd be back living in the "Quartier Nord" for the rest of my life. Looking back now, I think I ended up doing what I'm best at, although I don't think I realized I could make it as a player until I was about 16, training with the first team squad at Anderlecht and discovering I was as strong as they were.

I've always been very competitive so any kind of sport was good for me when I was young. In the end, I chose football. Part of that was because it was a team sport and I made a lot of friends playing football at Anderlecht. Especially playing for the junior teams: those were friends I made for life, you know. And Anderlecht is very focused on developing young players. They're a bit like Ajax in Holland; it's what the club is famous for. That means, being there, you develop very quickly as a player and have a professional attitude to what you're doing from a very

young age. For the coaches there, working with young players isn't a hobby. It's a job and they were devoted to what they were doing. And, as a player, if you're not good enough then you're out of the team. From the very start, you had to battle to stay in the team and stay at the club.

So, for me, football has always been fun but I've always been in an environment where it was competitive too. I wasn't being paid, of course, but Anderlecht was something I treated like a job. We had our own training ground, Neerpede; we didn't really have a well-developed infrastructure like in Holland or France but, in Brussels, we always had talented players, kids who came in off the street. So, I would get home from school and the first thing I'd do would be to go off to training: two, three times a week, even from six and seven years old. Then, after training, I'd do my homework, go to bed and be ready for school again the next day. From the start, football asked for sacrifices. Except, when you're young, it

doesn't feel like sacrifice because you love playing the game. You're tired, the coach is shouting at you, but you don't feel as if you're being forced to do it because football is something you enjoy so much.

I don't think it was planned that way but, with the junior teams at Anderlecht, there always seemed to be two kinds of coaches working with us. First, there'd be the guy who was all about giving freedom to the young players, encouraging them to go forward and express themselves. And

> You're tired, the coach is shouting at you, but you don't feel as if you're being forced to do it because football is something you enjoy so much.

then there was the kind of coach who would give you a first knowledge of tactics, who would get you playing one-touch and two-touch football. Those two strands together were very helpful for me; I think I became a more complete player because of that mix. I tried to be the best at my age and didn't look too far ahead. All I concentrated on was getting to the next level at the club. If you made a mistake, someone would be after you! It taught you that you were responsible for what you did, on and off the pitch. I'm not sure there are many young people in Europe these days who learn that sense of having to take the consequences of your actions: if I played a bad game, I was out of the team.

People in my neighbourhood knew I played football: they used to call me "Anderlecht" because they knew I was training with the club. That meant that nobody tried to get me involved in life on the streets. Nobody would come up and ask me to do this or sell this or anything like that.

They knew I was a football player: they'd see me come home from school, get my bag and catch the bus to training. And, at nine or ten at night, they'd see me come home again. My friends always came from football. By the time we were ten, we were training four times a week. The boys I was close to were boys in the same situation as me, getting the bus and going off to training every night. There'd be a group of us, waiting for the bus and travelling together. In the winter, that felt like hard times! So, it's not surprising those were the boys who became my friends.

I have an older sister, Christel, and a younger brother, François. François plays in Belgium now, for Beerschot, and had a similar football background to me: he joined Anderlecht too. He's three years younger than me and so he would always try to beat me if he got the chance but our ages kept us apart at the club. In street games, we'd like to play on the same side. He was my little brother so it was natural that I felt protective towards him but there comes a time when you have to let him make his own way, of course. It's a responsibility for him now, back home in Belgium, that he's my brother. We look very similar and people always compare the two of us. That's not a good thing when, like François, you're 19 and trying to start your own career. It would be better for him if being my brother wasn't such a focus of attention. It's been less of a help and more of an obstacle for him, you know.

Things went well for me at Anderlecht personally and I was part of a very good youth team; maybe one of the best around Europe at the time. I have great memories as well, though, of playing away from the club, street games on pitches around the "Quartier Nord". One thing I remember is how the games would be different depending on who you were playing against. A game against North African boys, say, would be very technical, very skilful. The rule seemed to be that as soon as you touched anyone it would be a foul! Games against Central Africans, black Africans, would be much more physical: power and shooting, like real football but on a small pitch. Sometimes we'd play against guys from Eastern Europe who lived and worked in the red-light district; in those games there'd be no rules at all! If you got kicked, you just had to get on with it. There was no way they were going to stop and give you a free kick. You just had to keep jumping over the tackles. And these guys would be playing football in combat boots!

In the summer, around our neighbourhood, there'd be hundreds of boys out wanting to play football. There were always plenty of players but not enough balls. Sometimes I'd bring one along from the club that was finished with after the season. It was great. We played whatever the weather. We'd play in the winter, too, when there was ice on the ground, sliding around in our ordinary shoes. There'd be boys who you thought weren't any good, but then, in the summer, you'd see they could play. It was just that they couldn't play on the ice! And when the city put up those lights around the pitch, there was never an end to it. We'd play four against four, or five against five; the winner stays on. That was the rule everybody played to; there would be 20 teams waiting to play so you knew that, if you lost, you might as well go home because it would be so long before you could get back on. However tired we got – and every team would be doing its best to beat us – we kept going. We'd start at two o'clock in the afternoon in the sunshine and we would still be playing at midnight when they turned off the lights. No jokes, no tricks, no laughing if we were losing: those were really competitive games. But the competition is what I love most about football. I'd be as angry if we lost a game on the street as if I lost a game playing for my club.

If I could, I'd play football like that now. Nothing to drink, nothing to eat, winner stays on. But now, if I played a couple of games on one of those little hard pitches, I'd have to ice my knees afterwards and get massage on my muscles, you know! I have to stick to the "big game" now. Last summer, during my holidays, I went back to my dad's country, the Democratic Republic of the Congo, out in the east, near Lake Kivu, where the war's going on. That was with the charity SOS Children's Villages. There would always be a game going on, 20 against 20, on a big pitch somewhere, and I'd end up joining in. We were on top of a mountain and, if the ball went wide of the goal, the kids would have to run down the hillside to get it. And I'd end up getting mad because someone didn't pass to me; I'd fly into tackles. Even there, there was no way I was going to let my team lose a game!

But I'd look at those kids in the Congo: I was busy while I was there and wouldn't eat all day, but I'd still want to join in their games. Those children, though, might not have had anything to eat for several days but still they were just running and running. Hungry or not, they just had to play. Football isn't only about playing inside white touchlines, in a match with a referee and people there watching or being paid to write about every single little thing that you do. It's about the amazing things a boy can do playing on the street in Brussels, or on a field somewhere in Africa: the legendary move he's got the time to try out, playing in a game with his friends.

## PRIDE

Before I left Cuba, whenever I went back
to my neighbourhood after I'd been away
with the national team, I think people were
quite proud of me: "You played in the streets
with my children and my grandchildren.
And look where you are now."

~ MAYKEL GALINDO ~

# Cannavaro (ITALY)

*Fabio Cannavaro*

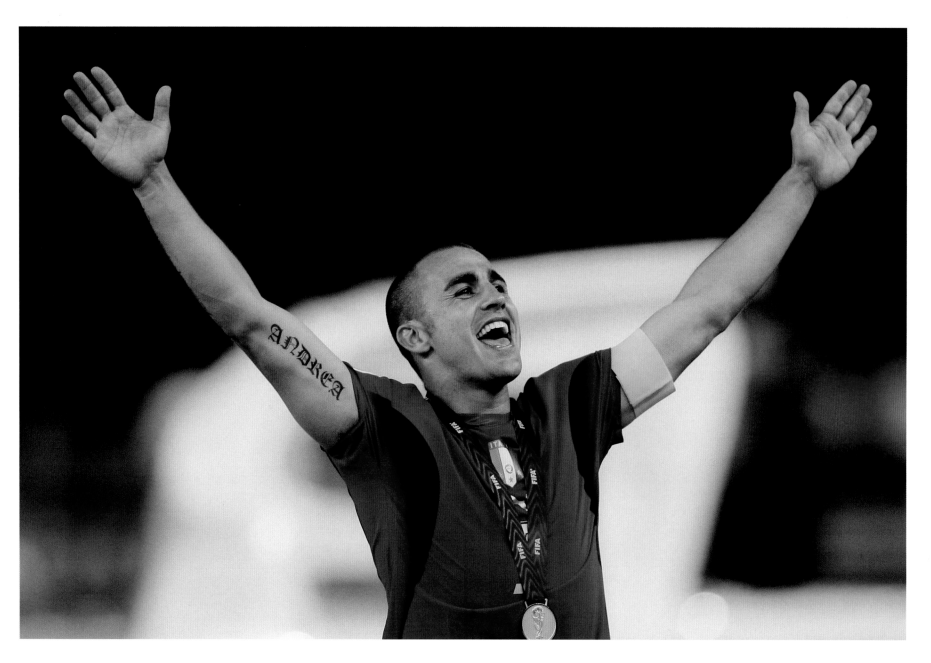

*Scugnizzo* is the word. In the old days, a kid growing up on the streets of Naples would be called a *scugnizzo*. That's to say a kid who's used to living out in the street; a sharp, streetwise kid, scraping his way through life; a kid living on his wits, used to going hungry, maybe, and trying to get on with life in a difficult city, trying to find ways of just getting by. I was a *scugnizzo*. In the old days, boys like me often wouldn't even go home; by the time I was growing up, though, things were different. I had a home to go to. But the street culture still survived and I was part of it.

People from the north of Italy are different from people in Naples: *scugnizzi* are kids specifically from Naples. We are that little bit sharper than kids from the rest of Italy. Life's an adventure for us. The city itself, Naples, is different from anywhere else in the country. Everywhere else, kids are *bambini*; in Naples we are *scugnizzi*. It's like calling us street kids but that's not necessarily a negative thing; it doesn't mean we're delinquents. It's just that kids in Naples are never indoors. They go to the beach or hang around the streets, playing football, worrying their parents; it's another way of life, unique to the city.

That attitude and identity comes through in the football that's played in Naples too. When you grow up in the streets and play your football in the street, that affects the way you play. If you want to survive on the street, you have to be sharper, quicker; you have to learn to do things when other people aren't looking or aren't concentrating. If you have a free kick, you take it before the other team – or the other kids in the street – are ready. Or you play a one-two off the wall, which was something that we did all the time when we played as kids. *Pim-pam*, against the wall, and you were away. You'd notice that they weren't ready, quickly play it against the wall and … *Goal*!

That culture really helped me to grow, as a person and as a footballer. You get used to having to be alert to everything, to seeing things quickly, to being really tuned in. You never turn your back or look down at the ground because, in a city like Naples, if you drop your guard someone will take advantage, take the ball from you. You have to make sure you're in control. You have to know what the opposition is doing, what's going on around you. With no rules to the game and very little space to play in, you become cleverer, more flexible. These days, perhaps, we risk losing those qualities. Some of the young players coming through at professional clubs now have grown up in a fixed way of playing and have difficulty swapping between positions and formations because they have a mind-set that doesn't allow any flexibility. Football has become too rigid.

We weren't lucky enough to have football pitches like there are everywhere now. We played in the street; I mean literally in the street, with the cars going by. We'd use whatever we could find to make goals: normally we would put down bins or rubbish bags. Or kids would play bare-footed and leave their shoes down as goalposts. The problem came when a car had to go by. We'd be playing and someone would suddenly shout, "Stop, stop. Car!" We'd stop the game, wait for the car to pass, and then carry on playing. We were playing on concrete, of course: it was hard and you'd do yourself some major damage

sometimes. You'd try not to go to ground, but I remember some kids who used to love diving in anyway: they just didn't care about hurting themselves.

It wasn't until I was 12 or 13 that I got the chance to play organized football, in teams and on grass pitches. When I started playing properly, though, I still carried on playing in the street too. I would go and train with my team and then come back and play in the street afterwards. I liked playing on the street, where there was always a game going on. It didn't matter if there were only two of you, or three, or four, or a crowd: you could always get a game of football; there were always kids around to play with. We'd eat at two in the afternoon and I'd be looking out the window and, if I saw any lads down on the street, I'd be straight out there, ready to play. My mum would shout at

> Back then, football was all about enjoyment; the best fun we could have: the fun of playing, scoring goals, taking on other kids. We'd come home, back to our neighbourhood, proud because we'd won.

me to do my homework or to go to the shops for her, but I'd just say, "Later Mum, later. I'm off to play!"

It was always the same kids from my neighbourhood who'd get together to play. Sometimes we'd team up and try to take on other kids, seven or eight of us against seven or eight of them. We'd look for other kids in nearby streets to play against. Back then, football was all about enjoyment; the best fun we could have: the fun of playing, scoring goals, taking on other kids. We'd come home, back to our neighbourhood, proud because we'd won. And it wasn't

just winning the game: we used to play for a bottle of Coke or a bottle of water. There was nearly always some kind of prize riding on the game. We used to love betting on our games against other kids because we knew we were the best! It suited us to offer up some kind of prize because we nearly always won.

People around our neighbourhood got to know about us; they started to know that I was a good player and that there were others too. They knew we were good and realized that betting against us wasn't a very good idea. Through playing football, you earned a reputation around the neighbourhood. I used to play as a midfielder or a forward, so people knew who I was. People started to talk about me, kids started coming round trying to get me to come down and join in their games, to play on their side. And the older I got, the more people found out about me, I suppose. They started picking me out as the star.

I still remember one special game we used to play: one kid would be in goal and the others would be trying to score with headers or volleys. You had to keep the ball in the air and, after five passes, you could shoot or head for goal. If you scored, it was a point; if the goalkeeper saved it, he got a point. In the end, the person with the most points was the winner. The most important thing, though, was that if the goalkeeper made a save he came out of goal and the person who'd had the shot went in. We weren't playing to win so much as playing not to be in goal! I think those street games helped me develop as a player. We weren't playing for three points; we played because we enjoyed it, because we loved the feeling of winning. You know, we played for the chance to go home happy, thinking: "I won" or "I scored" or "I played really well". That attitude means you play in a different way; the football's more intense and minute-to-minute.

I think Naples, as a city, is more like Buenos Aires than it's like Milan. Life there has more in common with Rio de Janeiro than it does with the cities of northern Italy. There are so many problems in Naples; we're a poor city and there's a lot of crime. But we are a proud city too: Naples is a happy, lively, humble city where people live with a smile on their faces. And, like I say, it's a city that lives on the street: people are open and would rather be enjoying themselves than having to work. People in the rest of Italy will tell you that *Napoletani* are lazy and don't do things properly: if something bad happens, the rest of Italy will assume it's happened in Naples. We're used to it now. If somebody in Milan drops litter on the floor, other people will say, "He must be *Napoletano.*" If someone jumps a red light: "He must be *Napoletano.*" There's an element of truth in that and it's the image the rest of Italy has of us. Maybe they're jealous because we're different! I wouldn't say we live without rules in Naples but we're more laid-back, we have a kind of freedom about us. We're more open and we have fun and enjoy life more because of that.

When I was a boy, Diego Maradona was a god in Naples. He was for me. Our football club, Napoli, hadn't won anything for 60 years and suddenly, with Diego, we won the *scudetto*. It had always been Juventus or Milan or Inter winning things: the teams from the north. When Maradona arrived, it was incredible. Napoli won in Turin, won in Milan; Napoli won everywhere. It was the South beating the North for once and it felt like a party every day. I never played with a Maradona shirt on in the street; I didn't have the money for a Maradona shirt. But we would play in the street imagining we were him. Someone would do something good with the ball and everyone would shout, "Maradona!" But it was never a patch on the real thing, of course.

I was lucky enough to be at Napoli as a junior player while Maradona was at the club. I used to see him almost every day. It was incredible. He used to have to drive through my neighbourhood on his way home from training, too, and everyone would be out in the street as he came past, jumping up and down: "Diego's car! Diego's car!" He was a god for us, but a god we could touch: a god who was in our neighbourhood. I used to be a ball boy at the stadium for most Napoli home games. If I got the chance to hand the ball to Maradona, my eyes would mist over: "Wow, I just handed the ball to God!"

I still have a photo at home of the day Napoli won the league and were celebrating at San Paolo, our stadium. In that photo, you can see Maradona celebrating and, beside him, a kid in a tracksuit: a ball boy. That's me. I was 11 or 12. It was just amazing: all the other kids around Diego are my best friends from childhood, kids who I grew up with and who were at Napoli too. What a day! You know, when Juventus wins the league, there's a party in Turin: a million people in the streets, which is great. But then, the next day, it's forgotten. In Naples, it was different. After Napoli won the title, the party went on for weeks and weeks. It was a month before things calmed down. That tells you about the difference between Naples and the rest of Italy. It was incredible. Other clubs have won things, but no other club – no other city – has ever enjoyed winning things like we did. After 80 years of nothing, suddenly we were the best. It had an incredible impact on the city and on us kids too. We felt special and, for the first time, we had football heroes to look up to.

At the 1990 World Cup, which was in Italy, Maradona played for Argentina in Naples. He even played against Italy. I remember he told the fans, "Three hundred and sixty-four days a year the rest of Italy treats you badly; now they want you to support Italy! I am *Napoletano* 365 days a year!" He asked Napoli fans to support Argentina instead of Italy. That was clever and you could see why he

did it: Maradona meant everything to us and people in Naples did feel that the rest of Italy didn't really care about them. That feeling just underlined how different the city is to the rest of the country. And some people did back Diego over Italy. But only some. What Maradona said might have had some truth in it but this was the Italian national team. I – and most of my friends – supported Italy. I am Napoli through and through, the city and the football club. It's my identity and I won't let anyone attack my home city, but I am Italian too. I supported Italy at that World Cup. But, even so, I remember thinking, "Well, at least if we lose, it'll be to Diego." And when Argentina played Germany in the final we all supported Diego even though he had knocked us out of the tournament. If Argentina had won it, I think the people of Naples would have felt that the victory belonged to us too.

So, I played football in the street. I scored lots of goals and my hero was Maradona. Naples was a city of freedom, a city almost without rules: the kind of place that, in footballing terms, you would think leads naturally to the development of *fantasisti*, out-and-out creative players. And yet I ended up being a defender. It seems strange, really, that the two biggest players to have come from the city in the past 20 years – me and Ciro Ferrara – have both been defenders. For us to have come from this city full of life and happiness and *fantasia* – the city where Maradona was everyone's idol while we were growing up – and become defenders? I don't know how it happened! One day my coach got me to play at the back because someone was out injured and, after growing up as a midfielder, that was the start of my life as a defender.

When we were kids, it was great if a boy wanted to play at the back: the rest of us wanted to be playing up front. I never wanted to be defending. I wanted to be up front,

scoring goals. Better still was when we found a kid who really wanted to play in goal! It's like that all over the world, isn't it? Nobody else ever wanted to go in goal. Anyway, my education on the street – I didn't have a real education – wasn't one to prepare me for a professional career as a defender. When you play on the street, you play with freedom, for the fun of the game. When you get to a

to leave the key to your house by the front door, or in the car, but no one does that now. And kids don't go out to play football around my neighbourhood as much as we did: I think that can only be because they're afraid to. But if you go into the very centre of Naples, you'll still find street kids, kids like we were. You know, the *scugnizzi* will always be there!

## I am Napoli through and through, the city and the football club.

club, of course, you have to play according to what the coaches tell you to do. And sometimes that's hard. The coach will say, "Go there. Do this." And, at first, you can't do it. But you learn and, if it goes well and you win, you enjoy it. I was lucky enough to have a coach who could see the defender in me, despite me not seeing it in myself. Thank goodness! If I'd continued as a midfielder, I would never have made it as a professional player. I don't know where I'd be now.

I really enjoyed my childhood. Naples is a difficult city and it can be a dangerous city for kids. But we loved it. And now, when I go home to Naples, where my mum still lives and my oldest friends are, it's fantastic. We look back on times that we really enjoyed together. It's still a very special feeling, looking back. The only thing is that, when I go home now, Naples seems different. The city has really changed: people seem to be playing out on the street much less than we did when we were boys. I don't know why. Maybe their mothers are worried now about what might happen to their children, more worried than our mums were when we were growing up. It was always a difficult city but now, maybe, it's a more dangerous place. Or, at least, people think it is. You used

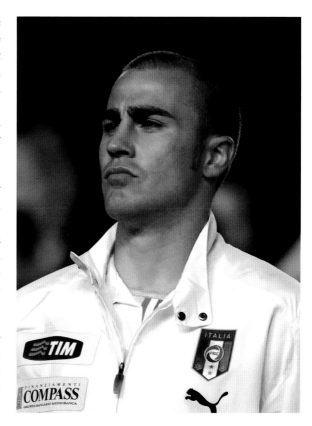

# Jazic (CANADA)

*Ante Jazic*

When my dad, Mario, came to Canada from Croatia – or Yugoslavia as it was then – he didn't know how to speak English. Pretty much all he knew how to say was "Toronto". So, when he arrives in Toronto, he says, "Toronto". But they said, "No, sir. You can't come to Toronto. It's already overpopulated. We're going to have to send you somewhere else." They gave him a train ticket to Halifax instead, which is where I was born and raised. That's how we ended up there. Halifax is a small city on the east coast of Canada, in the province of Nova Scotia. It's known as a fishing community and isn't anything like as big as the major cities in Canada. Not too busy, really family-oriented: a great place to grow up. There's a small Croatian community there but nothing like the numbers there are in Toronto or Vancouver.

Dad worked in the construction industry, like I guess all the European immigrants did. It was difficult for my parents when they first arrived but we were happy in Halifax when I was growing up. We lived in a suburb called Bedford. When I was growing up, Bedford was rated as one of the top ten places in the whole of Canada as far as quality of life was concerned: green, peaceful, great schools and very little crime. It was a great place to be a kid, absolutely not a big city where you had to lock your doors and stuff. Being Croatian, coming from the former Yugoslavia, soccer was all my dad and his friends cared about. They had a kind of pub team, a Sunday-league team. I'd watch every weekend, them having games against teams from the other immigrant communities, the Greeks and so on, in the local parks. That's where it started for me.

I played ice hockey in the winter and soccer in the summer, in organized teams, from a very young age. Hockey's an expensive game: I played that until I was 15 but, as I kept growing, the hockey gear was just starting to cost too much. With soccer, all you needed was your cleats and shin guards and you were good to go. The game was Dad's passion, so maybe it's not surprising it was mine too. My younger brother, Alan, as well – he stopped playing when he was about 20 but he now coaches a

## Soccer was all my dad and his friends cared about. They had a kind of pub team, a Sunday-league team. I'd watch every weekend, them having games against teams from the other immigrant communities.

senior men's team back home in Halifax. He's younger than most of his players. We used to play in the back yard together. That was one of the great things about Halifax: everybody had a yard, so there was always somewhere to play. Alan and I would play one v one. Those games would always end in fights: we're a year apart, so you can imagine how competitive we were.

As well as playing at home, we both joined teams when we were five, and so, from then on, we'd be training a couple of times a week too. At that age, you always joined the club local to you. Kids wouldn't travel across Halifax; it wasn't until kids were ten or 11 – and it started getting more competitive – that you'd start picking which club you wanted to play for. So, at first, we joined a club in Bedford itself: the Bedford Hearts. That seems like an awfully long time ago now. It was under-eights and I always seemed to be the smallest. We played in an eight-a-side league, on quarter-sized pitches. I remember I was always being caught offside because I didn't really understand the rules and just used to hang out around the goal, waiting to put the ball in the net.

Like I say, I was always one of the youngest kids. I don't think that was because I was particularly good or particularly keen. It was just Mum and Dad wanted me out of the house doing something, so they were ready to come up with the registration fee. And the club was happy to take their money! The coaching then was done by one of the parents. It wasn't really the most knowledgeable coaching: a guy would read a football handbook, maybe, and then take it from there. It was all about having a good time, everybody getting equal playing time. There wasn't much about developing your skills or anything: these were parents who had the time to coach a team, to help the kids out. It wasn't competitive; every ten minutes there'd be subs, so everyone got the same chance to play. They didn't want any of us to get discouraged: what kid would be happy just sitting on the bench? It was all about having fun. The facilities weren't the greatest. We used fields at the local junior high but, at that age, you don't need facilities. All we wanted was a patch of grass to hack around on. And parents were happy to commit a bit of time to us being active and involved in sport.

There were a handful of other Croatian boys who played but a lot of them lost interest. That's the problem in Canada: kids will play soccer when they're young but, once they get to 15 or 16, they stop or do other things. That was true of most of the guys I played with for

It was when I was about ten – playing under-12s perhaps – that I started trying out for teams. Those were the first teams you had to have trials for, where they'd make a cut. It started getting more serious: playing for Halifax at regional level and then national level. I actually enjoyed it becoming more competitive. The coach there was a gentleman by the name of Stephen Hart, who's now the technical director, nationally, for the Canadian Soccer Association. He was the first coach I had who really did anything to develop my technical skills. He invested a lot of his own time into working with me: he'd come and pick me up after school, work with me one-on-one. I was always smaller growing up, so he'd strap a weight jacket onto me and get me running up hills with it on. He's probably the single most responsible person for me making a career in soccer. He was even coach of the national team for a while. After all that time together back in Halifax, I was out there playing for Canada and he was on the bench, still coaching me. He's just like me, I guess: a man with a passion for soccer. Everybody needs someone who can open the door for them and Stephen Hart did that for me. Canada's a very big country and soccer's a very small part of it. How would scouts find you? You could be Maradona playing in Canada and they'd never discover you. Stephen Hart was my bridge to the professional game.

When I was a teenager, I idolized Dejan Savićević who played for AC Milan. I'll never forget watching him score for Milan in the European Cup final, when he lobbed the keeper against Barcelona in Athens. There I was, a boy living in Nova Scotia, watching the Champions League final on TV. It's amazing: when I was playing in Europe, I got transferred from Hajduk Split to Rapid Vienna. Savićević was about 35, coming to the end of his career, and I got to play in the same team as him. Me becoming a professional was a complete fluke. The summer after my

first year at college, I went to visit my family in Croatia. My uncle lived downstairs from the daughter of the coach of a little first division club and he asked her if her dad would give me a trial. It was the day I was due to fly back, but I thought, "I've played soccer all these years, I've got to try." And that was it. My first contract as a professional in Croatia, I was earning less than I had been pumping gas during high school back in Halifax. But I ended up, a few years later, playing alongside my hero, Dejan Savićević!

When I was growing up, I never imagined having a career as a professional player. Soccer was just recreation: you had to pay to play; any trips the teams went on, your parents had to find the money for them. I always thought I'd finish school, maybe go on to university and play soccer there, and then get a job somewhere and play local soccer in my spare time. Dad was always pushing me to make sure I finished school. He told me: "Well, you're never going to get a job in soccer." If I'd just stayed in Halifax, I'm sure I would have been involved with the game, coaching or being a director of a club; but I'd have had to do something else too. That's why I went to college to do a degree in Business Administration. I guess I'd have done something to do with business, but it wouldn't have been something I could be so passionate about.

Things have changed a bit in Canada now. Toronto play in the MLS and maybe there'll be more expansion. Boys now have a legitimate chance to go on and play soccer professionally in the A League in Canada. It's not at a great level but it's an income: you can make a solid income from playing. There was nothing like that when I was growing up. Really, soccer was a dead end. You played until having to work got in the way. And then you wouldn't be able to play any more. I was lucky. Or, at least, I made my luck. I took my chance when it came and it paid off for me.

Bedford Hearts – none of them carried on past 15 or 16. I just had a passion for the game, though. I'd rather play soccer than go to school or do anything. I'm still the same now: if there's a game on TV, I'll always be the one watching. My parents didn't have to push me; it was me pushing them to take me. It never happened that I didn't want to play or didn't want to go to practice. If I ever had a poor game, Dad wouldn't say anything. Instead, he'd ask me how I thought I'd done. He was honest but never really critical. Mum was the opposite: she'd always criticize me but I'd just tell myself, "Oh, what do women know about football?" That's how I'd manage to shrug it off.

We played because we enjoyed it, because we loved the feeling of winning. You know, we played for the chance to go home happy, thinking: "I won" or "I scored" or "I played really well".

~ FABIO CANNAVARO ~

# Gudjohnsen (ICELAND)

*Eidur Gudjohnsen*

I was born in Reykjavik but grew up in Belgium where my dad, Arnor, was a professional player. Dad played and now my oldest and middle sons are with the junior teams at Barcelona. I think we left Iceland when I was about a month old. My parents were very young – 17 and 16 – when I was born and they took me with them when Dad signed for KSC Lokeren, a club in East Flanders. He was there for five years and then we moved to Brussels when he joined Anderlecht.

From what I understand – and I can see it in my youngest son now: he's the same – I used to refuse to go to sleep unless I was wearing my little Lokeren football kit. I wore that kit every single day and every single day it would have to be washed. And if it wasn't? I would either go to bed wearing it dirty or scream my lungs out until I could! From when I was just a couple of years old, all I needed was a ball to keep me occupied. Even before I could walk properly, my dad has told me that, if he rolled the ball towards me, I would hold onto a table or something for balance with one hand and kick the ball back to him.

Football was never really introduced to me; it was always just the most natural thing in the world. The ball was there and I loved it: this round thing that – I don't know how – I just knew what to do with. You get young children who'll pick a ball up. Others who won't really be interested. I just walked up and kicked it. Definitely, it was in my family. My dad played, of course: professionally and for Iceland. But my grandfather played too. He was a fisherman, a big, tough old guy who lived up in the north of Iceland. He just played amateur football but he always said he was better than either my father or me!

Everyone's crazy about football in Iceland. English football has been shown live on TV for as long as I can remember. They would show one game and, at the same

time, the results of all the others would come up on the bottom of the screen. We could follow all the clubs. I didn't have a particular team or particular players I liked but I can still remember that I thought of myself as a Tottenham fan. Why? Well, when we were living in Belgium, my dad used to have videotapes of games he'd played in and goals he'd scored. And, when I was little, I would go downstairs in the morning at weekends – I wouldn't even wake my parents up – and watch those tapes. And, for some reason, there was a tape there with highlights of a match between Spurs and Luton, with Glenn Hoddle and Steve Archibald and Garth Crooks and all those guys playing. It was an exciting game, lots of goals and lots of action, and I just watched that tape over and over again.

Once Dad moved to Anderlecht, we lived in a little village, just outside Brussels, called Brussegem. It was natural that football was a big thing inside our family. But I played outside too: at school and anywhere I could. You know, when you're growing up, I don't think you really choose your friends. They sort of find their way to you and, for me, that was through football. That was always the common ground for me and my mates. There's a group of boys who want to play, you meet up and that's it.

There were only maybe a thousand people in Brussegem but we had a little football club there that I joined when I was about five or six. Those were the first training sessions I ever had. And the first goal I ever scored was for them. I can still remember: we won the game 20-nil. And I scored the 19th goal! I'd played a couple of games and my mum had come along to watch. She'd teased me, "Why don't you score any goals? If you don't score, you won't get in the team!" So, at last, I was able to come home and say I'd scored: that 19th goal was the start of it all for me.

For me, when I was a boy, it wasn't just that I loved playing football. From the very beginning, I had no doubt whatsoever: I was going to grow up to be a professional player. And from when I was very young, other people would look at me, too, and say the same. But my parents never pushed me with football. They taught me right from wrong in life and taught me the importance of respecting people. And then, when it came to football and what the future might bring, it was up to me to make my own decisions.

My dad played, of course: professionally and for Iceland. But my grandfather played too. He was a fisherman, a big, tough old guy who lived up in the north of Iceland. He just played amateur football but he always said he was better than either my father or me!

Dad used to sometimes tell me little things about the game, how to do certain things on the pitch, basic technical things. But he never told me, "You have to do this or you have to do that." He didn't have to. I never said I didn't want to go training or didn't want to play. I just loved football and never had any doubt about where I was headed. And Dad was my perfect role model: I still think he's the best player I've ever seen, even if I am a little bit biased! I think it's natural, if you have a good upbringing, that you want to be like your father. My mates used to tease me about having a "silver spoon" upbringing and we were lucky that we never lacked for anything when I was a boy. But, even so, there are still problems and obstacles you have to face up to during your life and your career. And my dad was an example for me when I had to deal

with those things. And I could always turn to him and to my mum for advice.

I suppose I felt a little bit like I was growing up Belgian. We were in Belgium for ten months of the year; I went to school there and I can still speak fluent Flemish. But the link with Iceland was always incredibly strong. We spoke Icelandic at home. And I can remember there were conversations about me taking Belgian citizenship, but I never wanted that. Every holiday, we'd go back to Iceland and

it always felt like going home. I'd see my grandparents, see my friends around Reykjavik, and I started playing for a team there as well during the summers. Basically, I just played football all year long.

The team I joined in Iceland was called IR and that was where I made the friends who are still my best friends today. It's good in Iceland: small and close-knit communities. It's very easy to organize tournaments for kids. During those summers at home, we'd just play football every day. And, because the days were so long – it never really got dark – we could play until midnight. My grandmother used to come out looking for me in the middle of what was supposed to be the night. But it was still light enough to play and I wouldn't stop until she came out to get me to come indoors.

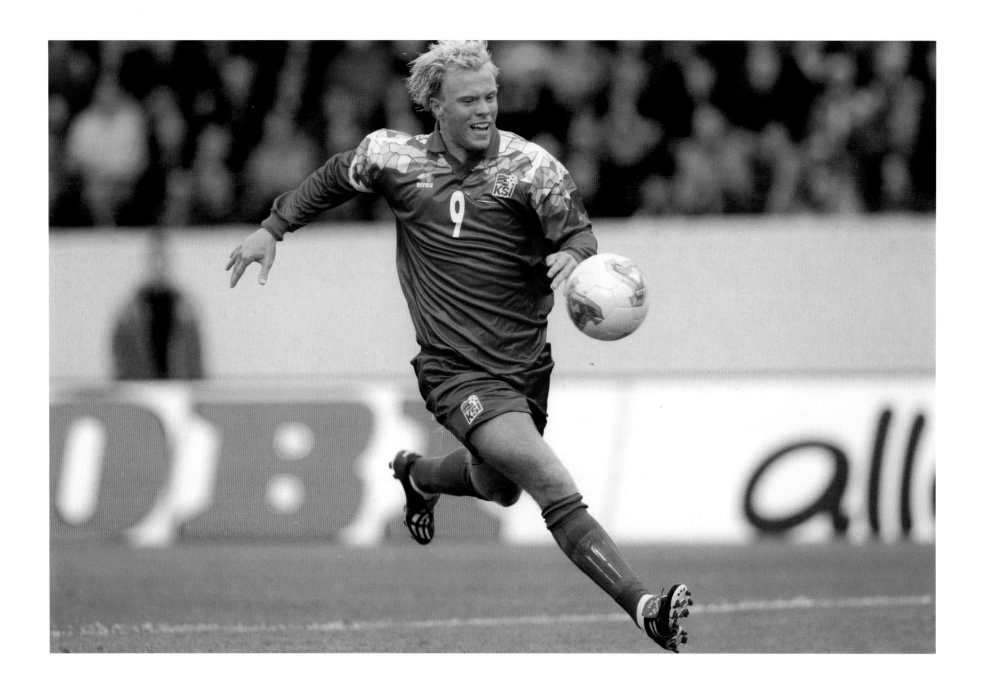

Usually, in Iceland, we played on gravel pitches. Facilities are much better now but, when I was playing for IR, if the coach told us we were going to have a game on a grass pitch the next day, we'd all get excited. A game on grass was like a treat for us. The weather in Iceland wasn't the best, so they tried to save the better pitches for the adult teams to play on. And it changed as we got older: by the time we were ten, we'd play our games on grass. But we'd still be training on gravel. Those were great times, though.

Remembering playing in Iceland reminds me: I think people know that I and my dad played together for Iceland. It's frustrating for me that we didn't play more: he went on with the national team for a couple of years afterwards but I was out injured all that time. And now my oldest boy, Sveinn, who's ten, loves football too. He's big and strong and he's training now with Barcelona. Anyway, there's a famous tournament they have every summer in Iceland for nine- and ten-year-olds. It's held on the Westman Islands, just off the coast, with a hundred teams from all over the country coming to compete. Everybody goes over to the island for four days with a sleeping bag and stays for the tournament.

I can still remember playing in the final of that tournament one year. I scored but we lost four-one. Everybody was there – all our parents and friends – and I just cried my eyes out afterwards. Last summer, we were back in Iceland and Sveinn played in that same tournament and his team got through to the final as well. They went a goal down; he equalized for his team but they ended up losing two-one. Exactly 20 years after I'd had the same disappointment, lost the same final and scored my team's only goal, Sveinn was there with his friends crying *his* eyes out. He couldn't believe it: the worst feeling in the world. And I explained to him that I'd had exactly the same experience: "It turned out all right for me and it will for you too."

You know, you see a bit of yourself in all your kids, don't you? But with Sveinn? Well, sometimes it's a little bit scary! He looks so like me, especially when he plays. It's a funny feeling, watching him, but exciting too. It's amazing. I've always thought that, when I stopped playing, I would naturally start living my life a little through my sons. But I'm still playing and it's already happening: maybe a little bit too soon for my liking because I still want to go on playing myself for a while yet! I go and watch Sveinn play whenever I can. And now my middle boy, Andres, who is six, has just started playing for the juniors at Barcelona as well. He's mad about football, even if he's not as naturally talented as his brother. But he'll still do things in a game that make you think there's definitely something there. And the youngest, Daniel? Well, he's like I was: he just wants to wear his little Barcelona kit all day long.

It was why I was so confident in myself from so early on. Maybe I've left it a little bit late for me to be able to play in the same team as Sveinn, but I bet, as he gets older, the temptation will be there to try: "Maybe I can go on playing myself for just one more year!"

Watching Sveinn play, I feel so many different emotions. When I watched him lose that tournament in Iceland, it broke my heart; even though I knew that, like all boys, he would only feel the disappointment until the next game, until the next time he won. The amazing thing, though, is that I have this sense that I always know what he's going to do in a game: I understand the way he thinks, I know where he's going to run. And, of course, it's always been the same for my dad. He'd tell me that he'd be watching me on TV and felt he knew exactly what I was thinking and feeling from minute to minute during a

[Dad] always had that sense that I would go on to have a successful career in the game. And I think that confidence, Dad's belief in me, rubbed off.

There is a natural way that you begin to focus in on the game. I see my boys play around the house or in the garden and I can see they enjoy football, so I take them along to train with a team. And there they are surrounded by other boys who all love football as well. It's like you find yourself inside a circle. My dad remembers that when I was still very young – eight or nine years old – he was already starting to try and work out, with the difference in our ages, when he and I might get the chance to play for Iceland together. He always had that sense that I would go on to have a successful career in the game. And I think that confidence, Dad's belief in me, rubbed off.

game: "I can see what you're going to do before you do it." And I'd say, "Yeah, yeah. People always say things like that, that they know what's going to happen next." But now I watch Sveinn play and I have exactly the same feeling. What my dad always used to say has turned out to be true.

# Galindo (CUBA)

*Maykel Galindo*

I'm lucky. I've played soccer ever since I was a kid, although that meant I left home at a very young age to go to school to study and to play soccer at the same time. I grew up in a family of women. I'm the only male grandson; the only son on my mum's side, although I have a half-brother on my dad's side of the family now. But on my mum's side, I've always been the little baby, the only boy in the family. I was raised in a good way, with a lot of love, in the heart of the family.

We lived in Santo Domingo, which is a small town that's attached to the city of Santa Clara, right in the middle of Cuba. I remember I was in fifth grade: a soccer coach, Lázaro García, came to the school. He said, "Who wants to play?" It was a kid's thing, instinct: I just raised my hand. If he'd been a baseball coach, I wouldn't be here talking about a career as a soccer player now. My first pitch was a soccer pitch: we'd run out of school to go to the field to train. Maybe we didn't have the right clothes, didn't have shoes, but we loved the game. That was really how it all started for me.

Before Lázaro García came to my school, we played games ourselves in the barrio. It was a built-up neighbourhood but there were some nice houses – houses with patios, plants and fruit trees growing on them. We had quite a big house. It was always a very close-knit neighbourhood: any time there was a problem for any of us kids, the mums would all get together to make sure things were OK. It was a family neighbourhood.

When it came to our street games, I was always the smallest one; the big boys used to tower over me. We played in the street and put rocks down to mark out goals. After school, from five o'clock until it got dark, we all knew we'd be out playing. We'd find a ball from somewhere; one of the boys would have one. Sometimes boys from other neighbourhoods would come along to play against us. Along the street, the mums and grandmas would all be saying we shouldn't be playing, saying that we'd be sure to break things. But we ignored all that! Cars would come along the street and we'd have to stop the match until it had passed. It wasn't a big space we had to play in, so we would split into smaller teams, four against four, and take turns playing each other; two teams would play and the others would wait. We'd make up our own rules. As soon as one team scored a goal, we'd change over. But sometimes the games would go on and on at nil-nil. Then we'd stop and have a penalty shoot-out to decide: each player would take a shot from their end at the other team's goal, without there being a goalkeeper. Sudden death.

Those are the best memories of my childhood, very beautiful memories. After I started playing for a proper team, if I came back to play in my neighbourhood and thought I was the best player, the older boys would put me in my place: "Hey, you're still just a little one, son!" People love soccer in Cuba. Whenever there's a World Cup or a European championships now, everybody stops to watch the games on TV. The whole country gets excited. Everywhere you look, you'll see kids kicking a ball around. What's missing in soccer in Cuba at the moment is just that the game isn't given the same priority as baseball. So, if you're playing at international level, for example, it's difficult to continue to develop as a player.

We had our heroes, though, when we were kids. When I was growing up, there was a player named Ariel Álvarez who came from Santa Clara province too. Back then, there was very little soccer shown on TV and the Villa Clara team played somewhere else but, once a season, they would come to play a game in Santo Domingo. That's when I'd see a game: the whole town would go crazy, all the kids running to the stadium to watch the match. And, after you saw a game – at the stadium or on TV – we'd all try and do the tricks we'd seen the players do. Álvarez was in the national team and I admired his way of playing the game. I was called into the national team when I was very young, at a time when the senior players like Álvarez were being retired. But when we came back to our clubs, because we were both from Santa Clara, we played together. We won a championship playing together.

Although the Cuban national team isn't widely known, there are international tournaments every year that we participate in and, for the players, that's an opportunity to travel abroad and compete. But when I was a boy, I wasn't thinking about that. I certainly wasn't thinking about going out and making a living out of soccer. I was just playing. It wasn't until much later, when I was called into the national team, that I realized that the game could be a career, a destiny; it wasn't until I was 19 or 20 that I realized it was what I wanted to do. It was only then that I realized there could be a different way of life, and a way to help my family at the same time.

Like I say, when I was a boy, soccer was just a game I loved playing. I didn't think about having a career as a player. What did I want to be? Well, I was raised by my mother's parents, my grandparents. My mum and dad both went to university and became engineers. They moved to a city called Cienfuegos, down on the coast. They took me with them, even signed me up for a school there. But I was the

only grandson in the family and, after a week, my grandmother showed up in Cienfuegos and said, "My grandson's coming back to Santo Domingo with me!" She didn't have a plan for me; she just loved me and wanted me at home, wanted to feel me there next to her! My grandfather worked as a train driver for the railway. We lived very close to the train line running through Santo Domingo. At four thirty in the afternoon, I'd hear the train coming and run down to meet it. My grandfather would stop and pick me up and I'd ride down to the station on the train with him. When people asked me what I wanted to be, I'd say, "I want to be a train driver like my grandfather!"

My grandfather liked football a little bit, but he especially liked seeing me play in the number nine shirt. When he died, I was away in Havana preparing for a youth international and nobody at home told me he was unwell; but he was buried wearing my number nine shirt. My grandmother liked coming along to matches too, but she always left before kick-off because she got so nervous and didn't want to see anybody fouling me! I loved being with her, I loved being on the train and hanging out with my grandfather, but, luckily for me, after I started playing soccer I got a scholarship to be able to go and study and play at the same time. At first, my grandmother didn't want me to go. It meant I had to leave home and go away to a special scholarship school in Villa Clara. I cried a lot. My grandfather said it would be hard not to be able to see me all the time.

But it was an opportunity – my grandmother knew that – and so they let me go. That was when I was about 15.

I've always had close friendships in football. When I was little, I used to play all the time with a boy who lived next door to me, Jan Leon. Really, we grew up together; we were raised together. We were really good friends all through childhood. Jan actually lives in Miami now. And then, when I started playing for the local team and got more involved in soccer, I got to know a boy, another player, called Alien Cantero. We were together a long time, practically lived together: we were in the same kids'

## My grandfather liked football a little bit, but he especially liked seeing me play in the number nine shirt. When he died ... he was buried wearing my number nine shirt.

team, got our scholarships at the same time, and then we both went to Havana to be with the national team. After reaching the under-20 level, he didn't continue with his career but, until then, from when we were young boys, we'd taken every single step side by side.

Before I left Cuba, whenever I went back to my neighbourhood after I'd been away with the national team, I think people were quite proud of me: "You played in the streets with my children and my grandchildren. And look where you are now." It was an incredible feeling. I'd get home and the neighbours would come round to ask where I'd been, what I'd seen, what I'd been doing. Those were wonderful experiences; Santo Domingo was proud of a local boy who'd made it with the national team.

## LOYALTY

If you play football at all, you have players
you watch and look up to. Even though I was
a young player, when I watched Highlanders
I was watching more like a fan. Being a fan
as well as a player means you are passionate
about the game.

~ BENJANI MWARUWARI ~

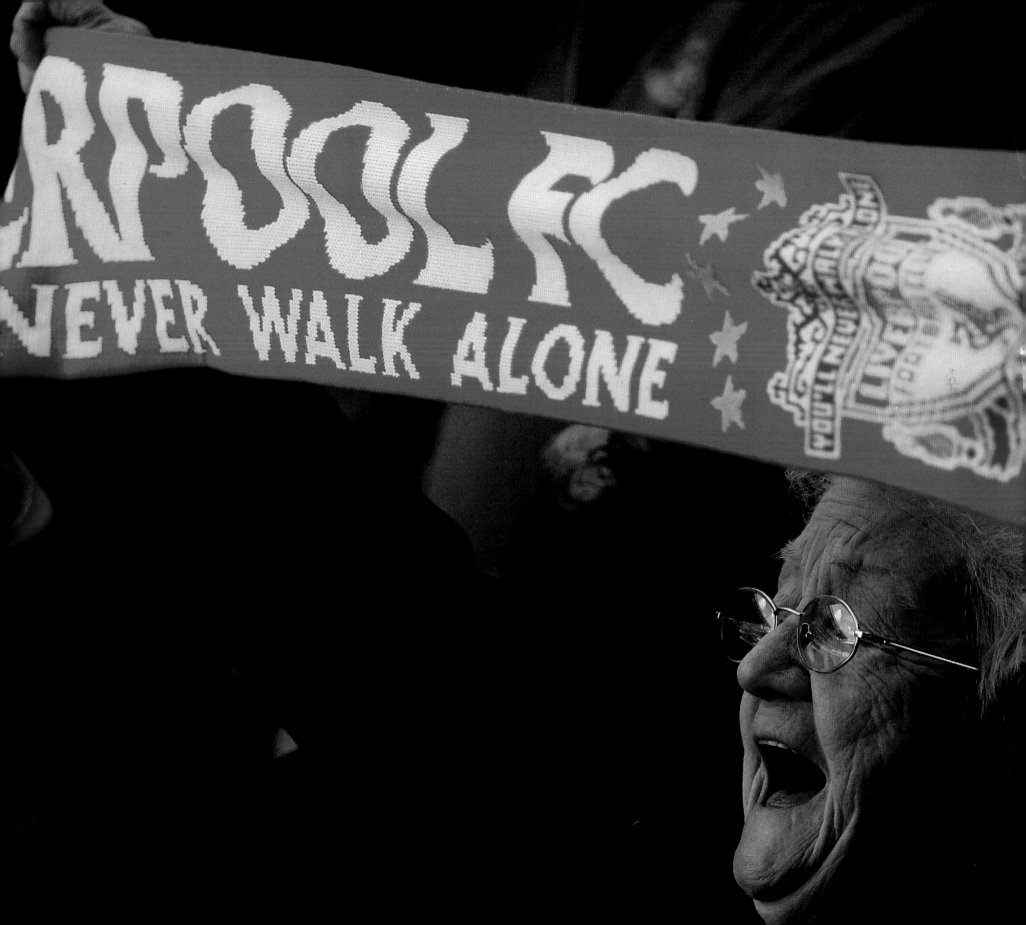

# Benjani (ZIMBABWE)

*Benjani Mwaruwari*

My parents were from Malawi originally but moved to Zimbabwe. My dad used to tell me that he'd been a goalkeeper when he was younger but he didn't want me to play football; he was always telling me that I needed to go to school and learn. He worked for a company making pharmaceuticals – tablets and things. You know, in Africa, your father is the main man and, whatever he says, you have to follow it. Here in Europe, maybe a boy has his own options, where he can say, "I don't want to do that." And he's given that respect and freedom. In Africa, what your father says is what he says, no matter what. Your father wouldn't be someone you would play with, football or anything. When Dad comes home, you're scared so you don't get the chance to say, "Let's go and kick a ball."

We lived in quite a good area of Bulawayo, a neighbourhood called Magwegwe, which wasn't too crowded. You can find a patch of ground in every township, somewhere to play just by the side of the road. As boys we used to spend a lot of time playing football, barefoot, in the streets, you know how it is. We enjoyed it and I think that's where natural talent comes out. You have no teaching, no coaching. You learn to play yourself, and then, when you go to a club and get coaching, you can see that talent come through. I can't remember when I first started playing. It feels like I've been playing forever, but it wasn't until I was 13 that I joined a local club in Bulawayo. That was when I first played in football boots. Until then, I played all my football out in the street. Most of every day.

We'd come home from school, have something to eat and then, out. We'd get together and chill, laughing and joking, and then: "What about a game of football?" I can remember, when we were a little older, we'd have games where we'd have a bet on who would win; maybe a one-dollar bet. And after a few weeks, if we won, we could combine all that money, buy some food and drinks and have a little party. It gave us something to fight for in our games. We would just organize all that ourselves. For young kids, a dollar was a lot of money. If the person who was looking after the money spent it, then there would be trouble!

I played football at school as well. I was one of the best players at my school so, looking back from where I am now, I can say maybe it's not just luck that I'm here. I did well at school and I think being a good player too gave me a respect. They knew: Benji's there, so anything's possible! We had a team for running and a team for football and we would play against other schools around the same area; then against other schools in the region, and then there was a national championship for all of Zimbabwe. We played those kind of tournaments right through primary and secondary school. We knew who the good players were from other schools and from other areas. I can still remember who some of those boys were. I hope they still remember that, from our area, there was Benji. Anyway, they knew that if I wasn't playing they had a better chance to win!

Football is definitely the national sport in Zimbabwe – a big thing for everybody, like it is everywhere. One of the biggest teams in the country, Highlanders FC, are based in Bulawayo. When I was a boy, I used to go and watch them play. I used to go along to the games on my own.

If you play football at all, you have players you watch and look up to. Even though I was a young player, when I watched Highlanders I was watching more like a fan. Being a fan as well as a player means you are passionate about the game. There were lots of players I admired back then: the best players, it didn't matter what team they played for. When I was young, Peter Ndlovu was my number-one hero.

I had my heroes, and now, I guess, I am a hero for some of the young boys playing football in Zimbabwe. And I know it's important for me to lead by example. I need to be there for them and to show them a way forward. Then it

> I had my heroes, and now, I guess, I am a hero for some of the young boys playing football in Zimbabwe. And I know it's important for me to lead by example.

means something if they say to themselves, "I play football and I want to be like Benji." That's one of the reasons why, whenever I can, even if it's just for a few days at a time, I go home. It doesn't matter how difficult things are in Zimbabwe, home is home. I still have friends from when I was playing football as a boy and, when I'm home, they come round. We chat, we chill out and we talk about our memories – good and bad – from when we played together.

Now I have children of my own I don't think about them being footballers. I think about them being whatever it is they want to be. I didn't have that freedom when I was a boy so, more than anything, I want my children to have that freedom now.

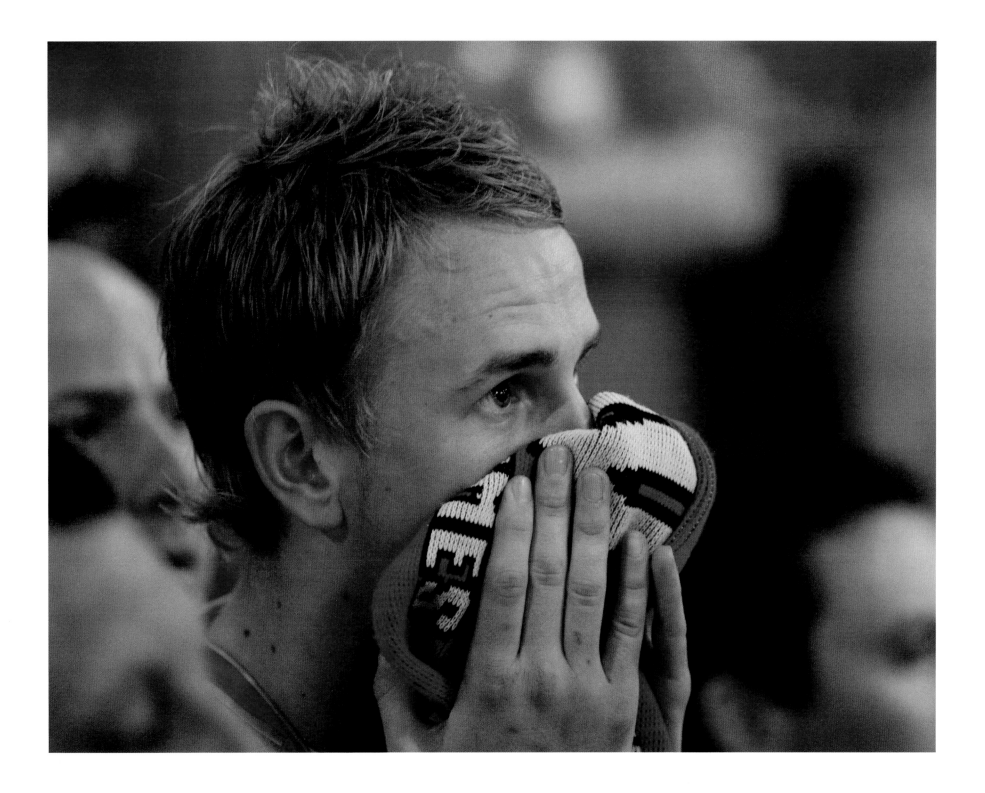

# Smertin (RUSSIA)

*Alexey Smertin*

Three years ago, I set up my own football school in my native town, Barnaul, in Siberia. We work with about 1000 children. The headquarters are in Barnaul because that's the capital of my region, the Altai Territory, but we have nine satellite schools in other towns too. I've realized that when you're young you learn more easily than when you're an adult, whether that's a foreign language or the basics of football. I wanted to create a good situation for a football education to happen in.

Children come to the school when they're six or seven years old and can stay until they're 14. The idea for the school came out of a conversation I had with Roman Abramovich, the owner of Chelsea, when I was playing for them. He has a programme in Russia building 250 artificial pitches all over the country, to be used by everyone from children to professional teams. Remember: we have snow and ice for at least half the year. Anyway, we had a game in Moscow against CSKA and Mr Abramovich came up to me and said, "I want to build something in Barnaul and I want you to look after it. Find the site and I'll build it." I spoke to my best friend, who still lives in Barnaul, and we decided to set up the school. The Altai region has a lot of talented young players. We have a lot of good coaches too. The school is to help develop the level of football there.

Any boy can come there after school. At age 12, we have a special group: a class that goes to the same school together and then comes to us to train. They're together all the time. We have a budget from the local government, so the school is free for the children. I had to pay the coaches for the first three months when we opened but now it's subsidized by the regional government. It's been a lot of work – we're having to build another pitch now because we're so busy – and I spend all my holiday time now back in Barnaul, but it's been fascinating for me. When I was a boy, our facilities were poor: pitches, balls, everything; we

didn't really have anything. All I had was a big motivation. I was inspired by football, thanks to my father.

Barnaul is a typical Siberian town: very industrial, lots and lots of factories. There's a population of around 650,000 people. And everybody loves football! We have two or three amateur leagues which run just in Barnaul; they're more organized now than when I was young. My father,

Gennady, played for an amateur team; a team from the factory in Barnaul where he worked, where they made engines for tractors. He was addicted to football.

My dad always told me he was a crap player: quick but stupid; no skill, nothing. He decided to realize his dreams for the game through his children, you know. He did well: my brother, Yevgeniy, who's six years older than me, was

a great footballer and a great example for me. He played for some of the best teams in Russia: Dynamo Moscow, Torpedo Moscow. Yevgeniy played his whole career in Russia. He's a coach in Moscow now. When he was a professional, it was difficult for Russian players to go abroad. Now, of course, it's quite easy.

Even when I was very young, five or six years old, I saw that my father was very hard on Yevgeniy; my father was like a dictator! You know, sometimes I wouldn't want to go and play football but he insisted. That's why I'd play and train every single day, often twice a day. Now, I appreciate it. It was him that pushed me into football and, thanks to him, I've achieved a lot. He started me with football when I was five or even younger. There was never any chance that I could do anything else.

When I was a boy, it was in the Soviet Union – I was born in 1975; the Soviet Union was dissolved in 1991 – so there was no professional football like there is now. So, people thought I was a fool: playing football instead of going to school. If my team had a game and it clashed with school, I'd go to the game. And my father, who was a well-known coach then in Barnaul, would write a letter, saying, "Sorry, my son cannot come to school today. He has to play football." My mum, Antonina, accepted it too, and she would put homework together for me to do at home later on instead. Football wasn't a commercial project then, a career like it is now. If you could earn any money playing, it would only be a little. But that was what my father wanted me to do.

In Russia, a typical apartment building will have nine floors. We lived on the eighth floor. My parents still live in the same flat. It's a very ordinary area with lots of apartment blocks. Sometimes, when I came in from school or training, my dad would get me to play in the flat: dribbling the ball round chairs or kicking a little ball against the

wall. The neighbours could hear the bang, bang, bang of the ball through the pipe-work in the block and would get really angry.

I used to play outside as well, especially in the winter. You can't imagine how extreme the difference in temperature is between summer and winter in Siberia. In winter it can be 30 degrees below zero. In summer it goes up into the plus 30s centigrade. A 60-degree difference! So, in wintertime, we'd play outside on the snow. Ice hockey, too; Dad said that was important for strength and fitness. We even played football on skates. You play for two hours and then, instead of going home, you'd stand around talking to your friends. It was really cold and I got ill a lot: my chest and my throat.

harsh judge. Rude, sometimes, too. A good organizer, but he would just coach one or two boys. He hadn't been trained as a coach, so he would just speak to you, two or three at a time. It came naturally to him.

I didn't fight against my father. I was scared of him: he was my dad. And he knew that. Now, I have a son who's ten years old. He spends a month every year in Barnaul and my father tries to be with him how he was with me. Except he knows that between him and his grandson, now, stands my wife! He knows he has to be a bit softer with my son because of her.

But for me, back then, he organized everything. He gave me my love of football. Sometimes I'd play against much

My father was really popular in Barnaul because he was so enthusiastic about football. I bought a flat in Moscow for them to move to but my father said, "Every dog and every drunkard knows me in Barnaul. Why would I want to leave?"

There were 20 or 30 of us boys who played all the time. My father was really popular in Barnaul because he was so enthusiastic about football. I bought a flat in Moscow for them to move to but my father said, "Every dog and every drunkard knows me in Barnaul. Why would I want to leave?" And he's stayed. Anyway, we improvised a pitch on a patch of hard ground near our building. It was terrible for your knees, your back; and for the footballs – we had to change them all the time. Our building was very popular: all the guys would come because they knew my dad would be organizing a game. He was a very

older boys. Or I would play two of us against five, just to make me tougher; to teach me how to keep the ball; to force me to work harder. Everything he did was about improving me as a player. And it worked. All the time I was growing up, I was slim like I am now. Physically, I wasn't really strong enough. But I had strength of character to make up for that; I wasn't the best player, perhaps, but I worked harder. That's what my father passed on to me. And now he brags a little. That's all right. He can be proud that he produced two good professional players: me and my brother.

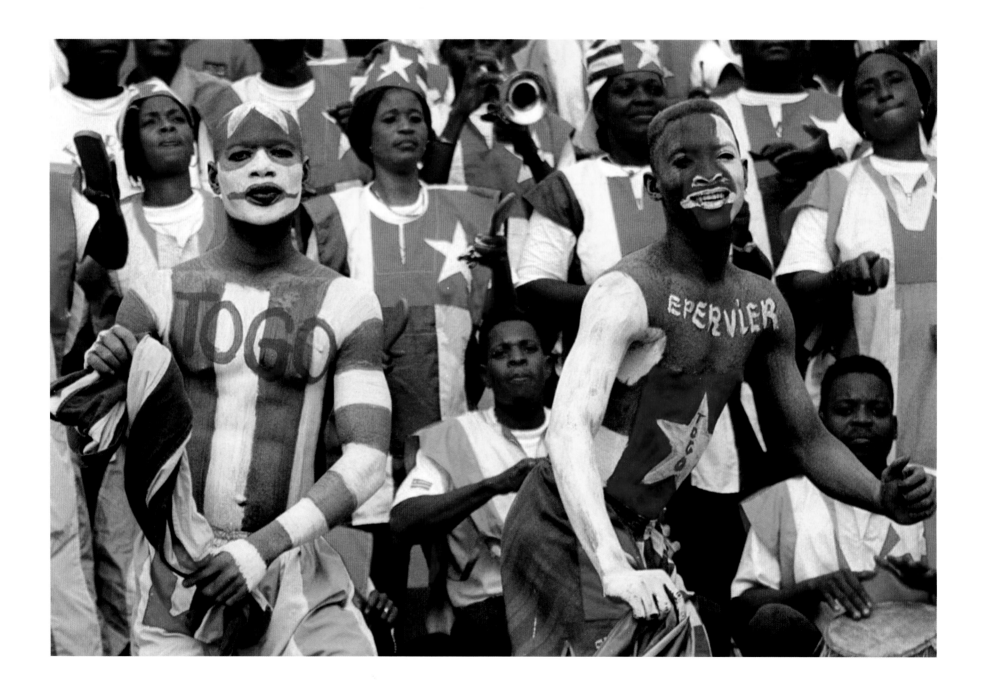

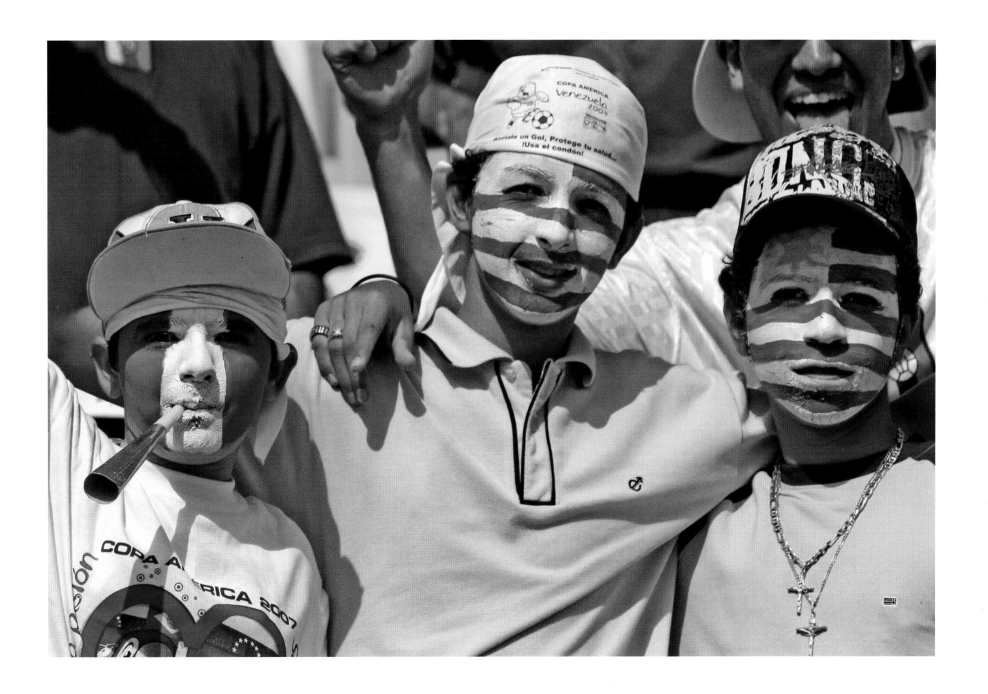

# Ribéry (FRANCE)

*Franck Ribéry*

I grew up with my parents, my two brothers and my sister in Boulogne-sur-Mer, on the northern coast of France, overlooking the Channel. It's a working-class city; you could say that, over the years, it's a place that has been undermined by high unemployment and everything that comes with that. Even so, I loved the atmosphere of Boulogne-sur-Mer while I was growing up and still do. It's the kind of community where everybody knows everybody. There's a sense of togetherness about us as people. When I was a boy, living there felt like being a part of a very big family.

Maybe the best thing about growing up in Boulogne-sur-Mer was that the town was always full of other kids! I spent almost all my time hanging out with lots of friends. I still think back a lot to those days of my childhood. Even now, I've still got lots of the same friends that I made when I was a boy. It gives me a good feeling knowing that they're always there; that they've always been there. Those friends are the ones who really understand the journey I've made in my life. They know where I've come from. And that means they are the friends who know me best.

Football was always a big thing in our city: the number one thing people loved doing and watching. Whenever there was a live game of football showing on TV, you'd find there was hardly anybody out on the streets around town. Other than watching those games, I used to spend whole days at a time kicking a ball around with my mates. We'd have games that went on for ever. And, when I was young, at bedtime I used to want to take the football to sleep with me. It goes without saying that football was a very important part of growing up. I was kicking a ball whenever and wherever I could. My dad's always reminding me: I did some real damage to the door of his garage from taking shots against it as hard as I could. That door ended up in bits. And it wasn't just footballs I'd take shots with. Anything round, anything that reminded me

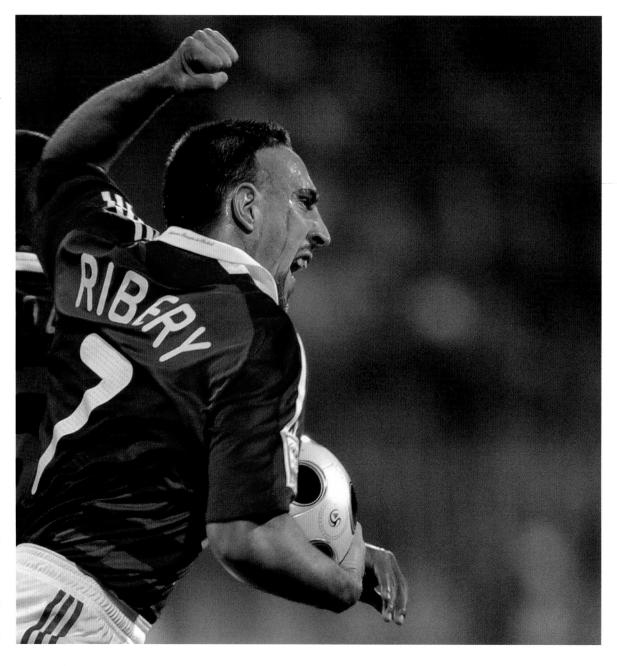

of a ball would do: an empty can or a little round stone. My first teammates and my first opponents were mates from the neighbourhood and cousins of mine who lived nearby. We played everywhere. Anywhere. In the street, of course, and in school too. We'd get a game going whenever we could during break times. After school, we'd play out in front of the apartment building where we lived, on a piece of gravel somewhere or on a flat bit of ground, just dirt that had been trodden down. It makes me smile when I go home now. The neighbourhood hasn't changed that much but they've built a nice little stadium with an artificial pitch for the kids to play on.

My whole family loved football. Dad played in the lower leagues and, every Sunday, I used to go and watch him. He played for the town team in Castors: their big rivals were Les Aiglons and FC Conti, which were the two local teams that I first played for. I think my father realized I had some ability very early on and, as soon as he did, he never stopped supporting me as I made my way in football. To be honest, the whole family was always behind me: my first supporters, my best supporters. Dad always believed in me. When clubs were turning me down early in my career, he was the one who stood by me. Neither of my parents used to tell me off; they always found a way of working through problems calmly. And, if I've got any honesty and humility in my character, it's because of the upbringing my parents gave me.

I started in organized football with little local clubs and then played for the town team in Boulogne-sur-Mer. I was about 12 when I started with them and played through the ranks until I was turning out in the third division of the national league by the time I was 17 or 18. I can still remember those games as a teenager: every game was completely committed and we fought for every single ball. They were battles! But battles played in the right spirit, I think, even though some of the lads used to

get pretty hot-tempered during them. All my friends back then were friends through football although most of them ran into problems and never broke through into the professional game.

As far as football went, the player I looked up to more than any other was probably Zinedine Zidane. But I wasn't a great one for having heroes, you know. I certainly didn't spend my childhood glued to the telly: I was too busy outdoors with my mates, playing football and having a laugh. The game was a passion for me, always. I loved it. But I never dreamt what might happen and, of course, there were lots of other things, like schoolwork, that I had to have in my mind too. I suppose it was during my adolescence that I first got the idea that football might be something

Certainly I'll never forget him: a calm, straightforward man who thought a lot of me. It was the best of times we spent together when I was a teenager.

I think, as a person, I've always been straightforward too. I've tried to be humble and always ready to learn. Even though, as I grew up, I heard people talking about me, saying how good a footballer I was and so on, I don't think I ever got big-headed about it. I don't feel as if any of that praise ever changed me as a person. I've never forgotten where I came from, the community I grew up in and my family. That's very important to me. And I have the feeling that other people are happy enough with me: they see I'm a positive person, someone who enjoys life and enjoys having a laugh. I smile every day!

## I've never forgotten where I came from, the community I grew up in and my family.

I could do as a job. But it never felt like work. Not the kind of work that people have to do every day to earn a living and get by, anyway. Yes, it's work for me but it's also a pleasure. I've always felt that way: what's mattered most to me in football has been enjoying the game.

Apart from my family, the one person who had the greatest impact on me as a young player, I think, was a man called Jacky Colinet. In fact, I developed a kind of father/son relationship with him. As far as my career is concerned, he was the guy who really discovered me. Jacky was a coach at Boulogne-sur-Mer and it was him who pushed me up through the different levels at the club. I don't think I would have made the breakthrough into national-league football without him. He pushed me in at the deep end! With his help, I got to grips with what the game was really all about. I still see Jacky whenever I can.

You know, when I was very young – two years old – I was in a car accident with my mum in Boulogne-sur-Mer. We were hit by a truck and I had to have a lot of stitches in my face. Those scars now are part of me, part of who I am. They're a sign, maybe, that I haven't always had it easy and they're a reminder of my past and of my roots. I've never felt any shame about them. The opposite: why would I want to hide myself away? I had that accident and I think, from it, I've found an inner strength sometimes when I've had to. There was a time when we were short of money and I stopped playing football. Instead, I'd get up early every morning and go to work with my dad, as a *terrassier*, to help pay the bills at home. I'm proud of all that I've done and been, but I know – from my own experience – that things can change very quickly in your life, change for better or for worse.

# Rosický (CZECH REPUBLIC)

*Tomáš Rosický*

I grew up in Prague. Prosek isn't in the centre of the city; it's just an ordinary suburban neighbourhood. We lived in a block of flats, one of a lot of blocks all quite close together. Our block was seven storeys high and we lived on the sixth floor. There was space for children to play outside, though, and in front of our block there was a football pitch, with a sand playing surface. Not sand like on a beach; this was packed down hard. You didn't want to slide into tackles on it.

My brother was a really good player, the best goal scorer at the club. He'd win Player of the Tournament awards and, soon, Sparta Prague got to hear about him and wanted to sign him. He was nine, maybe ten. They came round to our house to talk to my dad about it. Dad said, "Yes. Jirí can come to play for you but, if you want him, you have to take this younger one, Tomáš, as well." I was like a little present that came with my brother: buy one, get one free! I was with the club for the next 14 years.

then, when I was a little older and training with the club, we would sometimes go to games and be behind the barriers, as ball boys. It was a big thing, throwing the ball back to the first team players during a game. Some of them I actually went on to play for Sparta with.

Playing football was what I wanted to do more than anything. I learnt about having respect and taking responsibility – for myself and my coaches – very young. I had the example of my brother to follow. And I'd say my dad was fantastic too. He never pushed me or my brother, never put us under pressure. He was never one to tell us what we had to be doing. With football, he always left it for us to make decisions for ourselves.

> I respected my dad, and my coach at the club too. I didn't want to let them down or cheat them. But, really, I knew I didn't want to cheat myself.

The games we played out in front of the house weren't organized at all. Anybody who was there could join in. But I was always the youngest player. At first, the bigger boys would leave me alone because I was the smallest player on the pitch. But once they saw that I knew how to play, it wasn't so easy for me. We'd play on the way home from school; any time we could. Every day. I loved football from the very start.

You could say I came from a football family. My father, Jirí, played for Sparta Prague before I did. My step-brother on my mum's side played for them too. And I have a brother, also called Jirí; he's three years older than me and became a professional player as well. While I was growing up, it was natural for me to try to follow in my older brother's footsteps. Whatever Jirí was doing, I wanted to be doing as well. We played around the neighbourhood and then he joined a little local club, ČKD Kompresory, so of course I wanted to join them as well. I was five.

So I was training with Sparta Prague when I was six years old. I loved it. The coaching was great. They always made it fun. We did lots of technical work. They let us play plenty of games too, but a lot of that technical stuff is what my game is all about even now. The under-seven coach was another Jirí: Jirí Hrones. I'm still in touch with him now – he has a travel agency and I book all my flights with him. I remember him bringing in these football tapes from Holland, showing us different technical exercises. There were about 15 of us in the squad and he named every technical move on the tape after one of us – like "the Tomáš" – to help us learn them. Like I say, the coach made training fun to do. But when it came to games and tournaments, he always wanted us to win.

I was never really what you would call a football fan. If I went to a game, I was just interested to watch the football. The atmosphere and the crowd was never such a big thing for me. When I was young, my dad would sometimes take us to watch Sparta play. Of course it had to be Sparta. And

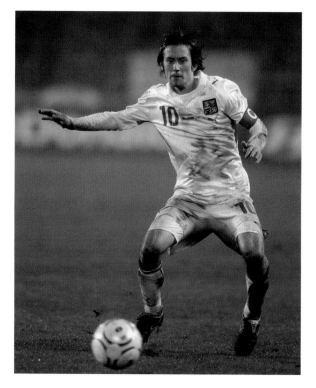

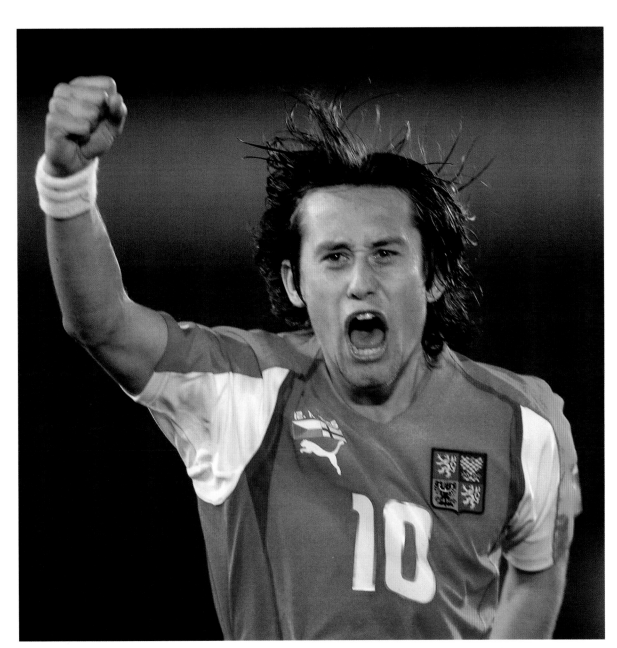

I can tell you how Dad was: I might come home from school one evening; I didn't want to go training. I'd come in saying, "I'm going out with my friends; I'm not going training tonight. I'm off to do something else." My dad wouldn't make a fuss. He'd just look at me and say, "That's fine. It's your choice. Whatever you want." He'd say it in the nicest possible way, "Well, whatever you think is right." He'd just put the responsibility back to me. I'd have to think about it for myself: "Oh, no!" And I would always end up going to training, of course.

I respected my dad, and my coach at the club too. I didn't want to let them down or cheat them. But, really, I knew I didn't want to cheat myself. Football was what I wanted to do. I played with a lot of talented boys when I was growing up; maybe boys who were more talented than me. But the difference was that they were distracted: by friends, by girls, by growing up.

Dad was always supportive. He still is. My mum, Eva, too. When we were young, it would sometimes happen that I was playing in a game on one side of the city and my brother would be playing somewhere else. My mum would go with Jirí. Dad would come with me. They both did everything they could. We'd have to get up very early in the morning to go and play in tournaments. They would get up even earlier so that food and everything else we needed was ready.

I suppose you would say my mum was there to care for us and Dad was there to give us advice. And everything I did was always with my brother. It was good because it wasn't just football: we'd play ice hockey, tennis, table tennis. Whatever we played, for me it was about competition. Jirí was older than me; maybe he was better at something than me, so I wanted to beat him, whatever we were doing. That rivalry was such a big part of me growing up.

## FRIENDSHIP

Sometimes, we'd have matches against boys from other neighbourhoods. We might see them in school and we'd say, "OK, seven-a-side on Saturday at such-and-such a place." Back then, we loved Oranzade, which is a Polish fizzy drink made with orange juice and sugar. We used to bet against the other team and whoever won would have enough money to buy a box of Oranzade. We loved that stuff. And the games were fun too.

~ ARTUR BORUC ~

# Boruc (POLAND)

*Artur Boruc*

My hometown, Siedlce, isn't far away from the Polish capital, Warsaw. Maybe 60 miles. Which is why, ever since I got interested in football as a very young lad, I supported Legia Warszawa. Siedlce itself wasn't the best place for playing football, to be honest. We didn't have good pitches or good facilities or any of that stuff. My neighbourhood was all big tower blocks and a little bit tough, you know. When I was little, the family lived together in two rooms.

There we were, seven of us in the family living in 40 square metres. It wasn't so easy but the one thing that helped me was football. It got me out of the house. You know, a crowded house is nice because you can talk to everybody, but it got suffocating. So football was a release. So was dancing, actually. I did classes and passed exams in Polish dancing. Mum wanted me to go. In the end, my football took over but, for a time, dancing was another escape.

My father, Wladyslaw, was an ice-hockey player and I think that's where my interest in sport started. I skated all the time too when I was young. The first place I remember playing football was on a patch of ground in front of our block. There were a couple of trees at one end and we put some stones down at the other end as a second goal. I was never a goalkeeper back then, though. Like every boy, I guess, I wanted to be a striker, scoring goals. The biggest, fattest boy would be the one who went in goal because it would be harder to get the ball past him.

In Poland, before every Christmas and before every big holiday, we have a tradition where everybody cleans their home. People would bring their rugs out and hang them up to beat the dust out of them with a stick. We used to use those rugs as goals, too. It was like having a net: when you scored, you didn't have to go and chase after the ball. That was just on special occasions, though. But playing football was fun all the time. Sometimes, we'd just be hanging around the block, waiting for something to happen. You know how it is, nobody around but then, all of a sudden, something happens and people are there. That's how it would be with a game of football.

When I first started playing – I was probably about five or six years old – it was with other boys who lived in my block, my best friends. My older brother, Robert, played too. He was two years older than me. I remember Robert got a football as his present for his first communion; that was a very big thing. A proper leather ball! We played with that ball non-stop for weeks until it got kicked into someone's garden who wouldn't let us have it back.

Sometimes, we'd have matches against boys from other neighbourhoods. We might see them in school and we'd say, "OK, seven-a-side on Saturday at such-and-such a place." Back then, we loved Oranzade, which is a Polish

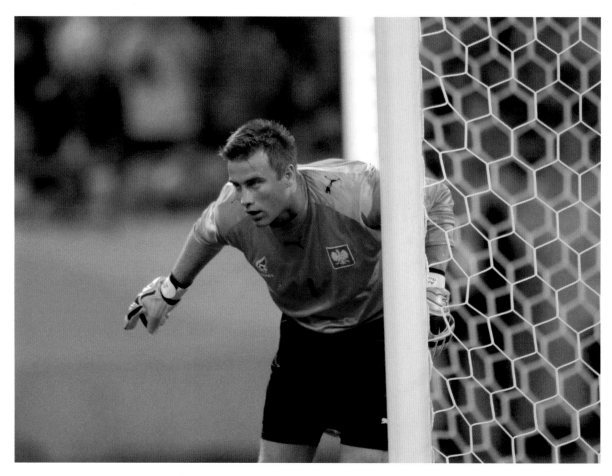

fizzy drink made with orange juice and sugar. We used to bet against the other team and whoever won would have enough money to buy a box of Oranzade. We loved that stuff. And the games were fun too. I can still remember how passionate we were about football.

When I was at primary school, I was never thinking that I might be a professional footballer. I played for the school team but I played basketball for the school too. I wasn't very focused on school, to be honest. I was more focused on enjoying life, I think, even though most boys studied hard to get qualifications so they could get out of Siedlce and go to Warsaw to work, for better money and a better life. But I wasn't thinking about a career at all, in football or anything else. That wasn't until I went to secondary school and I was 14 or 15.

Dad was OK with me playing football. But my mum, Jadwiga, wasn't happy. Nor was my grandmother, Helenka. She was always saying to me, "You're not going to eat by playing football, Artur!" My mother's dead now, but whenever I see my grandmother now, we have a laugh about that. I don't think she's too happy that I won't stop reminding her about it. Even though my dad played ice hockey for 20 years, he wasn't pleased about me missing out schoolwork either. Sometimes I'd miss school altogether, you know, just to have a bit more time having fun with a ball.

In Siedlce, there wasn't much for us to do except football. There were two big factories in the town: one manufacturing animal feed and the other producing steel for buildings and stuff. The town's more famous for its prison, I think. Siedlce has one of the hardest prisons in Poland, in the middle of the town, across the road from the little stadium where Pogoń Siedlce played, which was the first club I joined as a junior when I was about nine. Robert took me down there; and it's where I first became a goalkeeper. We'd be playing on our little pitch and we'd be able to hear the prisoners shouting out of their windows at us!

That club, Pogoń, was a third-division team. They even got relegated to the fourth division. But it was something to do on Sunday, even before I joined them, to go along and watch a game of football. Dad had friends at the club because he played ice hockey for them and he took me along. It was easier for Mum, anyway. There were five children but if Robert and I went to football she just had the three girls to look after. When it came to training with them, we didn't ever have a proper pitch to use. We'd train at a school or something like that. They have the same problem even now. There's not much money or interest in developing young players in Poland, although maybe that will change now with the EU and people returning to the country from abroad.

My first coach at Pogoń was named Józef Topczewski. I had a lot to thank him for. My parents didn't have much money but he tried to help us whenever he could. Not just me – he organized trips abroad to places like Denmark and Holland. We couldn't afford to pay for the trips but he managed to find people and sponsors who would pay for us to go. And I think that was a good experience: it's a strong motivation, seeing what other people have got when you have very little. It makes you determined to succeed and to make a better life for yourself.

Like I said, football was an escape, a way out. It was something that stopped me getting into the wrong habits, falling in with the wrong crowd. You have to have luck and I had that. I think to myself now, "What would have happened if I hadn't played football, hadn't had the chance to train and play and then eventually join Legia Warszawa?" I'd be getting up and going to work in the factory at eight o'clock in the morning, then coming

## I don't forget about my family and my old friends: I'd like to have a game with them in front of our block again, me playing centre forward instead of in goal!

home, sitting around the block, drinking a beer. I have a couple of cousins who are in that prison in Siedlce. Maybe that would have been me. But my life has changed because of football, even though I don't forget about my family and my old friends: I'd like to have a game with them in front of our block again, me playing centre forward instead of in goal!

I'm a different person because of football too. You learn things from playing the game. Maybe the most important is that it teaches you how to lose. We have a saying in Poland: "One minute you're driving the car, the next you're underneath it." You have to learn how to handle that, handle the worst moments – in a game or in your life. I'm a goalkeeper and so when you make mistakes it's obvious. Sometimes you let in a bad goal. Everything you've done before for the team counts for nothing; they're all looking at you and blaming you. It feels like life couldn't get any worse. But you have to get up again, don't you? Take the lesson for yourself, lift your head up and try to be even better.

You play football and you make friends, even when you're really young. If you both respect the game, you don't even need to speak the same language to play football together. ~ ROBIN VAN PERSIE ~

# Van Persie (NETHERLANDS)

*Robin van Persie*

Kralingen is on the east side of Rotterdam, close by the first professional club I played for: Excelsior. It's a neighbourhood with a really nice mix. On the other side of Kralingen is the rich area with the expensive houses and the wealthy lifestyles. Where we lived was OK, but it was the poorer part. My mum and dad split up when I was very young. Until I was six, I lived with my mum in the richer part of Kralingen. Then I moved in with my dad over on the other side. My parents decided that between them but, even then, I could see my mum was busy with my sisters and I thought, "I like where Dad lives. There are lots of places near him to be outside and play football." I had a great relationship with my mum and my sisters and I still do. We always spent time together. Our houses were just a walk apart. But, by the time I was six, I had settled over at my dad's: I had my life there; all my friends were there.

So, all through my youth, that's where I grew up: living with Dad, two boys together. And just two blocks away, we had a fantastic street to play football in. We called it "The Cage". It was a council playground set up for football, surrounded by nets so the ball would stay inside it. The size of the pitch was perfect for us – 25 metres from goal to goal – and it was really central, so people could come from all the neighbourhoods around to join in. I played there almost every single day. Almost all my friends were boys I met at The Cage: friends from around the world. Rotterdam is a port city so people have come from everywhere. I had friends from Holland; friends whose families came from Morocco, from Turkey, from Surinam, from the Cape Verde Islands. Those were friends from when I was very young; I started playing football in The Cage when I was seven years old.

It's a nice thing about football: because of the game, you make friends. You know, playing and growing up, you would look around the other players to see who was the best, and then there'd be this feeling of competition. Nothing would be said but you'd compete against each other and then, afterwards, you'd shake hands and you were friends. Relationships would build up from there. That's exactly what happened for me with a guy who plays professionally in Holland now, for Willem II, named Said Boutahar. Said was a really good player, one year older than me. We played for the same teams and played well together; out of that came years of a really good friendship. From age seven to age 12, we were together every day. And with just one idea in our heads: to play football.

The games we played in The Cage depended on how many people were there. There are games you can play on your own: there were benches and you could try to kick the ball against them from different distances and angles; you could kick against the wall, try keeping the ball up in the air, practise tricks. If there were two of us – say, me and Said Boutahar – there was one special game we always played. We called it "Goal to Goal". You each stand in front of one of the goals. You have to try and score in the other goal but, to do that, you can't go more than two metres away from your own. Shots from about 23 metres. You can't use your hands but you can pull yourself up on the crossbar to kick the ball away; we learnt special tricks like that to go with the game.

Goal to Goal is where I got my strong shot from: we were practising without realizing it. At eight or nine years old,

we were playing it just because it was a good game, something really competitive for just two people. I must have played Goal to Goal almost every day for two or three years. We played first player to five, or to ten or to 50. Sometimes you played using only your weaker foot. And, when you're a little boy, kicking the ball 20 metres is kicking it a long way. I wasn't thinking about developing a hard shot. I just loved that game. But, looking back, it was so important for me. That age is very important: your body's growing, and you're learning about football. You're young, so you recover quicker and you don't really have limits. The only time you stop is if something hurts; you're not thinking about eating or about anything else. Only pain stops you.

Of course, if you were in The Cage for a while, pretty soon other guys would turn up. We'd play two against two, across the pitch. There were basketball hoops on the sides of the pitch and, to score, you'd have to kick the ball against the pole: it's more difficult, more precise. You could play two-touches, three-touches, whatever you decide between you: everybody on the street knew the

> From age seven to age 12, we were together every day.
> And with just one idea in our heads: to play football.

rules of all the different games. Once there were enough of us to play four against four, everything changed. Then we'd play on the full pitch; maybe with goalies who can come out or, if there were little kids around, we'd put them in goal. Those proper games were the ones we were waiting for. It was a fantastic time.

Even after I joined Excelsior as a junior player, I still used to go to play in The Cage. I used to have a game for

Excelsior on Saturday at midday but, Friday evening, I'd still be out playing football on the street until 11 o'clock at night. I just never thought about resting; it was the joy of the game. Football made me happy and, looking back, that period – from seven until I went to high school when I was 12 – was the best time of my life. Those Friday evenings: everybody had finished work and school for the week, people didn't have club games. Everybody came to The Cage. Sundays too, especially in the summer. People would come with their own teams from other neighbourhoods. Their own goalkeepers, wearing gloves; all very professional. Sometimes there'd be 20 different teams there waiting to play, teams made up of all ages: older kids from high school, grown-ups as well. I always made sure I was in a good team. Sometimes I'd even bring boys along from my club. We'd play Friday evening and all of Sunday in The Cage and, in between, on Saturday, we'd have a really important game for Excelsior.

When did I start playing football? Well, my dad has a picture of me: I'm only just walking and the picture is me, on the beach, holding a ball; a ball that's bigger than my head. Mum and Dad say that, as soon as I could walk, I was kicking a ball. For surprise presents, my dad always used to give me balls to play with. All kinds of balls: tennis ball, table tennis ball, beach ball, volleyball; football size three, size four, size five. Balloons! It was his idea to get me used to a ball. When I was very young, he gave me a balloon to keep kicking up in the air. I tried and tried and kept bursting them but, at last, you get the timing right and I think that made a difference when it came to playing with a normal ball.

My mum and dad were both artists; they still are. Dad is a sculptor. Mum is a painter. She didn't really have a connection with football until I introduced it to her. But Dad always liked the game. He never played for a club but used

to play on the street when he was younger, with his mates. He was a real fan and would watch whoever played the best football. In Rotterdam, it's like a disease to say you support Ajax, because they're from Amsterdam. But Dad would say, "Well, I'm for Ajax because they play the best football!" Which they did at the time. He's a football fan. And he says he saw something in me when I was still young. Who can tell? Every parent sees what they want to see in their children: I think my son is the best two-year-old footballer around! But it's a long journey in football. Anything can happen on the way to a career in the game.

Maybe they had different ideas because they were artists. Dad always told me – Mum said it too – that watching TV could be a bit of a waste of time. Being active and doing things with other people was better for you as a person. So I was never really into TV. I just used to watch one football programme on Sunday night. Like *Match of the Day* in England, they used to show all the goals from the games in the Dutch league. I used to get really excited about watching those highlights but I wasn't into watching every game that was on. And the big European games came on too late at night for me. I was busy playing sport. Not just football: me and my mates went through phases, as well, when we were really into playing tennis or table tennis; swimming too. Any sport, you know; but most of it with a ball.

I think I was quite competitive with my friends and sometimes that could make things difficult. I just wanted to win every time we played – played anything – and I didn't really care about their reaction to that. A lot of my friends, like Said, were the same. Even just swimming 50 metres, I wanted to be first. Playing table tennis, if I won a game 11-3, I wanted to win the next one 11-2, 11-1, 11-nil. And I've still got some of that attitude in me now. Maybe

it's not a nice thing for other people to be around all the time: if I lost, I'd be angry, frustrated. I wanted to win. And maybe you need that desire to make it as a professional football player; you need that strength to survive the bad things that come in your life. If you collapse after the first disappointment, you'll never be a footballer. You have to come back, again and again, after a disappointment. We are all going to have them, you know. But problems are there to be solved.

I'd tell my teachers at school, "I'm going to be a footballer." From aged ten or 11, that's what I knew I wanted to be. Obviously, when you are a bit older, you realize

## I think I was quite competitive with my friends and sometimes that could make things difficult. I just wanted to win every time we played.

there are things that can come with a career in football: money, cars, fame, if that's what you like; you understand that it can make things in life easier for you and for your family. But that's just a small part of it all. Mostly, it's the same as when I was a little boy. I play football because I like the game. And because I want to be different. Not flashy; not something on my socks or with my hair. I always wanted people to look at me and say, "He does something different. There's something special about him as a player." That was always my ambition. And it pushed me on. I always wanted to do everything I could – everything I needed to do – for my team, but then I wanted to do something extra, you know. I can recognize when someone plays because they love the game. I think football fans can see that too. And they know that one thing about top players is that they never give up: they don't

make excuses or look for other people to blame when things go wrong.

You know, a great thing about growing up, playing football in The Cage: I'm really grateful I had the chance to eat food with people from Surinam, go to hang out at a Moroccan guy's house, to experience Turkish people's culture. You play football and you make friends, even when you're really young. If you both respect the game, you don't even need to speak the same language to play football together. Football is a language on its own. And it grows from football: you make friends; you see the way other people live. When you're 18, if you haven't had that

chance because you've just lived inside your own culture, how do you know how other people around you think and see the world? An interesting thing: when we were young, I think that, apart from one Dutch friend, the boys whose families had come from other countries were more competitive than the Dutch boys. And maybe that's why I was drawn to them and got to know them. We clicked. Like with Said Boutahar. And that was a blessing for me. When it was happening, I didn't really understand what was going on; I just went along with it. But, looking back, I can see now how much I learnt in that time. And not just inside The Cage. Outside it as well.

# Diarra (MALI)

*Mahamadou Diarra*

My first memory of football is playing in the street in Bamako with my friends when I was eight or nine years old. There were lots of us: 18 or 20 boys, so we could play ten against ten. Quite a lot of them have gone on to become professional players. They were the best times and the street was the best place for me to start, I think. We set out our own pitch. Put two stones down, a metre apart, to make a goal. Then two more down at the other end of the street. And then start: a game lasting two hours without a break. The best! We'd get an old ball – one that had burst – from an older brother, cut a hole in it and stuff it full with old clothes so we could keep using it. Those balls were hard. No bounce at all. But playing was easier for us then in the street. Now there are more children. We were 20, maximum. And, nowadays, the streets are full of cars in Africa too.

When I was little, I had an older brother who had a satellite dish on the TV at his house. I could go round and watch football. He'd call me up when there was a big game on. I'd sit on the floor and watch, while he told me about the big teams and the great players. I learnt about football that way. I liked Pelé. I liked Maradona; Zidane too. But, when I was a boy, a player I loved was Robert Prosinečki. I was a big fan of Olympique Marseille and I remember their European Cup final against his team, Red Star Belgrade. I remember watching. Prosinečki played so well. I said to myself, "That's the player for me." I never met Prosinečki, but I've met Pelé and Zidane. I was happy to meet them, in a way that young people are happy to meet me now.

I was lucky. The house I was born in was very close to all the football stadiums in Bamako. I used to go to the stadium to watch the Mali national team. You know, in Africa, it's different: if you are young, not yet a teenager, then you can go in gratis, if you are with someone. I would

go along and take somebody by the hand, an adult – I didn't know them – and say, "Can I come in with you?" And we would go into the ground and I'd run off. But then, if a policeman saw you on your own, he might say you had to go out. So, you'd go out, wait, and then come in again! Or you would watch to see where the policemen were and then sneak round to another entrance.

My dad was quite old – he's dead now – and he didn't play football or know anything about it. When he started to watch me playing, I would have to explain everything that was going on. And my mum never watches me play. I think it's the same for a lot of older people, older mothers anyway, in Africa. The game is tough. She doesn't want to see me suffer. Or get injured. Or even hear me swear! It's too difficult and so she's never seen me play. And washing my clothes; she knew you got dirty playing football but I was always more dirty than everybody else. Mama would say, "What kind of football are you playing?!"

Until I was ten, I didn't have any boots but then my dad bought me a pair. I was so happy that I slept cuddling them for the next two days. I went to play in them; then, when I got home, I washed them and polished them very carefully and then went to bed with them next to me. Six months later, I was selected to play for the Bamako 11-year-olds' team to play in the annual tournament: the capital against teams from the other regions. And they gave me a pair of boots. So, after all that time without, suddenly I had two new pairs of boots in one year. All my friends came round for me to show them. I let them look but I wouldn't let them borrow them. If the boots got broken, I didn't know if I would ever be able to get another pair.

There are so many people in Mali who helped me when I was young, who pushed me to succeed. You know, I went

to the Centre Salif Keita – the academy in Bamako – but, at first, I wasn't thinking about football. All I was thinking about was studying for school. I remember one of the older players there, Koly Kanté, getting me to hold a football in my two hands. He wanted me to think, to be serious about football: he said that in eight or ten years, I could be playing football in Europe.

At first I said, "No. It has to be school first and football after." But they kept with me, helped me, supported me until, eventually, I said, "OK, now I have to play." But without people's help, I would never have got to that decision: Salif Keita, Kanté, Seydou Diarra, Sambala Sissoko and Mamadou Coulibaly. Those five, back in Mali, did everything for me. Those people saw something in me that I didn't see in myself. It wasn't until much later, when I went away to play with the national under-17 team, that I realized that they were right.

I love being around youngsters. I go on vacation to Mali, back to the street I grew up on in Bamako. That street's where I first played football. The kids there see me now. They smile, they want to laugh with me, play football with me. And so we play, for five minutes or ten minutes. Then it's time for me to go but, sometimes, they don't want me to go and I find myself in the middle of a game! I know how I have to play in those games: with the ball in the air. If I play on the ground, they'll run between my legs; or kick me in the shins! I play me against five or six of them; it's funny.

The street's where I started and that's where my heart will be, always. The friends I first played with will be the same guys I finish with, too, I hope. We speak all the time and, when I'm back in Mali, we meet up to play. Nine against nine, 30 minutes each way. Each team has a captain; but not me. No. I'm the captain of Mali but, with my friends, they won't let me be captain; we grew up

## I'm the captain of Mali but, with my friends, they won't let me be captain; we grew up together and they know better!

together and they know better! We play for a side of beef which I put up instead of a cup. The winner takes the beef but, whoever wins, we all eat it together. It's a party. How can I ever forget my friends? They're really important to me. Even though, in our games now, I'm always on the losing team!

We just wanted to be outside in the fresh air, having fun with our mates, getting covered in mud: that was really the experience. It took torrential rain to stop us being outdoors. ~ RYAN NELSEN ~

# Nelsen (NEW ZEALAND)

*Ryan Nelsen*

People might not think of New Zealand as a football country at all but, at young ages, it's quite popular. It's safe for young kids to play. Rugby may be the most dominant sport but, when kids are young, the Samoan and Tongan and Maori boys tend to be a lot bigger, so some mums try to get their children to play soccer instead. My dad, Wayne, was a big rugby man and wanted me to play rugby but my mum Christine's family were into football in a big way. Her dad – my granddad – managed the New Zealand team. And her brothers had played for the national team. So football was pretty much in the blood and Mum won the argument: I wouldn't mess with her and I guess Dad didn't either!

The Port Hills are the rolling hills that surround the city of Christchurch and that's the area I grew up in. The city itself is on a sort of big grassy plain and just 30 or 40 kilometres away are the Southern Alps. You've got the sea and the coastline too. There's just everything, right there. Christchurch itself is full of parks too. I think it's in the city charter that they have to have a park for every so many square miles. It was a very cool place to grow up. Every kid's playing sport, some kind of sport, somewhere.

I can still remember the very first place I played football. Of course I can. Dad dropped me down to our local park, a place called Spreydon Domain where Christchurch United play. I must have been four or five years old. It must have been like a Fun Day put on by the club, I guess. I just remember Dad saying, "Do you want to go and have a bit of fun here, then?" And I said, "Yeah, of course!" I jumped out of the car and off I went: there were all these other kids playing, all about my age, and I just joined in.

It wasn't just football for me. I used to play rugby too. Cricket, golf even – I played everything. It's not somewhere like England, where you play football and that's

pretty much it; growing up in New Zealand, you didn't really stick to one sport. Any kind of ball, any kind of bat you could get hold of, you grabbed it and played the game. When I was young, I didn't really take football all that seriously. At school, I'd play rugby; down the park with my mates, I'd play cricket. Kicking a ball around was just another thing to be doing to be playing a sport. We just wanted to be outside in the fresh air, having fun with our mates, getting covered in mud: that was really the experience. It took torrential rain to stop us being outdoors.

I can still remember we'd come back into class after the lunch break and we'd be drenched in sweat, muddy, socks ripped, shirts ripped.

As soon as school ended every day, we'd go off to a park or stay in the schoolyard or meet up at someone's place and wouldn't get home until it was dark. When night came down, you knew it was time to run home and get your tea. Back then, as long as we were in before dark, our parents wouldn't be worried about where we were. That was how it was all the time: playing in the street, playing in the park. In New Zealand, everybody's outdoors: adults are out walking or running or biking as well. It's an outdoor culture. Maybe it was a more innocent time then but, even when I go back now, I see everybody out, doing something. And the kids are still out in the parks playing sport. That's just how the country is.

It was the same during school time too. Touch rugby was the thing then. I can still remember we'd come back into class after the lunch break and we'd be drenched in sweat, muddy, socks ripped, shirts ripped. Those poor teachers! I went to an all boys' school. Every one of us stank. Those

teachers must have gone through hell. But those schoolboys I grew up with are still my friends. I've just been best man at the wedding of a guy who I've known for more than 25 years. We were kicking a ball around together when we were four.

We've a lot of ex-pats in New Zealand, a lot of English, Scottish and Irish. We're brought up with a lot of that culture. The English Premier League – it was the old First Division when I was a boy – was really highly respected.

People were interested in it: I can remember we used to watch a TV highlights show called *Big League Soccer*. That and the FA Cup final. That was all we got but it was enough to whet your appetite. The papers used to report English football too, because the ex-pats wanted to read about it. A lot of us are second- or third-generation Brits. We always had those close ties.

I'm playing in England now and I've got a little boy. Maybe, 30 years on, he's going to be missing out on some of the freedom I had when I was growing up. Then again, I look back and wonder if maybe us just cruising around having fun *wasn't* the safest thing in the world: or is that just a parent talking now? Anyway, my son's time will come; he'll be involved in plenty of sport. He'll have his opportunities. Maybe the difference will be that it'll be more organized instead of how it was for us, out in the park on our own, with a couple of trees – or maybe a couple of shoes – that we'd use as our goals.

# Metzelder (GERMANY)

*Christoph Metzelder*

Haltern is a small town, in between Essen and Münster, in the west of Germany. That's where I grew up with my mum, dad and three brothers. That's where I started playing football too. Haltern is on the edge of the Ruhr, which has always been a heavy industrial area; the region is changing now but it's still influenced by that history. Haltern, though, is in the countryside, very green and with a population of only maybe 30,000; it's somewhere people who live in the big cities in the Ruhr come for weekends and holidays, to enjoy the woods and the lakes. It's a place to relax and a place to enjoy nature. That made it a very nice place for a boy to grow up.

My parents were both teachers, although I never went to their schools; which I think was wise! But that's how we came to live where we did. Haltern was perfect for us as kids: we were close to big cities, but where we lived was green and we could be outside all the time. Sport was always a big part of life in our family. My father had been an athlete when he was younger, back in the 1950s: a middle-distance runner. So we all started very young; with kids' gymnastics – and with athletics as well – at a local club.

One of my best friends in kindergarten was a boy named Thomas. He played football. My father wasn't so sure about the game: football is a contact sport, it's a battle and there's a greater risk of injury than many other sports. But he let me go along with my friend to one training session; and that was it! I started playing regularly with a little group of friends. I was six. Then my younger brother, Malte, started playing as well. Although Haltern is a small town, all over Germany there are many, many sports clubs; different clubs for different sports. We had eight or nine football clubs just in our town. I started with the biggest: TuS Haltern. And I stayed there until I left to start a professional career.

There are thousands of clubs like TuS in Germany; they're small clubs so, you can imagine, the buildings and the pitches aren't perfect. But we were lucky because we had the right coaches teaching and taking care of us as players. They did a really great job. In the last ten years, four professional Bundesliga players have come out of that one club, including me and my little brother. I don't think there is another club anywhere in Germany where they've done that. If it's one or two players, that's down to chance. Maybe it's a good region for talented players. But four players in ten years? The one thing I can say for certain is that we had great coaching and always produced very competitive teams, from six years old and upwards.

For four or five years, we were coached by a man named Uwe Göttig. We trained twice a week and played games at the weekend. There were two aspects to the coaching at TuS. One was to give us an idea of the game. Uwe Göttig always tried to get us to play proper football. Even defenders: we learnt not just to kick the ball away anywhere; we learnt to pass it out from the back. The other was taking care of us as a group. We had maybe ten very good players and then some others who weren't so good or, at least, not at the same level. But the idea was that everyone played. Even in important games, Uwe Göttig would change players round so everybody got a chance. He was always thinking about us as a group.

I played away from the club as well, of course. There were little pitches near where we lived and we'd play: me, my brother and our friends. We'd play in the garden too: at home, there were four of us so we could play two against two. That garden suffered a lot over the years. There was a street near us, too, which was blocked off so that cars could park there but they couldn't drive through. The garden, the street: we could play football all day. And, of course, we played at break time in school as well. We

trained and learned at the club and then came home and played just for fun, trying out the tricks we'd been taught.

That was the big moment for me: going along to train that one time with Thomas. You go and you enjoy it and everything follows from there. But if I hadn't enjoyed it that first time? I think football is an easy game; I mean "easy" because you can play it anywhere: all you need, anywhere in the world, is a patch of ground to play on. That's all you need to get a feel for the game. Then you have a team, a group of boys around the same age and, because you're all from the same place, you're mostly friends as well. And then you win games and enjoy success together. It's the perfect combination of things when you're growing up, I think.

I don't think you are born as a football player. What you may be born with is a talent for being able to move and an ability to learn new movements very quickly. Then it's just one moment, one chance, which can decide which sport you're going to take up. My dad, Hans Alwin, was a sportsman. He chose athletics but he saw the same enthusiasm in me for football that he had had as a boy for his sport. He supported me. Mum did, too, and she enjoyed it, I think. She enjoyed our games but also enjoyed being with the other parents who came along. In a small town, that was a big social network. And then there was Malte, my brother. He was younger so, as we moved through the age groups, every two years we would be playing in the same teams. There was a little bit of competition between us, of course, and that was a good thing for both of us, I think.

There is a time for every boy who plays football, around 13 or 14, when he has to decide: do I want this game to be a hobby, something I enjoy, but do I also want to go out with my friends and do other things at the weekend? Or,

do I want to reach my goals, do everything I can to succeed in football? Society in Germany has changed a lot. There are so many other things for young people to do with their time; it's a problem for sport in general in the country, not just football. It's perhaps become more difficult to find and develop talent, but I think that, in the past few years, having nearly ten years at TuS, playing alongside my friends. I'm still in touch with Thomas, who took me with him to training that very first time. And I'm still in touch with my club in Haltern. Whenever I'm visiting back in Germany, my brother and some friends and I do what we can to help TuS. We are trying to improve the facilities

I think football is an easy game; I mean "easy" because you can play it anywhere: all you need, anywhere in the world, is a patch of ground to play on. That's all you need to get a feel for the game. Then you have a team, a group of boys around the same age and, because you're all from the same place, you're mostly friends as well. And then you win games and enjoy success together. It's the perfect combination of things when you're growing up, I think.

the German Football Federation has spent a lot of money on trying to improve the situation, bringing boys into professional clubs at six or seven years old. Back when I was a boy, I was just lucky I had such a good coach at TuS Haltern. Now, perhaps, there would be more chance for a boy to learn and get proper coaching at a young age.

Maybe it would have been better for me as a player to have been with a big club earlier on, but, as a person, I think my experience at my local club was a very important thing in my life. I'm happy with how things went,

and set up a more professional structure. That's to give something back to the club, obviously, but there's more to it than that. I'm 28 now, so I have a few years ahead of me. But I'm interested in football in general and, when I finish as a player, I would want to stay in the game, in management or administration. So, what I'm doing at my local club now is finding out how a club is structured and run, getting a little experience of that. I learnt a lot about how to be a footballer at TuS Haltern, and now I'm back there learning some of what I will need to know after I finish playing the game.

## HUMANITY

We represent our country as players but also
as people: people who need food, medicine,
sanitation, education. Football has been a way
of lifting up communities like the one I grew
up in. There's even a saying now in Valle del
Chota: "Play football or remain forgotten."

~ ULISES DE LA CRUZ ~

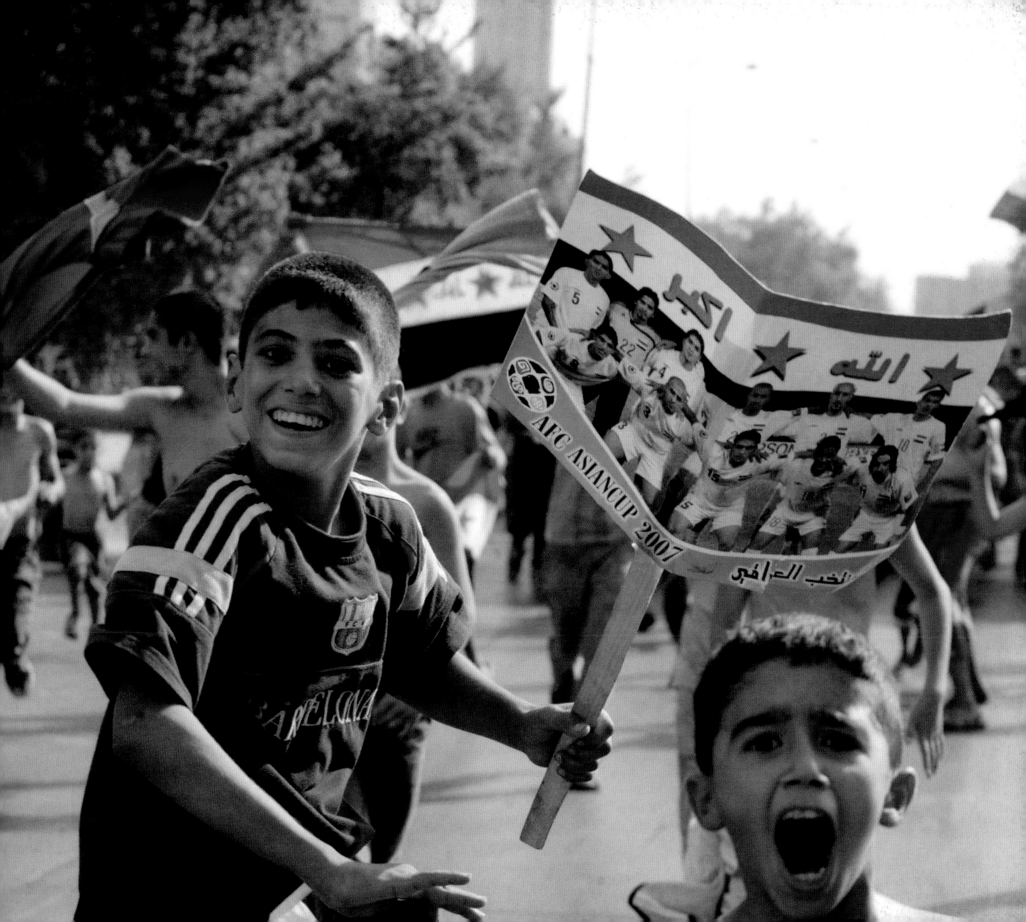

# De La Cruz (ECUADOR)

*Ulises de la Cruz*

I grew up in Piquiucho, in the north of Ecuador up by the border with Colombia. We're one of a dozen villages in the Valle del Chota, a farming region where the sun beats down all day. We are *morenos*; black people. The Valle del Chota is a forgotten area, really. The government hasn't done anything there for the people; there's no work, no sanitation, no medical facilities and little education. We are a people who have lived at the margin for two hundred years and ignorance has beaten us down. The lack of education has maybe made us accept our fate as an abandoned people.

So, when I started playing football in my village, it wasn't with the thought, "I'll become a professional footballer." I didn't have a role model or an idea where the game could take me. I just liked playing football. It was fun. It was a way of having a childhood. We played at school every day; it cost us nothing. We could find a plastic ball or a bundle of rags and we'd play out in the playground every break until the teacher came to drag us inside. The best players would choose the teams: three-a-side, four-a-side, 11-a-side, however many wanted to play. Girls too. Some of the girls were very good players, great ability and skill with the ball.

We didn't have TV in Piquiucho, so we didn't see people playing professional football. For us it was a natural passion we had inside us: come to Piquiucho any time, throw down a ball in the street and all the children will come to play, play football barefoot in the dust. And they're all good players. After school, we'd go down to the river and play on the sand. The teams were more organized and we would play against other villages. There were little tournaments between different schools too, but no football coaching. The teachers would perhaps do some preparation for the tournaments: "OK everybody, just run around!"

I remember everything from those days: the guy who was good who I wanted to get the better of; the guy on the other team you had to look out for. I remember my teammates too, and my friends; my friends who I had to have in my team because they were my friends even though it meant we lost the game! But when I was about ten there was another village nearby, Juncal, which had a better team and they came looking for me to play for them. They had two players who went on to play in England too, with Southampton: Augustin Delgado and Cléber Chalá. So, after school, I'd walk the mile or so to go and play for Juncal. The people in Piquiucho weren't very happy about it. And, one day, there was a game between the two villages. Who would I play for? Well, of course, I played for the better team: Juncal. I couldn't go out of my house for days afterwards.

We didn't have TV back then, so we would be lucky if we heard some commentary from the Copa Libertadores on the radio: "The ball's ten metres from the goal." How close was that? We didn't know whether to be excited or not! Now, of course, all the children in Piquiucho know about every team in the world. They can watch the games. And, most important, Ecuador has been in two World Cups, and the significance of that goes beyond football for us. We represent our country as players but also as people: people who need food, medicine, sanitation, education. Football has been a way of lifting up communities like the one I grew up in. There's even a saying now in Valle del Chota: "Play football or remain forgotten."

Black people in Ecuador don't have a history of social acceptance. There's a racial tension in the country but, again, success in football has changed the way we are perceived as black players and black athletes. If we hadn't got to those World Cups and given everybody joy by doing that, it would have been much harder for a change

in attitude to happen. Football is one of the only ways people from the lowest social classes and people who are black can earn recognition in Ecuador.

Of course, all that wasn't in my head when I was five or six years old. In fact, it couldn't be until I moved away and found the vision and the words to express it. Anyway,

Black people in Ecuador don't have a history of social acceptance. There's a racial tension in the country but, again, success in football has changed the way we are perceived as black players and black athletes.

when I was a little boy we had other things than football to think about: helping our parents to work, wondering if there would be something to eat at the end of the day. When it came to playing football, the dream couldn't be too big or too far away: maybe to go to the capital, Quito; maybe to be able to buy an apartment or a car.

I've come to Europe to play. I see the opportunities children have here; I know how difficult it is for children in Ecuador unless they live in Quito or they are from a wealthy family; and I've read and studied a lot about how society works. Six years ago, I decided that I had to make a commitment to society, to my pueblo. I have set up a foundation, a privately funded foundation, to take on projects in Piquiucho and the Valle del Chota. I've had help from banks and other businesses here and we have dug irrigation ditches to stop the village flooding. We've put in clean drinking water, built a sports centre and a medical centre. I'm working with a German company to build a field hospital for the Valle del Chota. Football has

given me so much, has enabled me to do so much. So how can I help? That's what gives a meaning to my life.

When I go home to Piquiucho, the children are still playing football in the street. And I play with them. They love that and so do I. At the school, the playground isn't dust any more; they've paved it over. But it's the same place I played. And now they have the sports centre too. I am a role model, a mirror for those children – part of an Ecuador team which has played at the World Cup. That success is something close to home now for them.

But what is important to me is that it shouldn't just be football which can be an ambition for the children from Valle del Chota. When I go back, I take a tape recorder and interview the children from my village. When I was a kid, if you saw a plate full of food in front of you, that was enough. Now, the children tell me they want to be doctors, teachers, footballers, professional people who can help their families. You know, that's what I'm committed to helping. And why I'm grateful to football: it's made it possible for me to do something. A child having those ambitions in life is how it will be possible to change the history of my people.

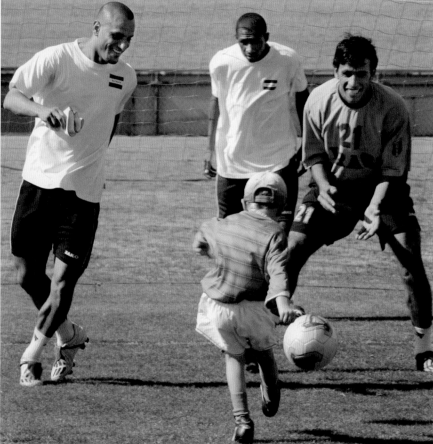

Football has given me so much, has enabled me to do so much. So how can I help? That's what gives a meaning to my life. ~ ULISES DE LA CRUZ ~

# Kanu (NIGERIA)

*Nwankwo Kanu*

I was born in Owerri and grew up in the east of Nigeria, in Imo State. You could say I was a "street boy": we grew up on the street, played on the street, did everything out on the street. It was a difficult life altogether, but that's how we grew up. My family was an ordinary family: my dad was a civil servant before he retired and my mum worked too. We could not always get three meals in a day; sometimes we'd struggle. But we always had soccer: something that everybody, especially in Nigeria, loves. It's something that pulls the whole country together, something that can bring peace and unity to Nigeria. When there's a World Cup or Africa Cup of Nations, everybody's into it: young and old, rich and poor. It's like a festival going on. Everybody wanting the Super Eagles to win.

When you're growing up, you have your heroes and you hear about people going off to other countries to play football but, when you're so young, you're not thinking about that. You just play. No referee, no rules. And when I say we played in the street, I mean in the road, with cars going past. We would just put things down to make goalposts and play with a rubber ball. If you were lucky, it might be like a tennis ball; something perfectly round. But often the ball wouldn't be like that. You wouldn't know where it was going to bounce. And maybe that helped us. We didn't realize it then but, looking back, maybe it was using a ball that we couldn't figure out where it would bounce next which helped us with our skills and ball control.

We had our own little stretch of street where we always played. Tetlow Street, people called it. Other boys knew where it was and would come there too. You knew everybody there and everybody knew you. We would take a stretch of the street, put posts down at each end and then, if a car came, someone would call out and we'd have to stop to let it pass. Weekends were the best time, especially Sundays, when everybody goes to church so the roads are

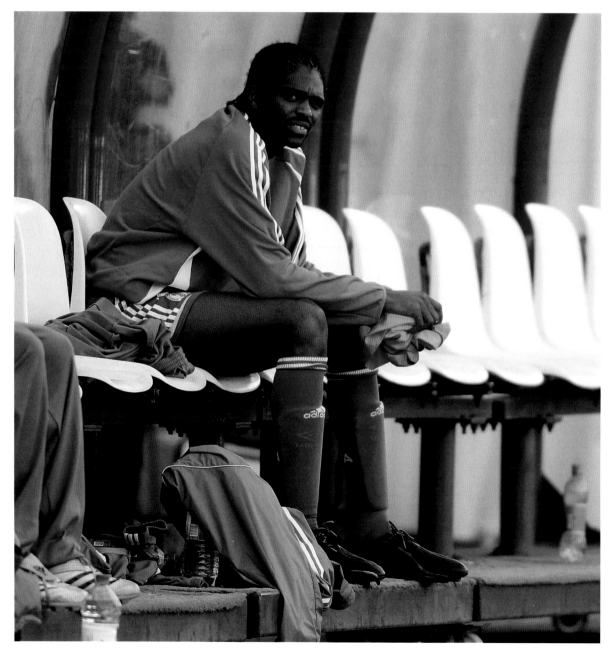

really quiet. Sometimes we might have enough players to make three teams so whoever wins a game stays on for the next one. And it was always good if you had the ball. We all wanted to play so, if you had a ball your parents had given you, nobody would say anything bad or stop you playing because, if they did, you could pick up your ball and go home!

Sometimes we would go to play on a "field", usually at a school nearby. That's a pitch, but I don't mean a pitch like at a professional club in Europe. Those are beautiful: green and flat. At home, it would be a hard, dry surface. Every time you fell over, you'd get cuts and grazes. But we'd run around, we'd play just because we loved the game. You wouldn't even feel those scratches. We were full of energy and we'd play from morning until night unless our parents shouted at us to come inside. We'd forget everything; forget to eat. Quick: get a little snack and a drink and then play again! I didn't have any kind of coaching until I was about 11. When you are younger, seven or eight, you just play and whatever skill is inside you can grow.

I played at school too. You know, if you have skills from an early age, people notice you. They tell you how good you are. And then, when it comes to games and selecting a team, they pick you first. That gives you confidence and encouragement. It gives you status too. Even if you arrive late at a game, they say, "Oh, it's you!" And they take you for the team. That gives you confidence for football and for the rest of your life too.

My dad played football – and lawn tennis as well – and so did my brothers. My dad was chairman of our local club, Spartans, for a while. But back when I was a boy, people didn't think of football as a career. Only one or two players, like Stephen Keshi, had gone to Europe to play. Sometimes boys would get in trouble for playing football: parents wanted their children to read their books and study. Most Nigerian footballers don't come from families who have a lot of money. The poorer families need their children to help out, to go on the street to sell stuff and do their bit to raise money to help and support the family. So, you see, they can't just be playing football all the time. I read my books and did my schoolwork. My dad wanted me to be an engineer. But, eventually, I was spotted for footballing talent.

I go back to Nigeria now and I still see boys playing football in the street just like we used to. What's different now is that people have seen what Nigerian players have achieved and, these days, everybody definitely wants to play football. It's a bit different now. Kids see what football can do for them: "I want to do what Kanu has done!" Parents think, "Football is something my boy can do, something he can do to earn a living." You'll have trials for a local team and 1000 boys will be there. I guess a person like me, now, is a role model. Nigeria is a big country: 145 million people. So imagine what it's like to stand up and everybody knows you. Kids want to speak to you, find out what makes you tick, how it has happened for you. It's important that I give something back. That's why I wanted to work with UNICEF, why I set up my Heart Foundation.

the end of every season in Europe, I gather up all the kit – shirts and boots – I can and take it all home for the boys. There's a lot of talent in Nigeria. Some of it is hidden away, out in villages nobody knows about. Their families don't have the money to bring them into the city to be spotted. My idea is to give kids the chance to train and play and allow their talent to come through. I want them to have the chance to show people how good they are. I want to pass that on.

I can still remember the boys I played football with when I was little. There was one, a boy named Uchenna: we called him "Lefty". We used to hang out a lot, playing football all the time. When I go home to Owerri, I still see some of those guys. And we still play. Some of them have moved away, some are still there. But you don't forget your roots and we get together, eat, drink, hang out. And, at the weekend, we play football together, for fun. We go and find a school field and have a game. And we remember the old days because loving football starts when you are young. Look at boys when they play: clothes all dirty; then they're washed at night before they put them on next day, and get them dirty all over again. All they're thinking of is to play football. They don't even think about eating. Football's their food.

> Look at boys when they play: clothes all dirty; then they're washed at night before they put them on next day, and get them dirty all over again. All they're thinking of is to play football. They don't even think about eating. Football's their food.

I have also set up a little academy back in my home state, Imo, so boys can have what they need to be able to play. At

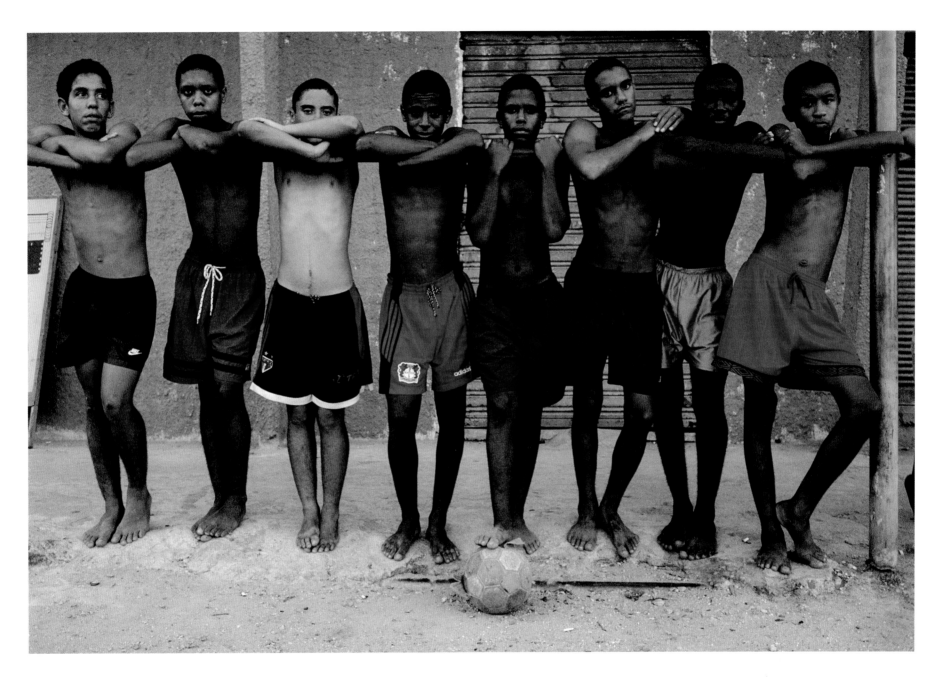

We could not always get three meals in a day; sometimes we'd struggle. But we always had soccer: something that everybody, especially in Nigeria, loves. It's something that pulls the whole country together, something that can bring peace and unity to Nigeria. When there's a World Cup or Africa Cup of Nations, everybody's into it: young and old, rich and poor. ~ NWANKWO KANU ~

# Schwarzer (AUSTRALIA)

*Mark Schwarzer*

My parents emigrated to Australia from Germany in 1966. My sister was born in 1969 and I was born in 1972 and then my younger brother was born quite a bit later, in 1982. My dad had always had the urge to leave Germany. Before they were married, he told my mum that he'd applied to go to three countries and the one that answered first was the one he was going to go to: "If you won't come with me, we might as well not get married!" Australia was the first to reply and the tickets for the boat were there in the envelope with the letter, the one condition being that they'd have to stay at least two years. My dad loved it from day one although it wasn't as straightforward for Mum. She didn't have a job to start with and then she was pregnant with my sister and me. It wasn't until later that she was able to go back to work.

When I was born we were living in North Richmond, which is a suburb about 60 kilometres west of Sydney, in New South Wales. Nowadays it takes an hour and a half or two hours to get into the city. When I was a boy, it was more like an hour. There's been that big a build-up in the population in the last 20 years, lots of new suburbs have grown up in between. When I was still very young, we moved further out to another suburb, Grose Wold, between North Richmond and a place called Kurrajong, which is in the Blue Mountains. Dad was a bricklayer and my parents bought a five-acre plot of land and built their own house.

Grose Wold was pretty rural, a fantastic place to grow up, really, but I suppose it's natural, when you're young, to yearn a bit for what you don't have: I always wished we were closer to the beach and to the middle of Sydney. It used to take me 45 minutes to get to school. The bus would pick me up first in the morning and then go the longest possible route round, picking up all the other kids on the way. And then, on the way home, I was the last person to get off the bus. You know, if I wanted to go to a friend's house, I couldn't usually just get on my bike and ride round there; I'd have to wait to get driven.

My dad brought a passion for football with him from Germany. He'd always been a fan; his team was VfB Stuttgart. He enjoyed watching other sports, like rugby league, rugby and cricket – the one-day games, anyway – and he was a diehard supporter of Australian teams. He thought of himself, first and foremost, as an Australian. But the first sport he introduced me to was football. I think he gave me a ball when I was very, very young and he never really wanted me to play any other sports. He was playing himself for a little local club called Colo, who are still going strong today. I think they have something like a thousand kids playing at all different ages and levels. Dad took me along to Colo to train with the juniors when I was seven and I played there until I was 11.

Colo was my very first club. In fact, I don't really remember much about playing football at all before then although I guess I must have, out in the paddock at home, kicking around with my dad. We certainly didn't have a team at school at that age. There were some kids at the club who I knew from school and others who went to different schools but, you know, football's a great thing for breaking down any barriers between kids, any insecurities they might have. We used to train once a week and play games at the weekend. It was usually a parent who took us for training; my dad coached the team on and off through that time, usually when there wasn't anybody else to do it. It was tough for him to fit it in around his work but, then again, he was mad about football! He'd try to teach us stuff that he'd picked up but, at that age, all we really wanted to be doing was playing.

Right from the start, the games we used to have against other local teams were very competitive. Back then, it was never a case of: "Oh, as long as you play and enjoy it, it doesn't matter if you lose." It was all about winning and being successful. I still believe in that now. Obviously kids have to learn about losing. That's the great thing about football: most teams don't win every week and kids need to know what defeat feels like. But I think they need to be competitive and play the game to win, even from a very early age. Anyway, the club was great for me. Not just from the football point of view but it meant I met lots of other kids and made new friends. We'd maybe go round to each other's houses after games or our parents would pick us up together on the way to matches. I think at that age it's the same for most kids: it's about the game but it's about the socializing as well.

I was an outfield player then. I didn't go in goal until I was about ten years old. Nobody really liked going in goal. One week we'd win four- or five-nil. The next week we might lose four- or five-nil. Either way, it wasn't that much fun for the goalie, who'd often be the one who got blamed if things went wrong too. Anyway, my dad was coaching us at the time and he made me go in: "You're my son; you've got to do it!" We had arguments about it all the time: before training, during training, on the way home. Sometimes we'd compromise and, if we were doing really well in a game and winning, he might get someone else to go in goal second half. Then I started playing for both the first 11 and the seconds, who'd play their games one after the other. I'd go in goal for the first game and then play out on the pitch in the next.

When I first went to Colo High School, which was a state school on the edge of North Richmond, it wasn't really the best when it came to the school football team. But there was a group of us who came through together who were full into the game. One of the other boys' fathers was English and had played professionally before emigrating.

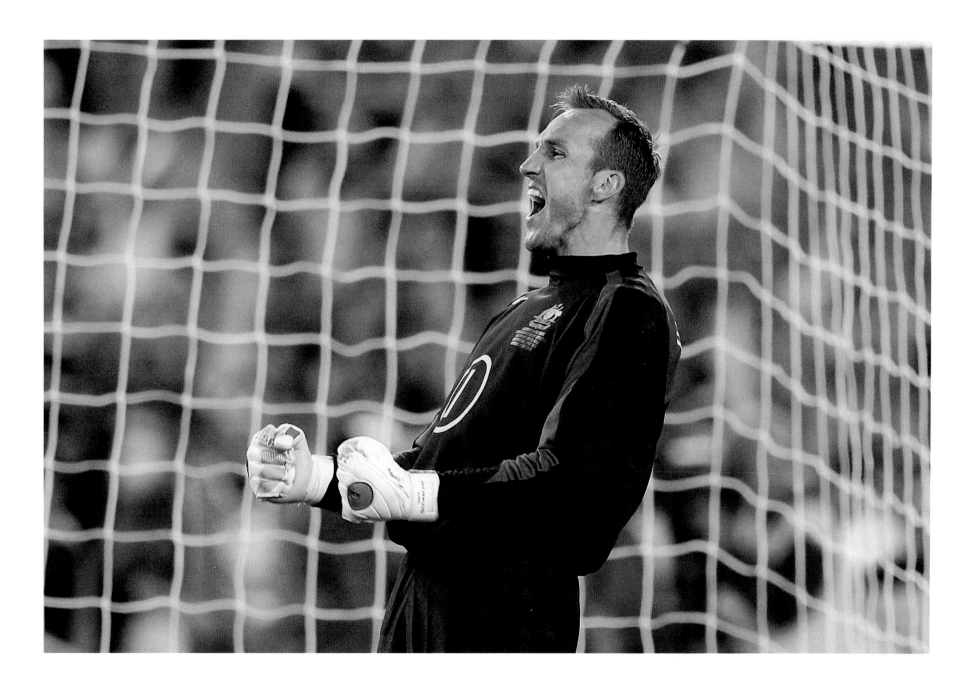

He was also heavily involved with the Colo football club I played for. He used to train us; we pestered him all the time. We had a spell of being pretty successful and a lot of us being picked for representative sides. Obviously, the school loved that. We played all the time: every break, every lunch time, on the concrete outside. I remember these yo-yos which were made in the shape of a football, little hard plastic things. But they were round and so we'd take the string off and play football with them. Brick walls all around, toilet doors for a goal at one end, jackets down at the other. We'd turn up for class with the sweat dripping off us. We were mad for it.

My friends came from school and from football rather than from the immediate neighbourhood. When mates did come over, though, we had plenty of room outside for football and we played all the time. We had goals – nets, as well! – set up in the paddock and could mess around out there, shooting and crossing, pretending to be famous players of that era. Of course, Australia had only reached a World Cup finals once, in 1974, and I didn't know about any of those players. I wasn't aware of the Australian national team; I knew more about the West German national team. Me and Dad used to watch them on TV at World Cups and European championships. My heroes were guys like Karl-Heinz Rummenigge and then, at Italia 90, Jürgen Klinsmann, and Rudi Völler and Matthäus and Brehme. Andreas Brehme I actually went on to play with, six or seven years later, at Kaiserslautern in Germany.

All of that, though – World Cups and professional football – seemed like a world away. It wasn't something I ever contemplated when I was growing up. I didn't even think of those players I watched on TV as professionals. My dad never talked about that, never asked me if I wanted to be a professional player one day. The last five or ten years, it's

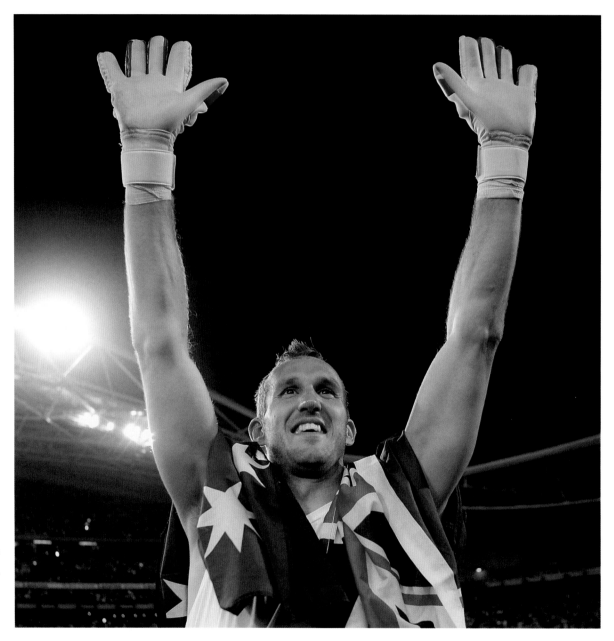

now very different for youngsters. There are Australian players in leagues all over the world and kids grow up thinking they could be the next Harry Kewell or the next Mark Viduka. Those same kids have watched us play at the World Cup. But back then? If you wanted to play sport professionally, rugby league was the thing. I loved the game: I used to forge Mum and Dad's signatures on the parental consent forms so I could play for my school. I even got asked to try out for representative sides but had to say, "Hey, look. Thanks a lot, but my dad would kill me if he knew I was playing at all!"

Football as a career wasn't something I thought about. I don't know, I guess I probably wanted to be a policeman or a marine biologist or something! It wasn't until I was 15 that I decided I wanted to be a footballer. I had a defining moment. We were in Scotland for the Under-16 World Cup. We were going to have our first game – against East Germany – at Aberdeen's ground, Pittodrie and, a couple of days before, on the way to training, our coach took us to have a look around the stadium. We were excited, of course, to look round a real professional club, to see their trophy room and everything else. We walked out of the tunnel and on to the pitch and just froze: the Great Man, Pelé, was out there in the centre circle with all these photographers clustered around him. We just sprinted across to get the chance to meet him and he was fantastic. Photographs, autographs: he was so friendly and willing to do everything. And a photo of me and another young goalkeeper, Zeljko Kalac, who's at AC Milan now, standing with Pelé in between us – we were both already much taller than him! – appeared on the cover of *World Soccer*. We were the first Australians ever to be on the cover of that magazine: it was a pretty big deal at the time. Playing in the tournament and meeting Pelé was the tipping point. It wasn't until then that I knew football was what I wanted to do.

All the time I was growing up, Australian football clubs were almost all orientated towards one particular European immigrant community or another. The first big club I played for – when I was about 14 – was called Marconi, an Italian-backed club. The name tells you. Even a club with a very Australian name, like Wollongong Wolves, was actually set up and backed by ex-pats from England. You know: the Greeks would play against the Serbs and against the Macedonians and the Maltese and the Italians; it was massive. Colo was probably the only

## The team out on the pitch was made up of players from so many different cultural backgrounds but all united and all Australian.

"Australian" team I ever played for and they were just competing in a little local league. My neighbourhood and my school were full of "Kylies" and "Adams" and "Scotts" and "Bretts" rather than the children of new immigrants. There were probably only about ten of us out of 1000 kids on the roll. When I started to move on as a player, though, it was with clubs which had been set up as a way for immigrants to stay in touch with their ethnic roots.

The new pro league in Australia now has tried to move away from those ethnic backgrounds, with clubs which are all first and foremost Australian. Football is a great way, though, for newcomers to find their way and make friends in a new country. I help write children's books now, where the main character is an English boy who moves to Australia and he goes through experiences that I knew myself when I was a boy and which are still difficult, maybe, for the children of new immigrants and their parents. The latest book has a character who's come to

Australia from Africa, for example, because we have a lot of refugees coming to the country now. Some of the sons of refugee families are actually starting to come through the young age groups in football at national level already. Those children have had experiences very similar to the ones my generation went through 15 or 20 years ago.

A big difference is that the Australian national team means a lot to kids now. Connecting with the team, I think, maybe helps kids who love football to connect with living here and becoming Australian. And it helps that the team itself is full of names that are clearly from immigrant backgrounds: Bresciano, Viduka, Schwarzer. There's Tim Cahill, too, who's a real inspiration for kids whose families have come from Pacific islands like Samoa. You know, four or five years ago, we had real tensions in Australia between different ethnic groups; there were riots going on in the south of Sydney. This was all happening just before we had our qualifier for the 2006 World Cup against Uruguay. We won that game, made it to Germany, and it just brought people everywhere together, right there that evening. The team out on the pitch was made up of players from so many different cultural backgrounds but all united and all Australian. It was the same in the stands: the mix of ethnic groups, all celebrating a victory for the same team. It was something felt all over the country: football being able to bring people together like that and unite them behind an Australian team. That sent out a message. An amazing, strong message.

# James (ENGLAND)

*David James*

I was born in England but, as much as I can gather, I spent the first year of my life in Jamaica where my dad was from. He was never really a part of my childhood, though. I was the seventh of eight children and, after the eighth was born, my mother took me and him back to England. So I grew up living with my grandparents in Hatfield, in Hertfordshire. We moved to Welwyn Garden City when I was about eight and lived with my mum, Sue. We were a single-parent family. Mum got remarried when I was 14. By the time I was 16, I'd moved out and started my apprenticeship at Watford.

I don't remember much about Hatfield, although I do remember the school I went to: The Ryde School. We lived on the same road as the school. I didn't play football there. In fact, I don't think I was into much of anything then: I was the odd kid, maybe. Without a dad, I didn't have a father figure and that can manifest itself in a lot of different ways, can't it? I'm sure there are other kids who have had the same sort of experience. On reflection, it was a bit of a strange time for me. I didn't really have friends as such: I can remember my eighth birthday party and there being only two other people there. That was just after we'd moved to our new house in Welwyn Garden City.

When we moved to Welwyn, the school there – Applecroft – played football. There'd be kids out on the grass playing every break time. My grandparents had moved to a house quite near that school but we lived on the other side of Welwyn. I'd go to my grandparents' every evening before I went home. There was a lad who lived near their house who went to my school. He was a year younger than me, named Daniel Novelli. I used to play football with him, out on a strip of green between two roads. But I'd go round to his house on Thursday nights and he'd always be out. He'd gone to football training. All that meant to me at the time was that I had nothing to do on Thursdays because Daniel wasn't there!

What I didn't realize at first was that Daniel's dad was the manager of the team he trained with: Welwyn Pegasus. I don't know who it was – Daniel or his mum or dad? – suggested I join the team. Under-tens they would have been. I didn't think I'd be able to because I was in the next year up at school, but Daniel's mum checked and my birthday, August 1st, was the deadline, which meant I could play in Daniel's age group. So at least I had something to do on a Thursday evening.

Games lessons at school, you have to do whatever's going on, don't you? Football or whatever. Well, I can remember one day, standing out there on the playing field and my team getting beat heavily. The ball's flying over my head, whizzing past me. I wasn't involved at all: I was the kid who didn't really know what to do and couldn't do it anyway. I thought to myself, "Surely I could do better than the guy who's in goal." So I went in goal. And enjoyed it. I think I was just coming up towards ten years old but I was already tall: five foot seven. Maybe that helped.

I enjoyed it and other people even said, "Oh, you're not bad at that!" You know, I've read reports about why certain people are good at certain sports and they suggest that it's often to do with low self-esteem. Growing up, I never felt as if I fitted in; maybe that was to do with being mixed-race in a white community. So to go out and play football and hear people saying, "You're good at that" – it made me think it was something I should go out and do a bit more.

So, I joined Welwyn Pegasus. We were rubbish! We'd win now and again but most weeks we were getting beat fives and sixes. I went in goal because that was what I was good at. I started playing for the school, too, around that time. We were playing against another school, Blackthorn, in a cup game. I don't know what the score was – 4-3 or 5-4? – but the last goal was terrible: this guy's had a shot, the

ball's bounced in front of me and gone in. But what I remembered from the game was one save I'd made, diving and catching a shot. I was going to Cub Scouts then and, that week, some of the boys from Blackthorn were there and I can still remember them saying to me, "Wow! How'd you make that save?" That was the boost football gave me: that other people liked something I was able to do.

You know, I wasn't a boy who was in love with football. The nearest I came to that, probably, was going to watch Luton with my uncle. I got the Barron Knights' Luton Town record, *Hatters! Hatters!* I had a Luton ring. But anything to do with playing football I had to fund for myself. My mum was an auxiliary nurse so she didn't earn much. I used to mow lawns at the weekend to get some pocket money. I remember buying a pair of Dino Zoff goalkeeper's gloves which got ruined – all the fingers came off – the first time I played in them. They cost me three weekends' money! The house in Welwyn made a difference, though. There was a little patch of green out the back where I'd practise. And it used to drive Mum mad: we had little Christmas decorations which I'd bounce against the wall in the front room and then dive to stop them landing on the sofa. I'd do that for hours.

While I was growing up, I had this motivation about being the best. Not just doing my best but being the best. That's difficult in football because it's a team game. Even a goalkeeper: if you keep a clean sheet, it's thanks in part to the players in front of you. That's where my mind-set was wrong when I was younger: everything was gauged around me being the best. I was always comparing myself to whoever was supposed to be the best or better than me. Sport became my way of trying to satisfy that. It was the same with athletics: I started doing javelin, high jump, triple jump. It was all about trying to break the records that were engraved on a board outside the gym block at

my secondary school. Getting a record, someone saying, "Well done," was what made it all make sense.

Anyway, I joined a club called Panshanger Yellows when I was 12. There was a lad there named Jason Solomon, a decent player, another mixed-race boy who didn't live far from me in Welwyn. We talked a lot: we argued a lot!

## That was the boost football gave me: that other people liked something I was able to do.

Jason's dad was passionate about football and he became a bit of a role model for me. We'd be in the car together and he'd tell us how we should and shouldn't be doing things. It was a challenge for me and that's probably why I argued so much with Jason: his dad was the first person who'd tried telling me what to do! But we got on and, a year later, Tottenham asked us to go there for trials. I remember kids at school being impressed with that: it was another boost to my self-esteem, I suppose. Their reaction made me feel like I was doing the right thing.

I went along to train at White Hart Lane for a year. At the end of the year, we had a game: against Watford. They beat us 6-3 and afterwards I thought, "That's me finished with football. One game and I've let in six goals." I'd never had any idea of myself becoming a professional footballer. I had no real sense of what might happen to me in the future at all. I'd always played football just because it was what I was doing at the time. I think I was a bit of a nuisance at that age, frustrated about everything I was doing. I was hard work: getting chucked out of lessons at school because I was disruptive. I remember having an argument with my mum one time and she said, "I'm embarrassed about you. People say to me: 'Are you that big-head's mum?'" My attitude was about self-esteem, wanting

reassurance; me saying, "Look at me! Look at me!" I think that argument with Mum was a wake-up for me.

Anyway, Watford took me and took Jason too. They said that, even though I'd let six goals in, they thought I'd played well. There was a coach there named Stuart Murdoch, another named Tommy Darling: there were a bunch of guys at Watford who, without me really knowing I needed it, took me under their wing. It goes back to that thing about father figures. I don't know that I really acknowledged what they were doing at the time. I haven't really said thank you properly since. I was moody, up and down, all over the place emotionally. But they stuck with me and pushed me along.

I would say that it's not all about an individual's drive to succeed. It's often more about what other people are prepared to do for you. When I was at Watford, we used to train on a Thursday evening down at Woodside in Watford. That was about 15 miles away from Welwyn: not a long way but, back then, further than I could walk or ride on my bike. Mum didn't drive. Jason was at Lilleshall, the national training centre, by then so I couldn't go with him. So my gran used to take me down in her little old Morris Minor. She'd sit in the car park while I went and trained and go through her musical notes for playing at Sunday School that coming weekend. Without her doing that? I don't know. I bet I had arguments with her too. If I'd been my own kid, I'd probably have said, "Why should I bother?" But the thing is that, for me, all along the road, so many people *have* bothered.

## FLAIR

I think learning to play football in the street
makes you a better player in some ways: you're
ready for unexpected bounces; there are more
things to think about, more complications.

~ IKER CASILLAS ~

# Messi (ARGENTINA)

*Lionel Messi*

I was born in Rosario, the biggest city in Santa Fe province. We lived in a nice, ordinary house in a neighbourhood in the south of the city called Barrio Las Heras. It's still my barrio. We have the same house – although we've done it up since I was a boy – and I always go home to visit when I can and still see lots of the same friends. Family too: I have five older brothers and cousins and we all still remember getting together to play football every weekend, amongst ourselves or against other little teams of boys.

the road was unpaved, just dried earth. It wasn't the best of neighbourhoods but it was the kind of neighbourhood where everybody knew everybody and we were out in front of our houses, so my mum wasn't worried about me.

I started playing when I was five. At first, I wasn't always allowed to play with the bigger boys but that changed as I got older. It's funny: sometimes my older brothers didn't want me to join in those games in the street. That wasn't just because I was small. They said it was because they

When I started, we were playing in a seven-a-side league, against other little teams from the southern neighbourhoods of Rosario. I only got the chance to play as young as I did because of my grandmother. Grandoli didn't have a team for boys as young as me but, one Sunday, an older boy didn't turn up for his game and my grandmother pushed me forward to play. The coach wasn't keen at first but he let me play in the end.

That first game for Grandoli was with older boys. When it came to training with boys my own age, my dad was our coach. By then, I was playing every hour of every day that I could. I'd go to school, come home and, straight away, go out with a ball. Then I might go to training at Grandoli, come home, have something to eat and then be back out in the street again. I was always out in the street. And always playing football. I even kept a ball with me when I was indoors. My brothers didn't have to worry any more: the other kids in the neighbourhood sort of looked after me. They got to know me, got to know what I was like and how I played football. By the time I was eight or nine, I didn't have to be afraid of being kicked by anybody. I could just play.

> I'm happy because, more than anything, I love playing football. And it's been like that since I was very young. I enjoy playing: it's not something that feels like a job. It still feels like fun, like it did when I was a very small boy.

I got given my first football when I was very young: three, maybe, or four. It was a present and from then on it was the only present I ever wanted, Christmas, birthday or whatever: a ball. At first, I used to collect them. I didn't want to take them out in the street in case they burst or got damaged. After a while, though, I started taking them outside and actually playing football with them!

There was green around the house but no garden to play football in. There was an abandoned military base nearby, which we called "Batallón", which had some pitches and sometimes we'd sneak in there for a game through a gap in the fence. But usually, playing football meant playing in the street, outside my house or anywhere else in the neighbourhood where there was a game going on. In those days

were playing against older boys. The thing was that the other boys wouldn't be able to get the ball off me: my brothers were worried that I would end up getting kicked or that something bad might happen to me if the other boys got angry. I don't really remember that but it's what my brothers have told me since.

Almost at the same time as I started playing football in the street, I joined our little local club, Grandoli. In fact, it wasn't just me: the whole family was involved at the club; all of us played there at different age levels and my dad was one of the coaches. We used to spend the whole of Sunday at Grandoli because we would have a member of the family playing in every different age category, from me through to my uncle in the senior team. We'd be there all day.

You know, I never really had any players who were heroes for me. Like all Argentinians, I admired Maradona. I remember watching videos of him playing for Boca. And I remember that I used to enjoy watching Pablo Aimar play when he first came through. But there wasn't anybody who was an idol for me as a boy. I grew up with my brother and my cousins, playing in the street. I watched and learnt things from there and, when it came to playing matches, my dad used to say things afterwards about how I'd done. I thought he was nagging me, really! My family have guided me in my life, but in playing football? Sincerely, the truth is: no. I've always just done what seemed to come naturally; and haven't had to think about it.

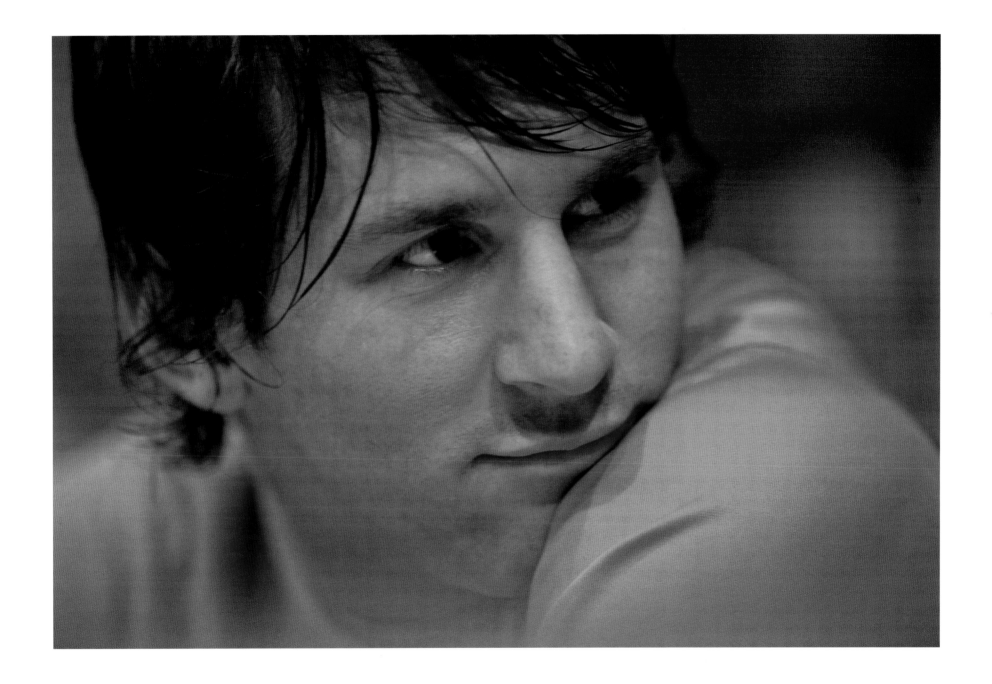

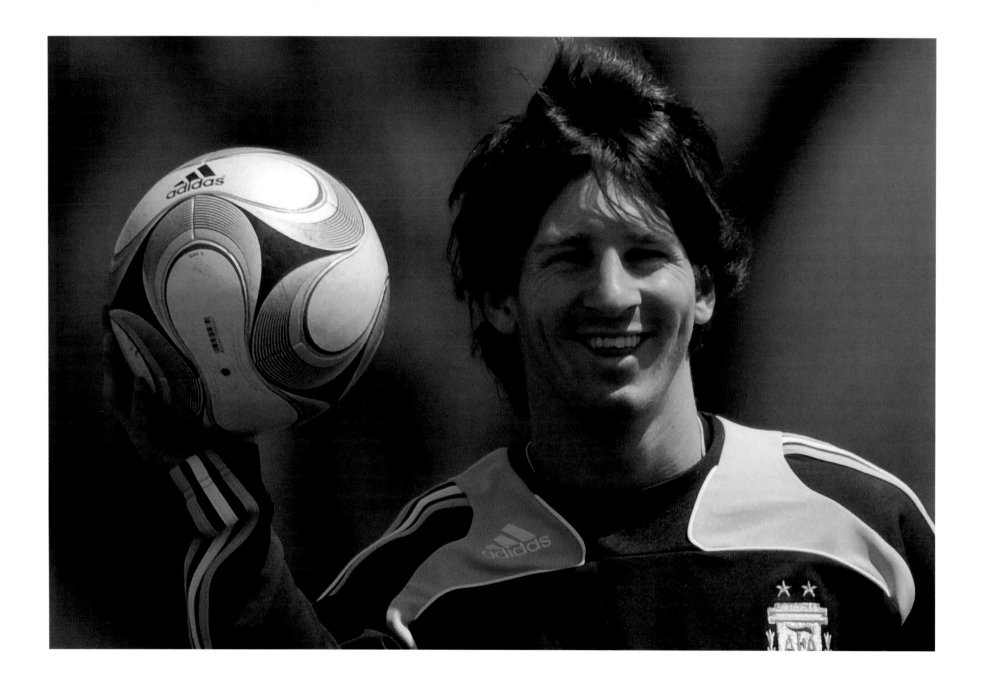

These days, I don't watch a lot of football and don't really follow it so much but, back then, I used to go to games all the time. With my dad and my cousins and uncles, we'd go to watch Newell's Old Boys, one of the two big professional teams in Rosario. I guess we were fans then! When I was young, I think that being a footballer was what I always wanted to do, although it was a dream. I never imagined it would come true and, of course, I never imagined the way in which it would come true. As a boy, I just played because I loved the game but, in the back of my mind, there was a dream of playing professionally, of some day being able to play on the pitch at Newell's where we all used to watch games together.

After a year and a half at Grandoli, I started training with Newell's too; also seven-a-side, but we played in a more competitive league. Newell's was a much bigger club and my last year there gave me my first experience of playing 11-a-side on a full-sized pitch. It was also at Newell's that I first went to see a doctor about being small. I had always been smaller than other boys of my age but it didn't really worry me when it came to football. Perhaps at the start of a game I could tell that other boys were looking at me and that made me feel uncomfortable but, once we kicked off, they saw how I played and there'd be no problems after that! So I never thought of it as something to worry about.

Newell's sent me to a clinic where they did all sorts of tests and the doctor told us that I had a dormant growth hormone. I was growing, but much more slowly than was usual. The doctor said I needed a treatment that would wake that hormone up so I'd begin to grow at the same rate as other kids. I was 11, maybe 12, when I started the hormone treatment. I had it for a year in Argentina, which my dad paid for. Then, when I came over to Europe, Barcelona already knew all about it and they took

over the cost of it, although that's obviously not what made me come here.

I was still a boy, 13 years old, when I came over to Spain. Dad came over first to find out about things and then, in September I think, I came over for a trial for 15 days.

I got given my first football when I was very young: three, maybe, or four. It was a present and from then on it was the only present I ever wanted, Christmas, birthday or whatever: a ball.

We went back to Argentina and then, in February, we all came – the whole family – and I started at the Camp Nou. It was a fantastic thing and what I wanted to do. But it was strange too. And difficult: there was nothing here that I was used to from my life back at home; no playing in the street, none of our little football matches, the *picaditos*. And the boys I was meeting and training with had very different customs; they'd all been brought up in a very different way. The most obvious thing was that, here in Barcelona, I couldn't just run out of the house, meet up with my mates and start a game. I still feel completely Argentinian, you know, in my habits and way of living – I still drink *mate* – even though I feel very comfortable in Barcelona because I've been here so long.

Maybe one thing I brought with me from Argentina was hating to lose! Hating to lose at anything. At everything. I'm always "heated up" on the pitch: we call it *calentón*. Ever since I was a little boy, I've never liked losing. I've got a feeling that sometimes, when I was playing football in the street with my brother and his friends, they'd lose a

game on purpose. They'd let me win because they knew that, if they didn't, there'd be trouble. It's a different mentality, perhaps. I remember when I first got here, when I was 13, and we played little matches in training: I hated losing but I'd see local kids who'd lose and it didn't seem to bother them! I just couldn't understand that.

I still go home to Rosario every Christmas and summer, and when the national team plays. I still see lots of friends from my barrio, although it's different for the kids there now. Even in Argentina, people are worried about their kids' safety and so you don't see so many *picaditos* in the street any more. Thinking back, I suppose I missed out on some of the experiences of childhood, back at home and after I came over to Europe: friends would come by and say, "We're going out," and I would say I couldn't because I had a match the next day. But I don't regret it because it's what I wanted. I'm happy because, more than anything, I love playing football. And it's been like that since I was very young. I enjoy playing: it's not something that feels like a job. It still feels like fun, like it did when I was a very small boy.

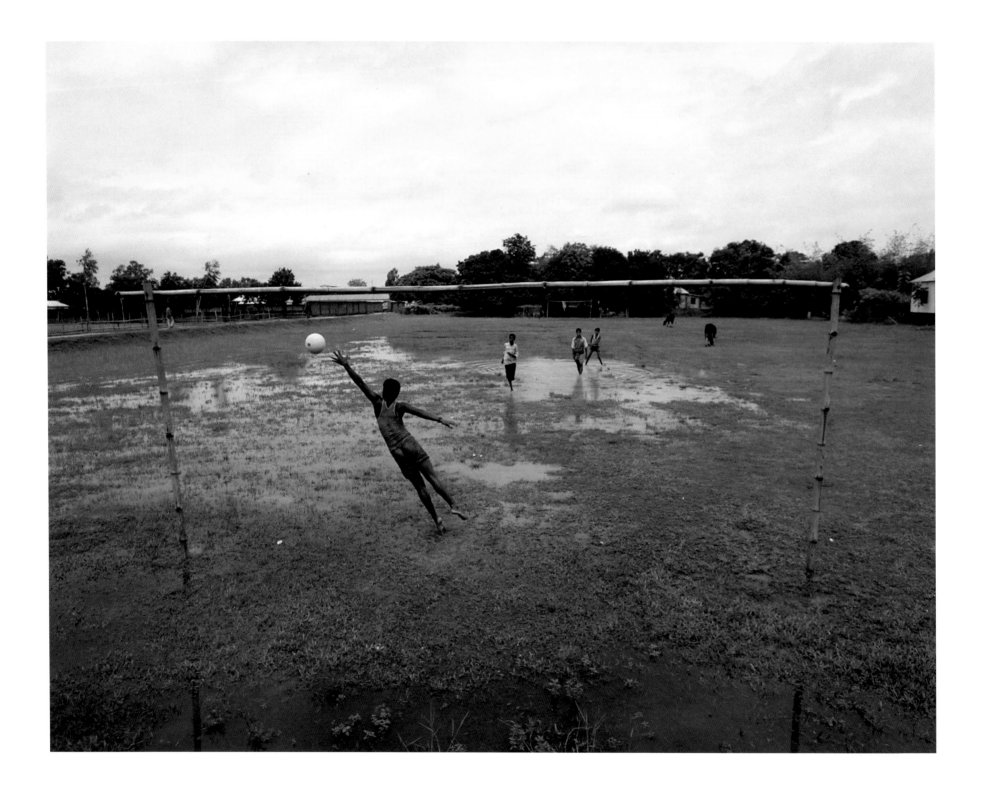

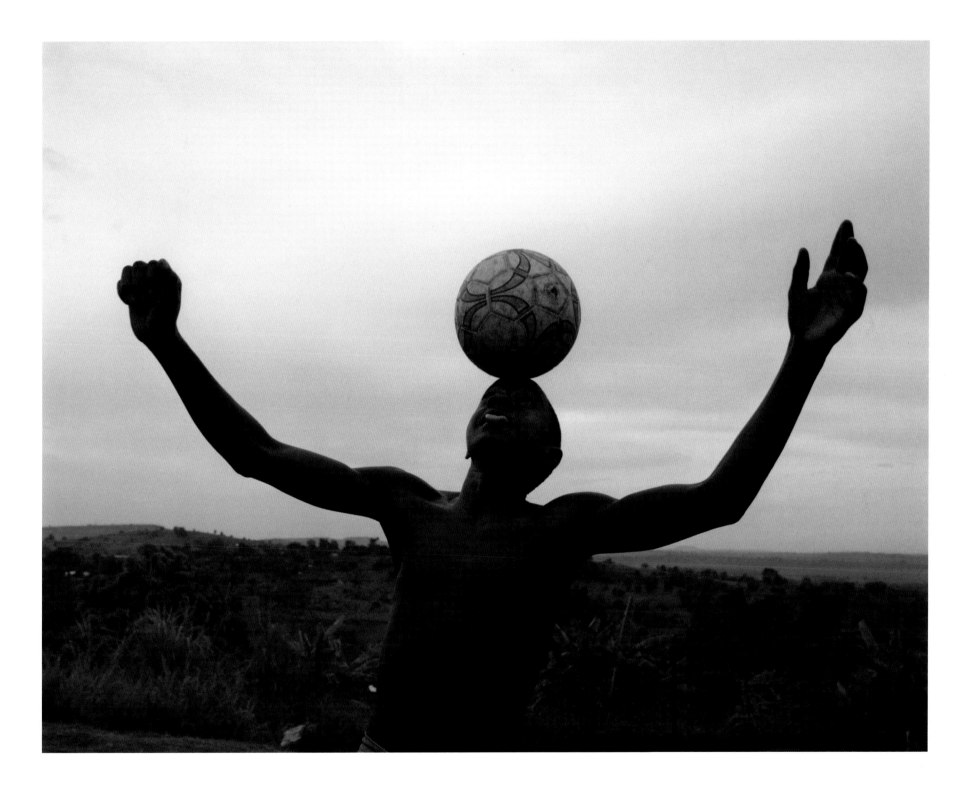

# Casillas (SPAIN)

*Iker Casillas*

I did an advertising campaign once and we chose the slogan: "I'm not a 'Galáctico', I'm from Móstoles!" That's where I was born; it's my home town: Móstoles. In truth, it's not really a town any more; it's a city that's really growing at the moment and is starting to gain its own identity, with a population of over 200,000 people, many of whom work in Madrid. It's a working-class place that is beginning to be a reference point in its own right, not just in the capital but further away too. It might have always been there as a suburb, serving Madrid, but it is much bigger now than, say, Soria, or Ávila, or Valladolid, which are all cities in their own right. I identify very closely with Móstoles: it's where I was born and grew up, where I went to school. It's where I became who I am and it's still my home. I think it's very important for a person to understand their roots – to know where they've come from – and that's what my home town represents for me.

Móstoles is about 20 kilometres outside Madrid and its eyes are turned on the capital to some extent; you're in Madrid in 15 or 20 minutes at the most. It used to feel further away though: communications and transport have really moved on. So has everything since I was a kid. When I was growing up, for example, there wasn't the infrastructure for kids to play football that there is these days. Now, there are soccer schools and some lovely Astroturf pitches; there has been a huge effort made to get kids playing and to help them get a start in sport. Back then, though, we played on sand, gravel, or concrete. I played in the street, in the park, at school. I didn't have the kind of organized football set up there is now. But, much as I think all that's fantastic now, I don't feel I missed out; I just loved playing football when I was a boy.

We used to go down to the park alongside the block of flats where I lived. We would set up games between the kids in my block and the kids from the block next door. *Portal* versus *Portal*. And we played like it was a European

Cup final; everyone gave absolutely everything to win. It wasn't a case of picking teams, of lads lining up to be chosen; instead, you nearly always played with your mates. We'd go off looking for other groups of boys to play against. I still see some of those lads; my friends from childhood were all kids I played football with. We still love the game but when we see each other now we don't talk abut football so much: we talk about other things. I wasn't from what you would call a football family, in

> We played a lot of *fútbol sala* – futsal – which is five-a-side rather than 11-a-side. For a goalkeeper it's a different game: you use your feet a lot more; the ball is smaller and the game is quicker.

terms of other members of the family making it as players. But my dad, José Luis, was always a big football fan. He had lived in Bilbao and was an Athletic supporter, but he also liked Real Madrid. Dad used to get me Athletic Bilbao kits as presents when I was little and I guess my love of football comes from him, a bit at least. Despite his connection to Athletic Bilbao, though, my team was always Real Madrid. I played a lot with Dad too. We'd go down to the park or onto a concrete pitch near our house and he'd take penalties at me. There was a school about 100 metres from our house and we would go there at the weekends. He'd take shots at me and could see that I wasn't bad at saving them. He got me some gloves, and a goalkeeper top and that's where it all started for me.

People say that it's the kid who isn't much good out on the pitch who goes in goal, but that wasn't how it was for me. I never really played out, even when it was just mates having a kick about; I always went in goal. I always loved

it. And I wasn't the last one to get picked either. In fact, I always got picked first because they knew that I'd be the goalkeeper. My friends knew I liked going in goal and they loved that. Not so much because I was good, but because I was prepared to play there; it meant none of them had to! We played a lot of *fútbol sala* – futsal – which is five-a-side rather than 11-a-side. For a goalkeeper it's a different game: you use your feet a lot more; the ball is smaller and the game is quicker.

When you're a kid playing on concrete or gravel or in the park, especially as a goalkeeper, you have to learn how to fall properly or else you'll do yourself some serious damage. When I look out across the grass pitches that Real Madrid have at our Valdebebas training ground, I think: "We're so lucky." They're all grass, soft, a luxury to fall on! In fact, I look at those new generation Astroturf pitches they're playing on in Móstoles now and I think those kids are lucky too. We used to fall over and rip ourselves on the gravel. I played with long trousers, knee pads, elbow pads: the lot! You had to, or else you'd tear yourself up: I used to get through so many pairs of trousers back then. But I think learning to play football in the street makes you a better player in some ways: you're ready for unexpected bounces; there are more things to think about, more complications. And being ready for those can make you a better footballer, a better goalkeeper. People will have different opinions: some say that learning the hard way is the best. Certainly, it

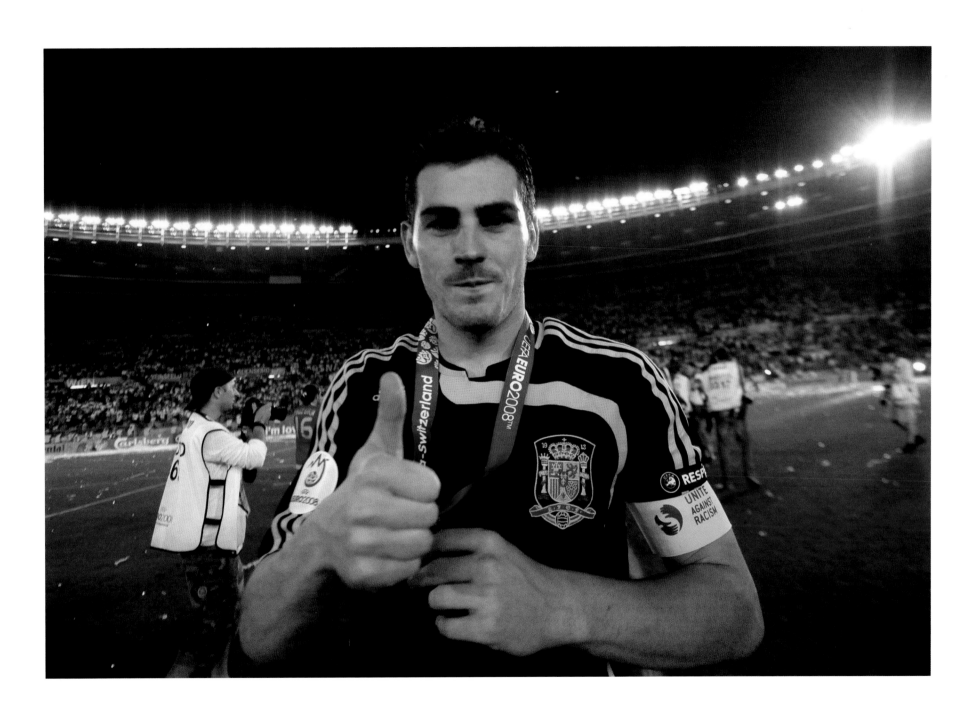

suited me. But others say that it's better to give kids the very best facilities.

When you're a boy, you play because you want to enjoy yourself and spend time with your friends, not because you're trying to become a professional footballer. That's something you dream about, of course: playing for your team, which in my case was Real Madrid. But it's just that: a dream. It's not until you start coming through at a club that you really think about a career in football as a genuine possibility. Once I joined Real Madrid and started making progress I did start to think about it, but, until that happens, you're just playing for fun. When you join a club, it's not only your attitude to football which changes; it's your attitude to life as a whole. You find yourself mixing with different kids; you're not just hanging around near home any more, loving football and playing with your friends. Your focus is completely different.

I don't think my dad had hopes of me being a professional. Not real hopes, anyway. He just wanted me to enjoy myself. Every dad would love his son to be a footballer or a tennis player or whatever, but the most important thing for parents is always their children's schoolwork. That's how it was with mine. My mother, María del Carmen, was a hairdresser and didn't particularly like football, but she was happy that I enjoyed it and supported me as much as she could. It was always her who had to deal with the kit too. I'd come home and it would be filthy or ripped. Or both. She sometimes got to the point where she couldn't take it any more! I'd come home and hand her this pile: well, it's funny looking back, the memories are fond, but I realize what my parents did for me. Mum must have been washing stuff every single night.

I didn't watch as much football when I was young as kids do now; there weren't as many televised games, for a start. Now there's a game on telly every day it seems! I used to go to some Real Madrid games at the stadium, though, and the Bernabéu was a place that left a really powerful impression on me. But it was a long way away: the metro, a bus, and then a walk. So I didn't go very often. It was a real effort to get to the ground but, when I did, I used to watch from the very top, the third tier, in a stand along the side of the stadium. Whenever I could, I'd try to find a way of getting lower down, closer to the pitch. When you're a kid you want to see the players close up, of course: stars like Davor Šuker and Iván Zamorano. It was incredible.

My real boyhood heroes were always goalkeepers: Buyo, Cañizares, Schmeichel. Goalkeepers are different but I don't think we're special or outcasts. As a kid I liked everything to do with football, even though my attention was always on the goalies. We're all players; just playing in different positions, that's all. You know, when you become a professional, your attitude changes a little but you still have to have a sense of hope and desire. And you have to enjoy playing football. If you have that, you're fine. If you lose it, you might as well leave the game; you might as well retire. When you no longer have something you feel you're aiming for, you might as well give football up.

I joined Real Madrid at the age of nine. I had never had a team before, not even a school team: I'd only played with my dad and my mates. The only club I've ever had has been Real Madrid. There were some trials at a school near my house one day. Some people in my neighbourhood said, "Hey, you're a pretty good goalie; why don't you give it a go?" So I did. My dad took me along – it was a kind of open day – and that's where they saw me. That first time, I was just a little boy, eight years old. They told me I was a bit too small and that I should come back the following year. They told me they'd call, and they did. About five months later, they called me in for another trial. They gave me a go, chose me and that was it. That was where organized football began for me.

While you're growing up, parents invest an enormous amount in you as a footballer and as a person. Without

## People are proud of the national team these days ... Now you go out on the street and the atmosphere is different; it's lovely.

them I can't imagine anyone being able to make it. I mean, you might see a kid who's a great footballer but what you don't see is his parents there with the car, ready to pick him up and take him to training sessions and games, often making real sacrifices for their boy. When I was a kid, my parents used to have to take me from Móstoles to Madrid and back and, in those days, the road wasn't the big motorway it is now. And we didn't have the car we have now, that's for sure! They made sacrifices: Dad started a law course but had to give it up when he started taking me to Madrid for training and didn't have enough time to study as well. He would go in to work at seven in the morning – he was a functionary for the Ministry of Education – and come home for lunch at three. Then, at four, he'd get me in the car and take me up to training in the city.

Joining Real Madrid was strange for me, a completely different experience. I'd always played on the streets with my mates or my dad and then gone home. Now, suddenly,

I had to grow up really quickly, even though I was only nine years old. I met new kids; I was thrown in with people I didn't know. One particular example: we had to have showers together. It might seem silly, but I had never had to shower with other kids before; I'd never had to get undressed in public! I had always gone home to wash. But now? Taking my clothes off in front of other people? I felt really embarrassed. New experiences can make you feel uncomfortable; they force you to change and to grow up quickly. I had to learn things I'd never expected to have to learn, things I'd never even thought about.

Life for me, aged nine, at Madrid was a challenge. But hard? No, I wouldn't call it hard. It was just new: new experiences and a new way of thinking. I'd never really thought of Real Madrid as having a youth system or a kids' team. Madrid was Madrid: the famous players. I never imagined this group of kids being part of what Madrid was about too. I'd never imagined the club had so many teams, so many lads on their books. In fact, nor had my mum! She thought my dad must have been making it all up: "Why would Madrid have a big team for boys who are just nine or ten years old?" Anyway, I was suddenly thrown into a whole new world. It seemed crazy. I'd have to travel 40 minutes to come into Madrid and train; it felt then like it was so far away. It was somewhere I'd only ever been to if Mum had to go to the dentist or something. And now I was there all the time. Madrid: the big city. *Madre mía!*

I think football has always been important in Spain, but, since we won the European championships in 2008, I think it has become even more important for us as a society. There's always been a kind of flatness about Spain as a football nation, a lack of hope and a sense of disillusion about ourselves. Our clubs did well but the *selección* never did. We lacked that inspiration a national team can give the country but I think we've found it now. It's something palpable. In the past, playing for Spain felt edgy;

people would give up when things went wrong and there wasn't that sense of hope, that shared sense of joy that we have now.

People are proud of the national team these days; rather than letting their heads drop, they puff out their chests. And that filters down through football all over the country, right down to the kids kicking a ball around with their mates. Now you go out on the street and the atmosphere is different; it's lovely. That comes from Spain winning and, when a team wins, everyone wants to experience that sensation again. People look forward to the major tournaments now. That wasn't the case before. Sure, you can lose. But there's hope now and a sense of anticipation. When we were boys we dreamt about playing for Madrid, but people didn't really talk about playing for Spain. Now, though, I think kids are beginning to do that: maybe, after Euro 2008, they have a new dream.

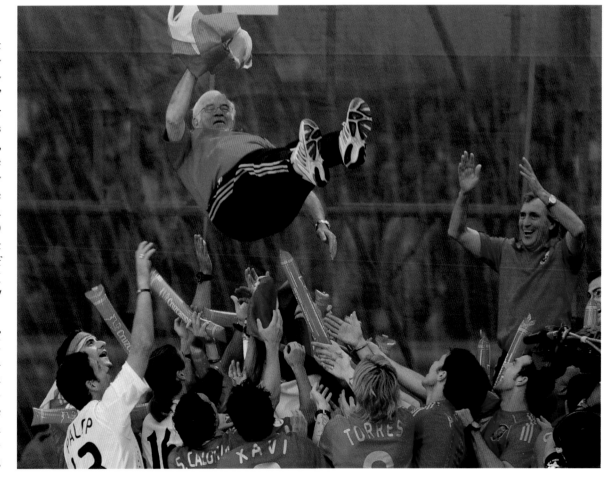

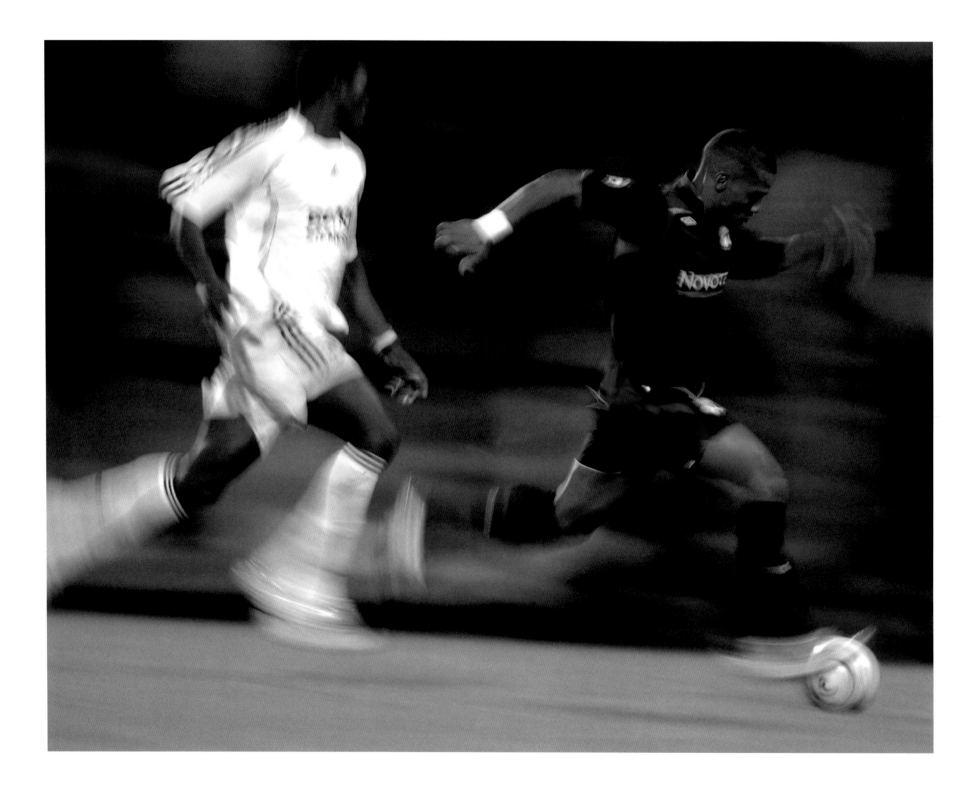

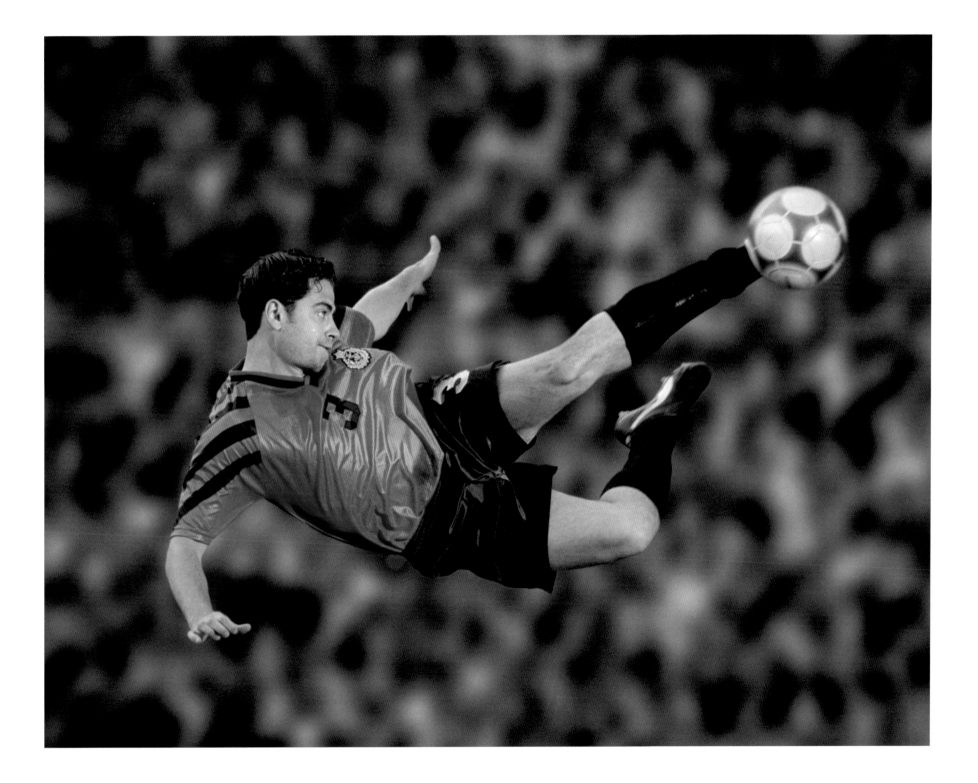

# Figo (PORTUGAL)

*Luís Figo*

My parents, Antonio and Maria, moved to the capital, Lisbon, from the Alentejo region to find work. So I grew up in Almada, which is just across the bridge, on the south side of the river Tagus, from the city itself. When I was young, it took longer to make the journey into Lisbon but now Almada has become what we call a "dormitory town": lots of residential buildings, where it's mostly people who live in Almada but commute to work in the city. We lived in an ordinary, pretty crowded neighbourhood called Cova da Piedade and that's where I first played football when I was a boy.

I've played ever since I can remember: my memory goes back to age seven or eight but I'm sure I started before then. There was a little pitch behind our house, with fences all around, where we used to play five-a-side football all the time. It was the only one in our neighbourhood and was marked out with circles instead of straight lines: people used to play handball and basketball on it as well. All my friends played and we had a little team, just boys in our street, and we would play matches against teams from other streets. We were only eight or nine years old but those games were really competitive.

My dad played football when he was younger in his village but never as a professional. He loved the game, though, and used to take me to watch games all the time. When I was young, he was a Benfica supporter, so we used to go to the Estádio da Luz to watch them play. It wasn't until I started playing for them that he became a fan of Sporting, but I remember us going together to watch them play as well. And we would go to see the national team play all the time too. It was a good time for the Portuguese team. We qualified for the 1984 European championships and the 1986 World Cup and I can still remember the players I admired back then: guys like Fernando Chalana, Paulo Futre and Fernando Gomes.

We used to play a lot at school as well. There was an area of the playground set aside for football and it was part of our lessons too. In Portugal, there is school time for sport which I still think is a really good thing. Children can choose what they want to play: football or handball or basketball. Right from the very beginning, I just wanted to play football. Dad knew how much I liked the game but he never pushed me and, most important, he never built me up like some parents do their children. He never said, "Oh, Luís. You're the best!" And whatever I wanted to do in the game, he always gave me the responsibility for it. I think that counted a lot for me when I was young: knowing that my dad trusted me to make my own decisions.

I joined my first club with some of my friends. The club was called União Futebol Clube "Os Pastilhas". They used to call us "The Mints". You know, at that age, none of us was thinking about growing up and becoming a professional player. We just played for fun, although the coach there – Hernando – was the first person to teach me a little bit of the technical side of football. Anyway, that team was only together for a year because the club was very short of funds and we lost the pitch that we used for training. "Os Pastilhas" had to stop putting a team out for games. It was time for me and my friends to move on.

Alcochete for a day for them to have a look at us, though. The trial period lasted about a month: I remember having to ask the coach what they wanted to do with us!

It would take over an hour, after school, to get to the training ground. This was before they built the Vasco da Gama bridge near Alcochete. We would have to get on a bus in Almada, then take a ferry across the river and then another bus up to the *academia*. And it would be the same coming home. It would already be dark when I got to my house and I had to be up early for school the next morning. It wasn't as if my family could afford to keep paying all my fares either. But, in the end, the club took me on and that was where I got my start in professional football. I joined the *academia* at Sporting when I was 11 and played for the first team when I was 16.

Once I was a part of a big club, things changed, of course: football and the rest of my life as well. And things happened quickly for me. Thinking back, I was lucky to join the club I did. The coaches who worked with the younger boys at Sporting were excellent. They were very good coaches but also it was to do with the culture of the club: Sporting have always brought their own young players through. They have never had the money to try and compete against the bigger, richer clubs in other parts of Europe. So, those coaches worked hard and, for me, they

## I don't remember being nervous at all. Just very excited.

There were a few of us went over to Sporting Clube de Portugal for trials. I must have been about 11 and some of my older friends were already on the books at the club. Being so young and going there with friends, I don't remember being nervous at all. Just very excited. This wasn't just a question of going over to the *academia* in

worked well. They knew they were responsible for the heritage of Sporting CP, a tradition that had been handed down through several generations. They weren't just looking after us as young players; they were looking after the future of the football club too.

Right from the very beginning, I just wanted to play football. Dad knew how much I liked the game but he never pushed me and, most important, he never built me up like some parents do their children. He never said, "Oh, Luís. You're the best!" And whatever I wanted to do in the game, he always gave me the responsibility for it. I think that counted a lot for me when I was young: knowing that my dad trusted me to make my own decisions. ~ LUÍS FIGO ~

# Gamst (NORWAY)

*Morten Gamst Pedersen*

Vadsø isn't the biggest town in the world. The county we're part of, Finnmark, is one and a half times the size of Denmark but there are only 65 or 70 thousand people living in the whole county. In Vadsø itself, while I was growing up, there were only about 6000 people. It's up in the north of Norway: some forest, some mountains, and lots of prairie. I've travelled a lot and been all around Norway and I think Vadsø was a really good place to grow up. It felt like a little city to me. Everybody knew everybody, I suppose, but it was good in the sense that it was easy to get around, easy to get training time on the indoor pitch, whereas in a bigger city you'd be told: "Oh, no. You can only play here at this time or that time because we have other things going on." I think I was really lucky to grow up there.

I lived in a house with my mum and my dad and my sister. The important thing was that we had a decent-sized garden so I could play football. There's space for everybody to have a garden in Vadsø. Those are my first memories of playing football: with my friends, in the garden around our house, playing for fun. We played in lots of different gardens but most often in ours because we were allowed to play all day at my house. We had a clothesline with two posts holding it up – perfect. That clothesline never got used for hanging clothes on. But we could play anywhere. Our parents never needed to worry about where we were. There was nothing to be afraid of. Once I got home from school and did my homework, I could just be playing outside for the rest of the day.

I come from a very sporting family. Dad played football and handball at a good level and my mum did handball too and was a good swimmer when she was young. I was born in 1981 and my generation, all of them would tell you that our parents, back then, were unbelievable.

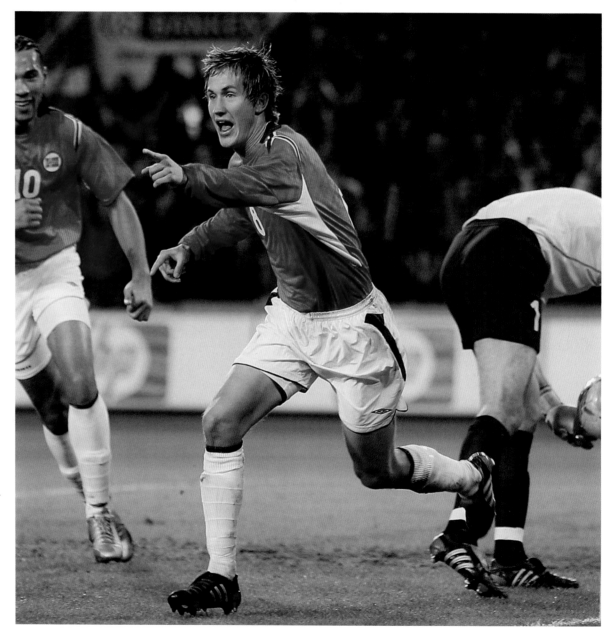

They were always there if we needed something, driving us around if we had to get somewhere. It was fantastic. And the facilities were really good: two full-size gravel pitches and one grass one, an indoor pitch, handball courts, a 25-metre swimming pool and a smaller pool too. There's an artificial pitch now too, which they've named after me because they got the money for it from my transfer!

We were a group of friends and we did everything together: football, handball, ice hockey. It was such a small community: 90 per cent of the children who played football together played handball or did ice hockey as well. It was a bunch of us, always together. Vadsø is north of the Arctic Circle so, in winter, we played football in the street, in the ice and snow. We'd be bundled up against the cold and play in whatever we had on.

To go to school, we could catch a bus at seven o'clock or one at eight o'clock. We'd always be on the seven o'clock bus so we'd have an hour to play in the schoolyard. That was all year round but in the winter there would sometimes be 30 or 40 centimetres of fresh snow in the playground. The ball wouldn't roll so we would just kick it around through the snow until, after a while, it would get packed down. But it was great: everybody would be happy going in goal because you could dive around in the new snow and it didn't hurt when you landed! You'd try to sprint in it and your feet would just slip like you were running on sand, but you could go in for 30-yard slide tackles on the ice. We had some funny times there.

We didn't have school teams in Norway but, in Vadsø, from when we were five or six years old, there was a little club. We were called Myggs – that's "mosquitoes" in English – and we met up twice a week in the indoor sports hall, on a pitch about the size of a basketball court. Some of our parents would be there but nobody telling us:

"Do this. Do that." It was just a case of getting two or three teams up and playing games; or maybe a little competition, shooting from the halfway line or trying to hit the goal. Just playing some football and having fun.

Football was always the game for me but, when I was a boy, I was also doing handball, ice hockey, gymnastics, orienteering, skiing as well. I was pretty good at handball but there was never a doubt about football: I think I knew the word "training" before I knew the words "Mum" and "Dad"! You know how your mum will sometimes write down things you do or say when you're young. I don't remember saying it – I was four, or even younger – but she wrote down what I said: "I'm going to be a football pro: I'm going to be a millionaire; I'm going to have a Ferrari and a gold tooth!" I didn't know anything about money back then but I suppose, like some boys say, "I'm going to be a fireman," I always said, "I'm going to be a footballer." If I ever get that gold tooth, I'd have to make sure it was really far back in my mouth now!

As well as playing, I watched football all the time as well. The guy who looked after the indoor pitches in Vadsø, the caretaker, asked me, "Do you want me to rebuild one of the changing rooms as a flat so you can come and live here?" Every Saturday there would be a match of the day from England on TV, and our family got a satellite dish quite early on so I could watch football from other countries as well. Marco Van Basten was my favourite player: a great footballer, a goal scorer, and he came across as a nice

guy too. He had everything, I suppose. He was the star I wanted to be.

Even though Vadsø is a small place, I was maybe not the best player in my age group. There were four or five boys who went on and did really well as footballers. One of them, Steffen Nystrom, is playing in the Norwegian top division for Stromsgodset in Drammen. My best friend, Frodo, was training with a Premier League club in England but he tore his cruciate and medial ligaments in his knee and had to have surgery on his ankle too. Just bad, bad luck with injury. It wasn't until later that maybe I came through as the best player.

We had a really good team but everyone was welcome. Out of maybe 17 boys, we had boys with medical problems, who were on medication or had to have people looking after them; boys who'd lost a parent; boys from immigrant families. There weren't little groups within the team. It was all of us together. Maybe it sounds too good

> We had such a good time, all of us together. Playing football, everybody seemed to be smiling, laughing, all the time.

to be true but that's how it was: everybody got on, no fights, no arguments. When we had an important game, it would be the kids who weren't such good players who'd be saying, "Oh, we have to play the best players, play our best team!" They just wanted us to win because they knew they were all a big part of the group too. I suppose you could say I grew up on a pitch. We had such a good time, all of us together. Playing football, everybody seemed to be smiling, laughing, all the time.

## COURAGE

You know, when I was young, Dad made sure we had everything we needed. When he died, that was a big blow for us, for my mum. It was the first bad thing that had happened in my life. Everybody in the family had come to me and said, "You're the man of the family now. You're responsible now for your mum and your brother." That was a lot for a ten-year-old boy to think about. I thought I would go to school and then go to work to be able to look after my family. But then football came along. At first, it was something I just enjoyed. Then it started to seem like a way I could take care of my responsibilities.

~ RADHI JAÏDI ~

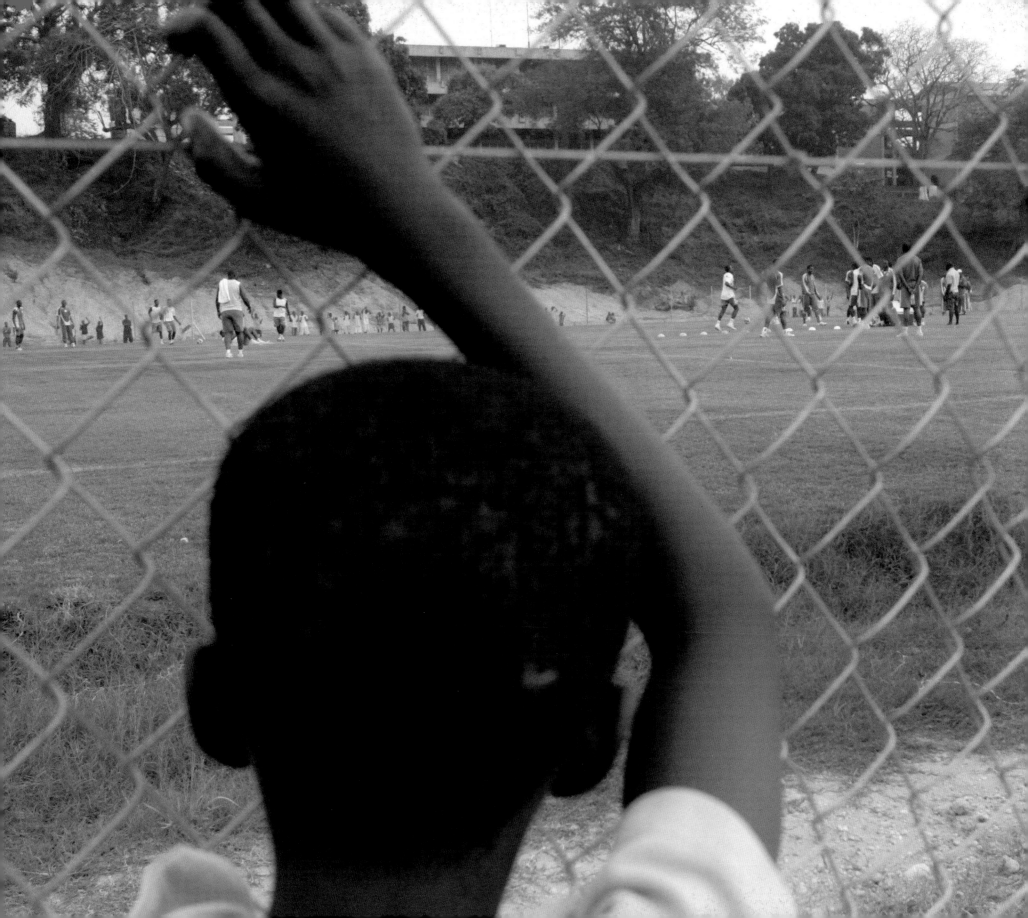

# Jaïdi (TUNISIA)

*Radhi Jaïdi*

I grew up in Tunis but, when I was ten, we moved to a town in the south of Tunisia called Gabès. It's much smaller than Tunis, of course. It's a more old-fashioned, traditional city. Our neighbourhood in Tunis was friendly enough, people would look out for you. But in Gabès? It was the kind of place you would come home and the house would be full of neighbours, watching TV and eating with you. If it got late, they'd end up sleeping at your house too. That's the Tunisian tradition. And Gabès was where I first played organized football, with the local team. It was where I first started to think about maybe having a career in football.

Before we moved to Gabès from Tunis city, my dad was still alive. He was always telling me to concentrate on my schoolwork, to make sure I got good results. I was like any other kid, sneaking out to play, football especially. We had a house with a garden where I could have played but I wanted to be out with my friends. Parents worry: out in the street, it's a mix of the good kids and the bad kids. Dad was afraid I might make mistakes, take the wrong influences; that bad things might happen to me. That was how people used to see football in Tunisia. Dad wanted me to learn about life but he wanted to protect me too.

I wasn't thinking about any of that. I didn't know about the wrong kind of influences. I just wanted to play. There was a little yard set beside but off the road. I go back there now and it looks so small: "How did we used to have a game in that tiny space?" Back then, though, that seemed like a big, open space to us: room for 30 kids in a game sometimes! I used to play with boys who were older than me, which was good. I felt proud I was good enough to get included in their games. Just games in the street, like everywhere. You can learn so much like that, without a manager or coaching, because you're free. Winning's not so important. You see one of your friends do something

good and you take your ball home and learn to do it yourself. Next day, you're back: "Look! I can do that too."

In Tunisia, whoever brings the ball to play feels like he's in charge of the game: "It's my ball and I'm the number one!" I had a plastic ball and I brought that sometimes but we preferred it when we could get hold of a real ball, a leather ball. Having a proper ball to play with made everyone happy. Like I say, I had to sneak out of the house

> I had to hide my tracksuit and my football shirt under the bed where Mum wouldn't find them. I'd say I was going to see a friend and then I'd get my kit, jump on my bike and go off to training. That meant I had to clean all my own clothes too. I struggled for a little while: I had a secret life.

to play. If my parents saw me going, they'd say no straight away. But a couple of years before my dad died, he made me a promise. If I passed the exams that we have at the end of the Sixth Year in school, and got into college, he would put me into one of the big teams in Tunisia – Club Africain, the club he supported. He was friendly with the first team goalkeeper there and said he would talk to him about it.

I was happy about that promise but, you know, at the time football wasn't everything in my life. It wasn't an ambition for me. That didn't happen until later. Dad died when I was ten. My mum wanted to be closer to her family; she wanted that support. She had two boys – me and my

brother – and so we moved to Gabès then. And within two months of us being there, out in the country, I really discovered football – amateur but organized football.

The club was called Stade Gabèsien. My first year there, I was in a new town. I'd go to school then come back home. I knew my cousins, my grandparents, my mum's family, but I hadn't made new friends. This was a new life for me. Football was something I could do with my time.

The family was worried I might get distracted by football, I think. Mum said, "As long as you get your scores in school, you can play football. If you don't, you'll have to stop."

For three years, that was fine. I got my scores at school. I enjoyed playing football. I was captain, a striker, scoring lots of goals. But in the fourth year in Gabès, I didn't pass my exams at school and Mum was very upset. But by then, for me, it was: "I can't stop football now." I loved playing. All my friends were from football. I had started thinking I could go further in the game, try out for junior teams at national level. But Mum didn't want me to play; I had a problem.

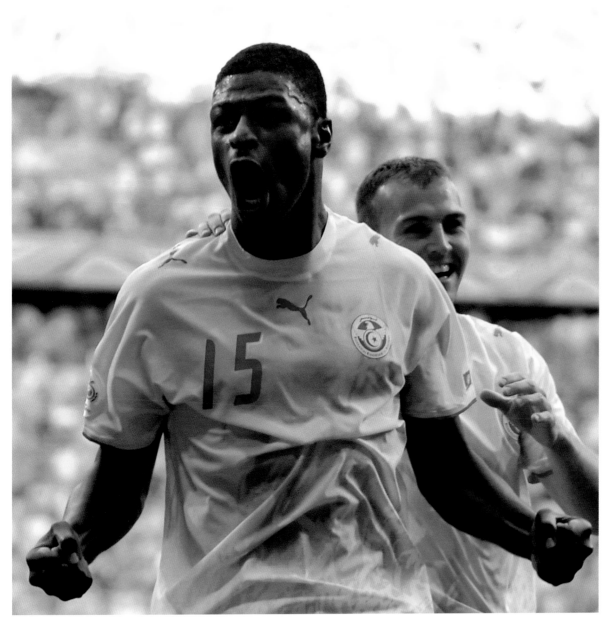

I had to hide my tracksuit and my football shirt under the bed where Mum wouldn't find them. I'd say I was going to see a friend and then I'd get my kit, jump on my bike and go off to training. That meant I had to clean all my own clothes too. I struggled for a little while: I had a secret life. But by then – I was just 14 or 15 – I would sometimes get taken to play for the club's senior team, big games with the big lads, and I could see a way to a career: earning wages. It would help me and help my family.

You know, when I was young, Dad made sure we had everything we needed. When he died, that was a big blow for us, for my mum. It was the first bad thing that had happened in my life. Everybody in the family had come to me and said, "You're the man of the family now. You're responsible now for your mum and your brother." That was a lot for a ten-year-old boy to think about. I thought I would go to school and then go to work to be able to look after my family. But then football came along. At first, it was something I just enjoyed. Then it started to seem like a way I could take care of my responsibilities.

By then, I couldn't keep the secret any more, could I? Football could be my job. I went to Mum and told her what was happening. She said, "What? You mean you'll have money and everything?" I said, "Yes!" I know she was happy but she didn't tell me she was. You could say that was where my life in football really began. Even though Dad wasn't sure about me playing football when I was a boy, he was a supporter himself, especially before he married and had a family. So, if he could see what has happened to me, I think he would be proud now as well.

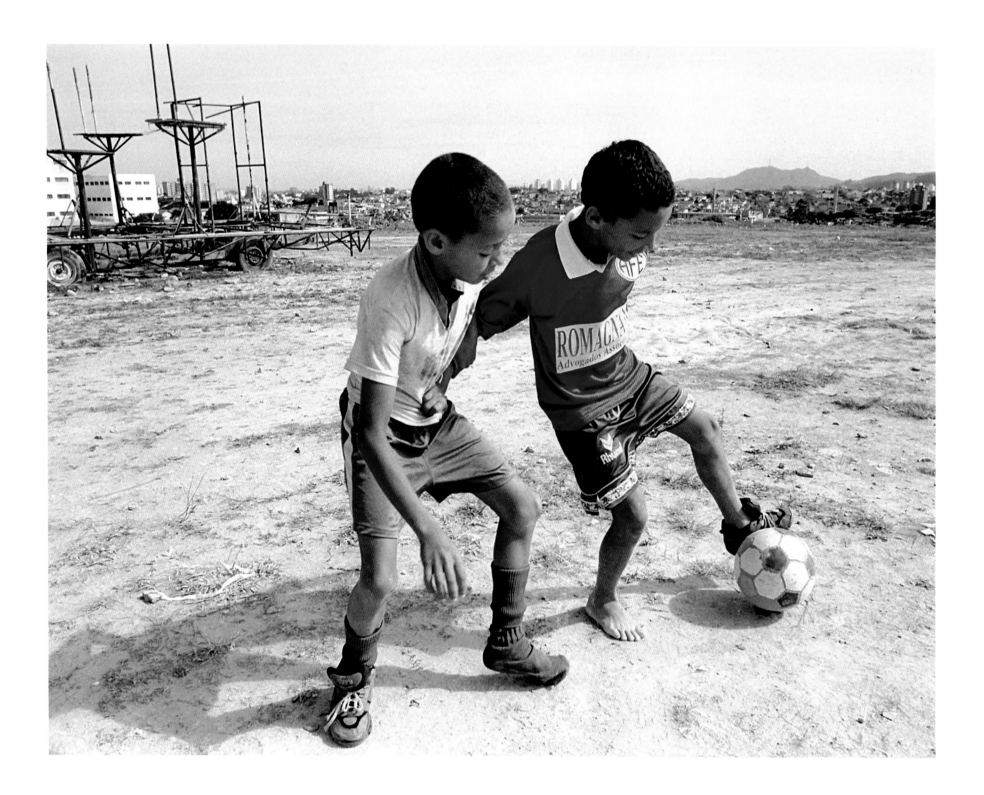

You see one of your friends do something good and you take your ball home and learn to do it yourself. Next day, you're back: "Look! I can do that too."

~ RADHI JAÏDI ~

# Ruíz (GUATEMALA)

*Carlos Ruíz*

Guatemala City is divided up into zones: Zone 1 to Zone 21. The richest people in the city live in Zones 10, 14, 15 and 16. In Guatemala, I don't think what you'd call a middle class exists; it's just rich and poor. I grew up in Zone 21, a very poor neighbourhood: tall buildings with lots of families living in them. We lived on the second floor in a very small apartment: a little kitchen and two bedrooms. I grew up with my mum and three sisters. My oldest sister had a baby when she was 15 and we ended up with eight of us living in that apartment. But all my memories of childhood were of having fun. I wouldn't want to change any of it, how I grew up. I was very happy when I was young. But life was hard, especially for my mum, Maria. She would leave home every morning at six to go to work. She worked at a big factory for Colgate Palmolive – she's only just retired from that job – and did everything she could for her family.

It was a hard time for us as a family but a good time for me. When I think back – my friends, my neighbourhood, my first soccer team – that seems like the best time of my life. When you have very little, maybe you appreciate more the things you do have. In poor countries in Central America – in Africa and South America too – playing some kind of sport is the best thing you can do and, in Latin America, soccer is the best sport. It can be difficult to find a way, though, because you need more than just ability to make it: money sometimes, the opportunity to show what you can do. You need luck too. I have a lot of friends back in Guatemala who were very good players but who made the decision to get other kinds of work. They had to bring money into the house and, to do that, they had to forget about soccer.

I was lucky, though. I got the chance to show what I was able to do. And that was because of a coach who's been like a father to me. Luis Grill Prieto is from Argentina. He

played and coached in Chile and Mexico before he came to Guatemala in the 1960s. He saw me play, talked to me, and told me he thought I had what I needed to be a professional player. But being a soccer player in Guatemala didn't seem such a great thing: the national team wasn't very successful; there was nobody playing professionally outside the country; there wasn't a role model who you could look at and say, "If he can do that, so can I."

When I was about 12, Luis Grill Prieto got me to go training. I'd sneak out of the house at about six in the morning. For two or three months my mum didn't know I was going. I'd just go to school in the afternoons. I'd wait five minutes after she went to work and then go and catch the first bus to be able to go to practice. Sometimes, I

> I have a lot of friends back in Guatemala who were very good players but who made the decision to get other kinds of work. They had to bring money into the house and, to do that, they had to forget about soccer.

would be supposed to be looking after my sister's little baby but a friend of mine would come in through the skylight in our roof. He'd say, "I'll look after the baby, you go off to training." And I'd go out of the house through the skylight too!

When Mum found out, she was screaming at me: "You have to bring something in to the house; soccer's not the right thing to do when it comes to looking after the family." Luis Grill Prieto called me and I told him: "I've

talked to my mum and she doesn't think soccer's the best thing for me." He said, "I don't agree. You have a chance to be a professional player and change the way your family lives completely." I told him I respected my mum and that I was going to stay at school and then go out and find a job. He came round to my house and talked to my mum for about three hours, you know. He tried to convince her: "Your boy can have a great future in soccer." But she said, "No. He has to help me here. He has to look after his sister's baby. He has to go to school, to work. He has to help his family."

Luis Grill was working for one of the best clubs in Guatemala, Municipal, scouting young players and coaching them. He said to my mum, "Ask him. If he decides to stay and do that, that's OK. But if he decides he wants to be a soccer player, let him come with me right now. We'll pay for him to go to school; he'll have food; and he'll play in the team all the time." Mum told me to go outside, to talk to my friends about it and then come back and decide. All of my friends had the same dream: to be a professional player. Some of them said I should stay and be with my family. But others said, "No. It's your dream and we understand because it's our dream too. You have to go." I went back in and told Mum I had decided

to go with Luis Grill Prieto: soccer was what I loved to do. She cried. My sister cried. But Mum said, "Promise me, if you walk out of the door now, you'll become the best soccer player in Guatemala." That was it. The last day I lived with my family. From then on, my life was soccer and the Municipal academy.

When Luis Grill Prieto said he wanted to take me to Municipal, a lot of memories came back to me: playing with my friends with a small ball, out in the street in the evening until it was dark. I think so many of the best players come from poor backgrounds because the game is all you have when you're growing up. It's the best way to keep out of trouble, to live the right kind of life. It's soccer that lets you dream: of playing for the first team, of playing for your country, even of playing outside Guatemala. I started early. My dad died when I was two years old but my mum has told me I was already kicking a ball with him before then. Every picture of me as a boy, I'm holding a ball. I was kicking a ball around all the time, all the time. The first present I was ever given was a ball. We played out in the street, anywhere we could.

At first, I was a goalkeeper. There were a lot of great players in the neighbourhood, older and bigger boys. Going in goal was my only chance sometimes to get a game. The first little local club I played for in my neighbourhood I joined when I was five. It was called San Juan de Dios, named after a big hospital in Guatemala because the man who looked after the team worked at the hospital. His name was Pedro Medina and he lived upstairs in our building. I was playing in goal but our team was so good that some games I'd never even get to touch the ball! I said to Pedro, "Look, when we play against these teams that aren't so good, couldn't I come out and play as a striker for half the game, just to get a touch of the ball?" He agreed and the following week – it was against a really

weak team – I played the first half in goal and then, for the second half, he put me on as a forward: and the first touch I had was to put the ball in the net. From then on, they let me play as a forward.

I still remember all the boys I played football with. We were all very close: lived close together, went to the same school, the same church, the same birthday parties; everybody in our neighbourhood knew everybody else. Some of those friends have died, some are in jail now: life led them to choose different ways to live, even though none of them were bad people. A couple friends in jail, and 12 in the cemetery: that's how life is. Maybe being a role model now, like the role model that didn't exist when I was a boy, is a pressure on me, but I'm enjoying my career and trying to do what I can for people back at home.

I talk to the young guys whenever I'm in Guatemala and try to explain the way I thought when I was a boy and the way I think now. Maybe people see me as a role model, as the best player ever for Guatemala – like I promised my mum I would be – but I hope they see me as a good person as well. They know that when I'm home, I visit the hospitals, that I visit the poorest neighbourhoods, like the one I came from, and play football with the young boys there. I have a team back in Zone 21 that I sponsor and help out any way I can. They play in an LA Galaxy strip and that makes me very proud. I try to remember who I am and where I've come from. You show people what you're like as a player when you're out on the field. You show people what you're like as a person the rest of the time.

# Silva (BRAZIL)

*Gilberto Silva*

I grew up in a small village called Usina Luciânia, about 200 kilometres from Belo Horizonte in the state of Minas Gerais. Usina Luciânia doesn't exist any more. It's sad: all that's left now is the sugar cane factory where my father used to work. Back in the 1980s, there was a strike at the factory; the workers were trying to get better wages. The strike wasn't very well organized and things got out of hand. It turned into a revolt, the workers fighting with the police. It was a big, big problem and many people were sacked from their jobs, including my father. So we had to move to Lagoa da Prata, a town about five kilometres away. My father needed to buy us a house to live in but didn't have the money to do it. I was about 12 when all that happened.

It wasn't just us. Lots of people had to move away and, once we were gone, they started pulling down the houses we had lived in. They didn't want anyone living near the factory; the workers had to live in Lagoa da Prata. In Usina Luciânia, we had lived in houses that the factory had built: one, at first, that we were in on our own and then, later, in another part of the village, one we shared with another family. Those houses were fine. Not big but they were OK, bigger anyway than the house my father finally managed to buy for us in Lagoa da Prata.

In our village, everybody knew each other; as children we were surrounded by our friends. And by our families: my grandparents, my aunts and uncles, my cousins all lived in the same village as me and my mother and father and my three sisters. It was lovely: open and flat. A great place to live if you liked riding a bicycle! And I had a fantastic time growing up. We weren't very comfortably off but I had everything else: things to do, ways to have fun; a sense of security and a sense of joy. We never even heard about drugs and things like that.

Football was always part of my life. We played all the time when we were boys. There were other villages nearby that had been built by the sugar cane factory too; and in every village there was some kind of a pitch. Not covered in grass, maybe, but somewhere to play football. Some of my first memories are of going to my grandmother's village, which was 20 minutes away, and playing football there. Everybody together: some friends – children – but grown-ups too, like my uncles. We were always barefoot: if we wore our shoes to play football, we'd have no shoes to go to school in!

If I stop now and look back, the memory of that still seems so fresh. I can still see his face, smiling and proud of me.

We weren't always allowed to use the pitch in Usina Luciânia. The factory used that pitch. But there was a little sports centre at the back of my school and we could play there: futsal, volleyball; we could swim and we would play a game called *peteca*, which is with a shuttlecock but you hit it with your hand instead of a racquet. Sometimes there would be enough people to have a game of 11-a-side football but usually it would just be whoever was there: five a side or three versus three or two against two but using just one goal.

And, of course, we used to just play football in the street too. Almost every day: you know, football is a huge part of people's lives in Brazil. There were always cousins and friends around for a game. We would put sandals or little piles of stones down to make a goal. And a little ball and we would play and have fun. I remember these hard, plastic balls which really hurt when they hit you! But we didn't care. On the street, the surface was very irregular,

maybe covered with little stones and on a slope. We had nothing on our feet. I think we learnt to adapt to the ground and to the bounce of all the different balls we played with. I think it made a difference to the way I learnt to play the game.

My father, Nizio, played football. Not professionally but for amateur teams, and I would often go with him to watch his games. My sisters are much younger than me and my mum, Izabel, would stay at home to look after them. So my father would usually just take me. His team would train a couple of times a week and play in amateur competitions. We'd run around – me and any other boys who were there – catching the ball when it went off the pitch, just to have the chance to kick a real football. That felt so good compared to the balls we played with ourselves.

My dad was a fan of Atlético Mineiro and he used to talk to me about their players. I used to like them, but at that time they used to show Italian football – Serie A – on TV in Brazil and the player that I think I really admired when I was a little boy was Franco Baresi. But, of course, the player I followed most was my dad! We went all around the nearby towns to games. He played for the team at the sugar cane factory in our village and they had a big rivalry with the teams from Lagoa da Prata. There was a tournament for the local teams every year and the factory used to provide transport for anyone who wanted to come from the village to support my dad's team.

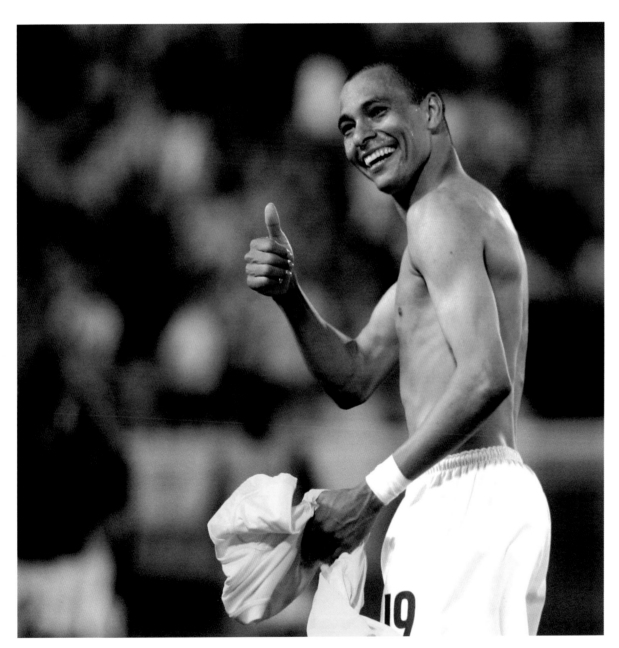

When I first started playing, my father used to say, "You're right-footed, so you must kick with your left. If you want to be a good player, you have to learn to use both feet." And the best lesson I learnt from my father? Well, when I was young he was always worried that I was going to get injured in games. So he told me, "Whenever you get the ball, don't run with it. Play simple. One or two touches and then move it on." He always said that and it's true that it's the best way, especially in the position I play in: defensive midfield. That was the best lesson I ever got about football and I still use it now.

We didn't really have a team at school but there was a guy who used to teach us a little when we had PE classes. Sometimes we had little tournaments: class against class. And, one time – I think I was about ten – we won the competition. I can still remember it so clearly. So many people from the village came along to the sports centre to watch. My dad was there along with the dads of the other players on our team. After we won, we all went off to a bar together – the only bar in the village – to celebrate: my father bought Cokes for everybody! He was so happy. It was great. If I stop now and look back, the memory of that still seems so fresh. I can still see his face, smiling and proud of me.

In Lagoa da Prata, there was a little soccer academy that the owner invited me to join when I was about 11. Teams from the town used to come out to play games in the villages. I had a really good friend who played for one of those but, whenever his team came to our village, we always won. We had a very strong team. This boy also played for this academy in Lagoa da Prata and, one time, he said to me, "Why don't you come along and do some training with us?" It was quite a long way away and we didn't have a car. I didn't have a bike or the money to pay for the bus. But eventually I started going along with a

cousin of mine who had a bike and the two of us would ride it together. He would pedal to Lagoa da Prata and I would have to do the hard bit: pedal back after we were tired out from training!

That first little academy, Lapratinha, was attached to an amateur club. We only trained or played once a week because the guy who ran it had a full-time job. After we moved to Lagoa da Prata from our village, though, when I was about 13, I joined another club in the town, Lagoa Football Club. There, we had two or three sessions a week. I even had an old second-hand bike to get to and from training on by then. I had a job as an apprentice upholsterer: I wanted to be independent, you know, even at 12 years old, to buy my own clothes and shoes. The money wasn't very good, though! My father had found another job, too, as a steelworker. But then we had some problems at home – my mother was very ill – and I thought I would have to stop going to the football club so that I could work full time and help pay for things at home, like my mother's medicines.

When I told the guy who had the academy that I would have to give up in order to find work, he arranged a job for me on a construction site where his company were building a little shopping centre. It was pretty hard physically and, at first, I got tired. The older guys would look at me and say, "Oh, you can't do this job properly!" But after a few months I got used to it and started getting stronger. And, two or three times a week, I could leave work early to go and train. That guy who owned the academy, José Antonio, helped me a lot back then. The academy had its own kit. I'd had one pair of boots but they had worn out. He bought me a new pair as a present and, by the time those wore out, because I was working, I was able to afford to buy my own. José Antonio helped my family too. I got paid every Friday and would give the

money to my father. He had to take my mum to another town for her treatment three times a week but he only got paid twice a month so it was important that I brought some money in every week.

I think every kid in Brazil has the same dream. We all like to think sometimes that perhaps we could be a football player. Even when I was seven or eight, living in Usina Luciânia, people used to say to me that I was one of the best in the village. The guys would say, "Oh, Beto, someone from Atlético Mineiro will come and get you to play for them." I'd always get picked first when it came to deciding on teams. I still played football as a teenager in Lagoa da Prata but, every day now, I had in the back of my mind that I had to work, that I had to get up in the morning and get to the building site for seven o'clock. Football and seeing the guys was two or three times a week and maybe playing a game at the weekend.

Back then, the idea of joining a professional club seemed a long way off: it would mean going to Belo Horizonte. But, you know, sometimes things happen in a moment. I was playing at Lagoa; a guy who was a big friend of my father's met somebody from Belo Horizonte whose father was a member of the América Mineiro club. They talked about me and another boy who played for our team: "Why not take them for a trial?" I was 16, my friend was a year older, and we went off to Belo Horizonte together to try out. We were there for a week. I passed but he didn't. And that was it. I joined their under-16s.

I found it very hard at América Mineiro. It meant moving away from home. My mum was better by now but I had to go and stay at a hostel with lots of the other young players. It meant I shared a room with four or five other boys. That was difficult for me and worse was that I really missed my family. I'd never been away from them before.

It felt as if I was having to become very adult very quickly. We got paid a little but not enough for me to be able to afford to go home to visit. Even the football was hard, training twice a day. I loved playing but our coach, Edson Gaúcho, was very tough, very strict and shouted at us a lot. When I think back, I realize that everything he did was very important for me but that was the first time when football didn't feel like fun. It felt like work. At 16, the simple joy of the game had finished. And the job had begun.

Away from training, Edson was very helpful to me. He was someone I could talk to. I explained to him that I wanted to go home: my mum was just getting over a serious illness and I felt like my dad needed me there to help. My dad would sometimes send me money and I knew he couldn't afford to. I remember Edson saying, "No. Stay here. If you stay, then – in a few years' time – you'll be able to help your family much more. Be patient." He believed in me but, in the end, he spoke to the directors and arranged for me to get enough money to be able to go home. My parents never asked me to come back but I couldn't help feeling that, if I was back in Lagoa da Prata, I could be working and earning much more and helping them. I told Edson, "I'm going. Please don't try to stop me." It was backwards and forwards! The owner of the club, the manager of the club, talking to me and trying to convince me that I had a future as a player; me just wanting to go home.

So, after I had spent four and a half months at América Mineiro, I ended up going back to Lagoa da Prata and getting a job in a sweet factory. I was there for the next couple of years and I ate a lot of those sweets to start with! People said, "Why have you come back?" I couldn't really answer them: I just had to, you know. If I had stayed away and something had gone wrong at home with my family

I would never have forgotten it for the rest of my life. Anyway, I kept playing: for the sweet factory team. We played against other factories and it was fun, you know. In that short time with América Mineiro, though, I'd learnt so much about football. I had a completely different idea of the game and, all the time, I had in the back of my mind the idea that I could go back to the academy in Belo Horizonte. I was still registered at América Mineiro and they loaned me out to amateur football.

be even though I'm away now. My parents understand it's what I want to do and they know I'm already thinking about going home to Lagoa da Prata to live when I stop playing. With my wife and my children and our families, all together, like it was when I was a boy.

I learnt about football from my father. I guess my father is proud now like he was when we won that tournament at school in Usina Luciânia. We still talk about football.

## I had people who put the right situations in front of me; I was lucky: I got a second chance and I took it.

The guy who ran the sweet factory wanted me to keep in touch with my club too. But do you know what my luck was? I was thinking of getting a different job, one that earned more money. The guy at the factory wanted me to stay and to play, so he said, "Oh, we'll find you another job, a better-paid job." But he never found me that job. If he had, maybe everything would have been different and I wouldn't have gone back to football. Instead, after a while, I said to myself, "Why not try again?" I talked to my dad but the decisions were up to me. This time I knew what I had to do, what was involved. I prepared myself properly for going back to América Mineiro. And, once I did, things just went upwards so quickly, like a plane taking off.

When I look back to where I came from and think about where I am now: how could I have imagined what would happen to me? How could I have imagined I would become a World Cup winner? How can I explain it now? I had people who put the right situations in front of me; I was lucky: I got a second chance and I took it. My mum is fine now, and that's great. I was there when I needed to

My first goal for Arsenal, after I came to Europe, was scored with my left foot. He said, "See? I taught you to use your left foot and it worked!" I think he still worries too. Whenever I speak to him before I go off to play a game, he says, "Be careful. Play simple." All the same things!

I have learnt so many things *from* football as well. It was one of the reasons why my childhood was full of so much happiness even though the conditions we lived in weren't so good. I don't just mean that I learnt the rules of the game. Look at those in a different way and you see they are rules of life too: when I was young, of course I wanted to win, but I think I understood from early on that to lose sometimes is part of the game too; if you want to win, even if it's just a little game in the street, you must have discipline; you need to have your tactics, a plan; and you have to have respect for other people. You must respect the other team you're playing against and respect your own teammates too.

In any poor country, it's the same: playing football and watching football is the one thing you can do to forget about a hard life.  ~ MIDO ~

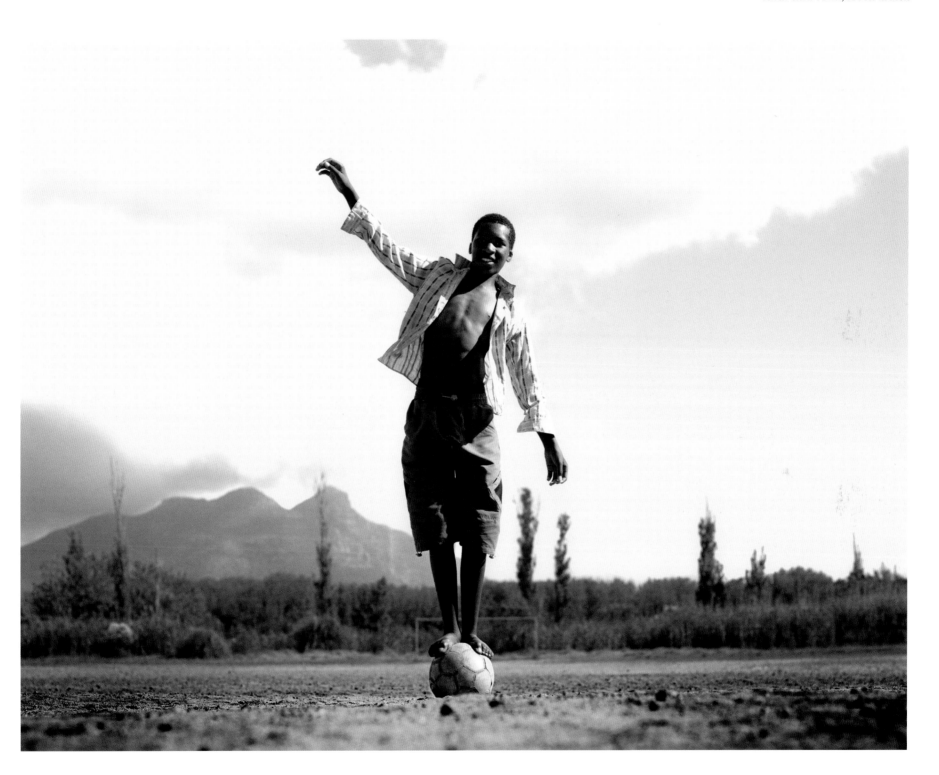

# Mido (EGYPT)

*Ahmed "Mido" Hossam*

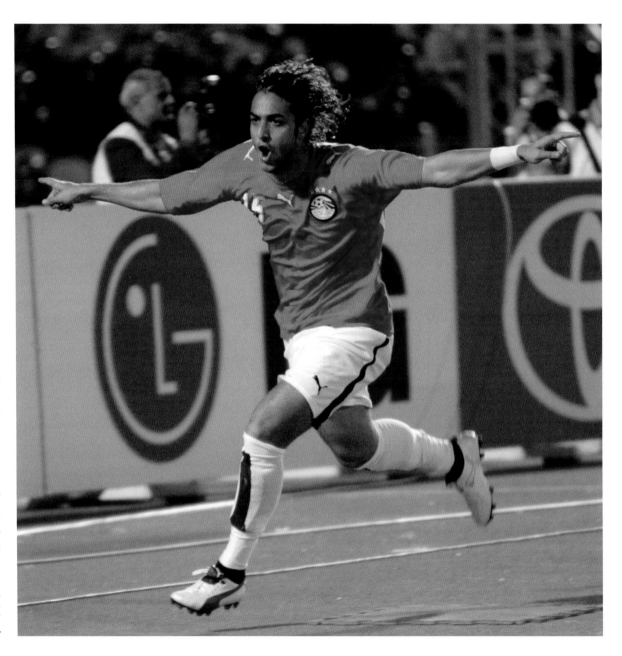

I can still remember the little green rubber ball we used to play with, in the yard outside my house. It was somewhere my mum could keep an eye on us. We lived in an apartment building so there was quite a big entrance. Right in front of that was a tiled area, set back from the road, so we could play and be safe from cars. I grew up in quite a nice neighbourhood but it was like every other part of Cairo: wherever you go, you'll see kids playing football in the street. Drive around and, every couple of minutes, you'll see a game going on. I've travelled all over Africa and I think it's the same everywhere.

Of course I can still remember the boys I played with too: boys from my apartment building – like Mohammed Salah and Ahmed Nour – or the block next door. When we were young we'd play two against one, or a goalie and one versus one. It wasn't until we were older that we played in organized games. We would be out in that little courtyard and Mum would look out of the window to make sure we were safe, that we weren't running out into the street. Then she'd just let us play. For hours. In the holidays, when there was no school, we'd be playing from morning until night. When my mum called me for meals, I'd run in, grab something very quickly and go straight out to play again.

You see, I didn't want to eat; I didn't want to do anything else. I remember when I was about ten, they started to bring out computer games: football games you could play on a computer. But I was never interested. My friends had them but I'd say, "Why would I want to play football on a computer when I can play it in real life?" Now, it's the opposite. I love those games. I play them all the time!

Maybe people don't realize it about Egypt; it's a real football country. People love to play, love to watch. Before I played for El-Zamalek, I used to go and watch them.

I was a fan. My dad played professionally for the club and so following them was something handed down in the family. I never saw my dad play, but the first big game I went to watch was at their stadium in Cairo in 1989. Egypt were playing Algeria. We won one-nil, with a goal by the greatest Egyptian player ever, Hossam Hassan. That qualified us for the World Cup in Italy in 1990. It was an amazing experience. There were 125,000 people in the crowd and we were behind the goal at the end where we scored. You know, I was just six years old. You can imagine what it was like to be there.

Egypt scored after about ten minutes, I think. Very early in the game, anyway. And I can still see the goal. We had a corner kick. An Algerian defender cleared it away with his head. One of our players – I can't remember who – had a shot and it went well wide but a guy called El Kaas picked it up and took it out to the left wing, cut back inside onto his right foot and crossed. Hossam Hassan scored with a great header.

Like I say, I was six when I saw that game but I know that to play football was already a dream for me, even then. It stayed with me. I talk about it with my mum still. We both remember a conversation a few years later, when I was 11 or 12. Mum was like any mum, wanting me to study, to learn and do well for myself: I said to her, "I don't need to study. I'm going to be a famous footballer!" In Egypt, when I was a boy anyway, being a footballer wasn't something people thought about as a career.

I have a son now and if he came to me and said what I said to my mum – that I didn't need to bother with school, that I was going to be a footballer – I'd tell him he had to study first! So many things have to come together for you to be successful as a player. You have to be very lucky, to start with. You have to be physically fit enough,

something you can't be sure about when a boy is very young. He might look good at ten years old but you can't tell how he will develop physically. I suppose there are quite a lot of things that I did which, if my son did them now, I'd be critical.

But that was me; I had that ambition for myself. Even though my dad had been a player, he didn't really take notice of me when I was playing in the street. It wasn't until later, when friends told him that I could be a good player, that he started to take an interest in my football. He took me along to Zamalek to try out and I joined them when I was eight. The first day I trained there, they gave me a club shirt and I saw all the famous players. Sometimes, we'd be training and the first team players would walk past on their way to another pitch and, even if we were in the middle of a game, we'd stop and watch them go by. This was the club I'd always supported. It was

to be better than them. The competitive edge is with boys that early, I think – from five or six years old, maybe even younger.

Like every kid, I had somebody I wanted to be like, someone I pretended to be when I was playing, a hero. My hero was Hossam Hassan. I suppose he was every boy's hero: the top international goal scorer of all time for Egypt, our centre forward at the 1990 World Cup. He's 40-something now and he's still playing. You see, Hassan was only in his early 20s when we went to the World Cup. So, later, I was able to play alongside him up front for Egypt, 15 times. We're good friends now too. I see him when I go back to Egypt. And if I am in Cairo today, I still see kids playing in the street like we used to. In any poor country, it's the same: playing football and watching football is the one thing you can do to forget about a hard life.

This was the club I'd always supported. It was great, and there was so much to learn. You go from being the best player in your little games in the street to being surrounded by good players. And you want to learn and to be better than them. The competitive edge is with boys that early, I think – from five or six years old, maybe even younger.

great, and there was so much to learn. You go from being the best player in your little games in the street to being surrounded by good players. And you want to learn and

# Acknowledgements

Significant thanks are due for help, advice, contacts and even hospitality. The players featured in *A Beautiful Game* gave generously and thoughtfully of their time. I am full of respect and admiration for them all, as players and as people. At crucial times, I was able to call on the expertise and goodwill of a lot of other people too. I'm very grateful indeed to all of them and hope they'll agree, when they see the book, that it was worth their trouble. They all believe in the game, I know, and believed in this project enough to help make *A Beautiful Game* happen:

| | | | | |
|---|---|---|---|---|
| David Beckham | Gary Double | Richard Law | Amanda Docherty | David Dein |
| Arsène Wenger | Harry Redknapp | Guillem Balague | Alan Sefton | Tony Stephens |
| Sara Chisnall | Tony Adams | Marta Santisteban | Makoto Kaneko | Marie Priest |
| Marcela Mora Y Araujo | Steve Morrow | Flor Rivera | Andy West | Jamie Jarvis |
| Sid Lowe | Herman Sferra | Paul Agnew | Ray Lewington | Lawrie Sanchez |
| Alexis Menuge | Luis Grill Prieto | Eddie Niedzwiecki | Rosie Bass | Mark Burman |
| Simon Oliveira | Matthew Kay | Mark Hughes | Gabriele Marcotti | Wendy Zych |
| Jonathan Harris | Andy Evans | Ivan Gazidis | Amy Lawrence | Nick Blackburn |
| Bill Hamilton | Carmelo Mifsud | Konstantin Kruger | Erik Bildermann | Ryan Maxfield |
| Jim Riordan | Sarah Brookes | Keegan Pierce | Terry Byrne | Julia Gorton |
| Richard Motzkin | Jose Miguel Terres | Steve Stride | Elaine Hogue | Darren Dein |
| Justin Pearson | Jorge Messi | Paul Faulkner | Andrea Butti | Philippe Auclair |
| Rhona Macdonald | Paul Davis | Claire Huggins | Luigi Crippa | Ian Ramsdale |
| Gordon Strachan | Graham Bell | Frank Yallop | Leo Picchi | Mike Lawrence |
| Gary Pendrey | Keith Lamb | Andy Maxey | Miguel Macedo | Ann Watt |
| Jim Blyth | Gareth Southgate | Kate Baldwin | Joao Castelo Branco | |

# Index

Abramovich, Roman 94
AC Milan 63, 67, 76, 79, 135
Académie Mimoscifcom, Côte d'Ivoire
    62, 63
Africa Cup of Nations 9, 128
Aimar, Pablo 140
Ajax, Amsterdam 69, 113
Álvarez, Ariel 87
América Mineiro, Brazil 168, 169
Anderlecht club, Belgium 68–9, 71, 82
Antonio, José 168
Armenta, Juan 16
Arsenal 20, 63, 169
AS Roma 24
Athletic Bilbao 146
Athletic Oriental, Honduras 50–1
Atlético Mineiro, Brazil 166
AYSO (American Youth Soccer
    Organization) 43

Bayashi, Waka 47
Beckham, David 6–9
Bedford Hearts, Nova Scotia 78–9
Boruc, Artur 106–7
Boruc, Helenka 107
Boruc, Robert 106, 107
Boruc, Wladyslaw 106
Boutahar, Said 110, 113

Cafu 62
Cahill, Tim 135
Canadian Soccer Association 79
Cannavaro, Fabio 74–7, 80
Casillas, Iker 146–9
Casillas, José Luis 146, 148
Casillas, María del Carmen 148
Chalá, Cléber 125
Champions League 12, 21, 79
Christchurch United 119
ČKD Kompresory, Prague 100
Colinet, Jacky 99
Colo club, New South Wales 132, 134,
    135
Coyotes of Nexa 16

De La Cruz, Ulises 124–5
Delgado, Augustin 125

Diarra, Mahamadou 114–15
Donovan, Joshua 42, 43
Donovan, Landon 42–3

Eboué, Emmanuel 62–3
El Karkouri, Talal 54–5
El-Zamalek, Egypt 172–3
European Cup 79
    Winner's Cup 24
European Football Championships
    149, 152
Excelsior, Rotterdam 110–11

FA Cup 33, 119
FC Barcelona 82, 85
FC Meyrin 67
Figo, Luís 152–3

Galindo, Maykel 86–7
Gaúcho, Edson 168
German Football Federation 121
Gordon, Craig 58–9
Gordon, David 58
Göttig, Uwe 120
Grandoli club, Rosario 140, 143
Grasshoppers, Switzerland 67
Grazer AK 12
Greenwood, Clint 43
Grill Prieto, Luis 164, 165
Gudjohnsen, Andres 85
Gudjohnsen, Arnor 82, 83, 85
Gudjohnsen, Daniel 85
Gudjohnsen, Eidur 82–5
Gudjohnsen, Sveinn 85
Guerrero, Diego 51
Guerrero, Iván 50

Hajduk Split 79
Hart, Stephen 79
Hassan, Hossam 173
Healy, Cliff 32, 33
Healy, David 32–3
Hearts, Scotland 58
HFIF team, Fårvang 28–9
Highlanders FC, Zimbabwe 90
Hossam, Ahmed "Mido" 172–3
Hrones, Jirí 100

IR team, Iceland 83, 85

Jaïdi, Rahdi 160–1
James, David 136–7
Jazic, Alan 78
Jazic, Ante 78–9
Jazic, Mario 78
Juventus 63, 76

Kaizer Chiefs 20, 21
Kalac, Zeljko 135
Kallio, Toni 24–5
Kanté, Koly 115
Kanu, Nwankwo 128–9
Khumalo, Doctor 20
Kompany, François 71
Kompany, Jocelyne 69
Kompany, Pierre 69
Kompany, Vincent 68–71
KSC Lokeren, Belgium 82

Lagoa Football Club 168
Lapratinha academy, Lagoa da Prata
    167–8
Laursen, Anders 28, 29
Laursen, Martin 28–9
Legia Warszawa 106, 107

Manchester United 7, 9, 33
Maradona, Diego 24, 42, 46, 50, 54,
    76–7, 114, 140
Marconi club, Australia 135
McCarthy, Abraham 20
McCarthy, Benni 20–1
Medina, Pedro 165
Messi, Lionel 140–3
Metzelder, Christoph 120–1
Metzelder, Malte 120, 121
Misono FC, Yokohama 46
Moshoeu, John "Shoes" 20
Municipal club, Guatemala 164–5
Muntari, Sulley 36–7
Mwaruwari, Benjani 90–1

Nakamura, Shunsuke 46–7
Napoli club 76–7
Nelsen, Christine 118

Nelsen, Ryan 118–19
Nelsen, Wayne 118
Newell's Old Boys 143
Novelli, Daniel 136
Nystrom, Steffen 157

OFI Crete 38
Orlando Pirates 21

Panshanger Yellows 137
Pedersen, Morten Gamst 156–7
Pelé, Abédi 37, 114, 134
Persie, Robin van 110–13
Pogatetz, Alois 12
Pogatetz, Emanuel 12–13
Pogoń Siedlce 107
Premier League 9, 21, 119, 157
Prosinečki, Robert 114
Pumas, Mexico 16–17

Raja Casablanca 54, 55
Rangers 33
Rapid Vienna 79
Real Madrid 9, 146, 148–9
Ribéry, Franck 98–9
Rocastle, David 20
Rosický, Eva 101
Rosický, Jirí (brother of Tomáš) 100,
    101
Rosický, Jirí (father of Tomáš) 100–1
Rosický, Tomáš 100–1
Ruíz, Carlos 164–5
Ruíz, Maria 164–5

Samaras, Georgios 38–9
Samaras, Ioannis 38, 39
San Juan de Dios club, Guatemala 165
Savićević, Dejan 79
Schwarzer, Mark 132–5
Serie A 24, 166
Silva, Gilberto 166–9
Silva, Nizio 166–7
Smertin, Alexey 94–5
Smertin, Gennady 94–5
Smertin, Yevgeniy 94–5
Solomon, Jason 137
Sparta Prague 100

Spartans club, Nigeria 129
Sporting Clube de Portugal 152
Stade Gabèsien, Tunisia 160–1
Sturm Graz 12
Suárez, Claudio 16–17
Suárez, Irma 17
Suárez, Sergio 16
Suárez, Xavier 16, 17

Thuram, Lilian 63
Topczewski, Józef 107
Tottenham Hotspur Football Club 83,
    137
TTPV club, Finland 24–5
TuS Haltern club 120, 121

Under-16 World Cup 135
União Futebol Clube "Os Pastilhas"
    ("The Mints") 152

Van Persie, Robin 110–13
VfB Stuttgart 132
Villa Clara team, Cuba 87
Vogel, François 67
Vogel, Johann 66–7

Watford Football Club 137
Welwyn Pegasus team 136–7
Whiteside, Norman 33
Wollongong Wolves 135
World Cup 24, 125, 128, 134, 135, 169
    1974 134
    1986 47, 50, 54, 152
    1990 76, 134, 173
    1994 42
    2006 135
    2010 21
    see also Under-16 World Cup

Yeboah, Tony 37
Yokohama Marinos 47

Zidane, Zinedine 9, 99, 114

ISBN: 978-0-8109-8290-1

Produced and originated by PQ Blackwell Limited
116 Symonds Street, Auckland, New Zealand
www.pqblackwell.com

Concept and design copyright © 2009 PQ Blackwell.
All text copyright © 2009 Tom Watt.
All images including cover images copyright © 2009 Getty Images,
except pp 7-9 copyright © UNICEF/HQ08/David Turnley.
Book design and image research Carolyn Lewis.

Additional image locations:
Front endpaper verso – Rwanda; p. 2 – New York, USA.

This edition first published in 2009 by Abrams UK, a subsidiary
of La Martinière Groupe.

Printed by Midas Printing International, China.

10 9 8 7 6 5 4 3 2 1

Abrams books are available at special discounts when purchased in
quantity for premiums and promotions as well as fundraising or
educational use. Special editions can also be created to specification.
For details, contact Abrams UK at the address below.

 Abrams

The Market Building
72-82 Rosebery Avenue
London EC1R 4RW
www.abramsbooks.co.uk